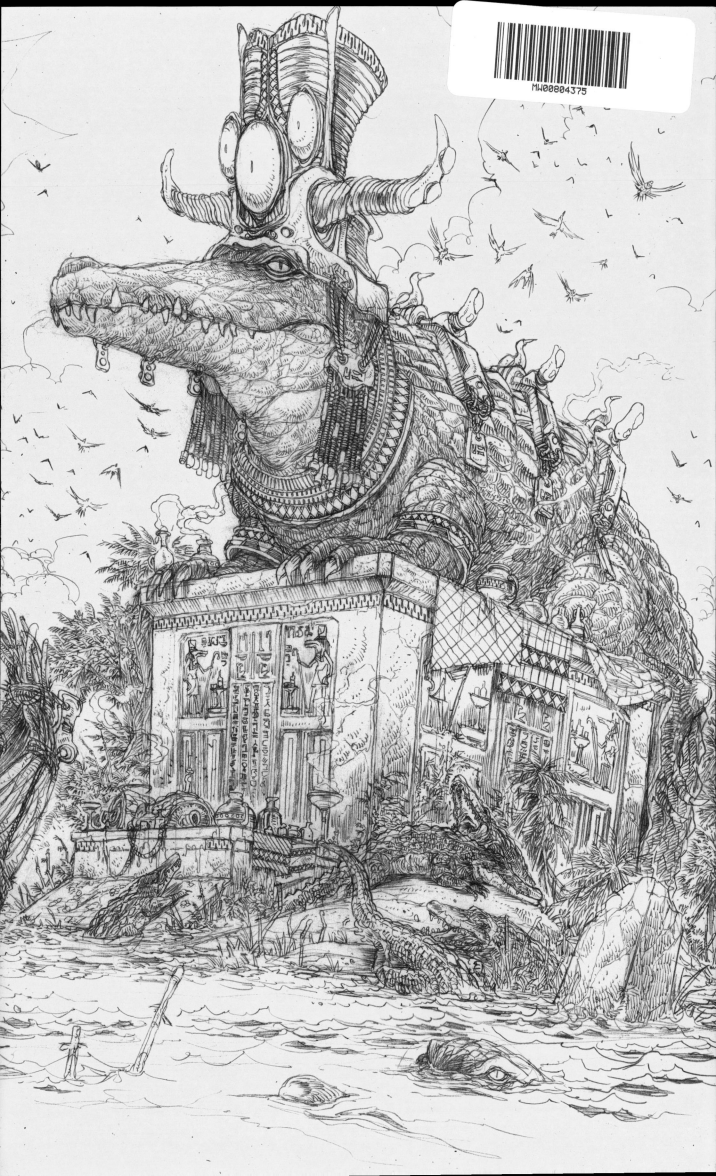

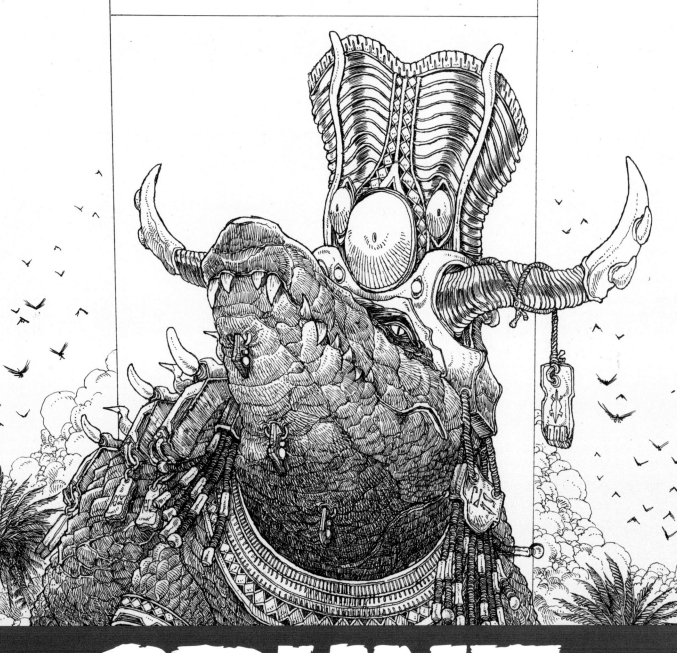

GRUNT

THE ART AND UNPUBLISHED COMICS OF JAMES STOKOE

GRU

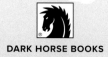

THE ART AND UNPUBLISHED COMICS OF JAMES STOKOE

DARK HORSE BOOKS

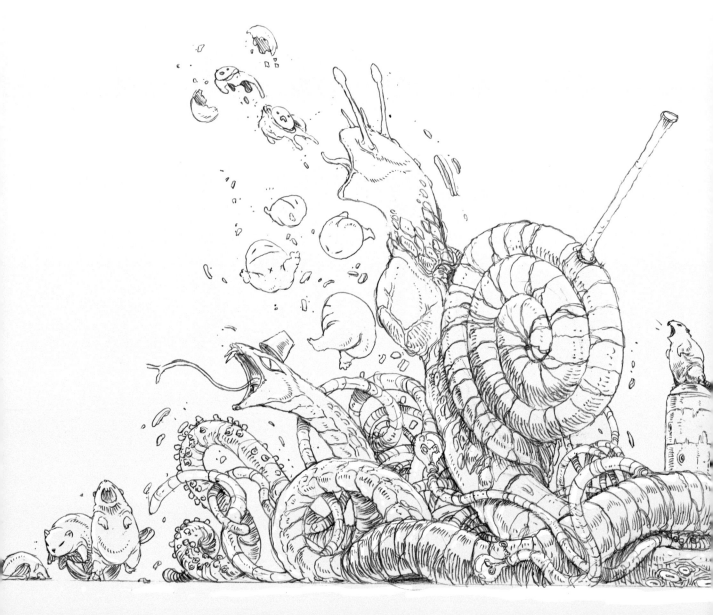

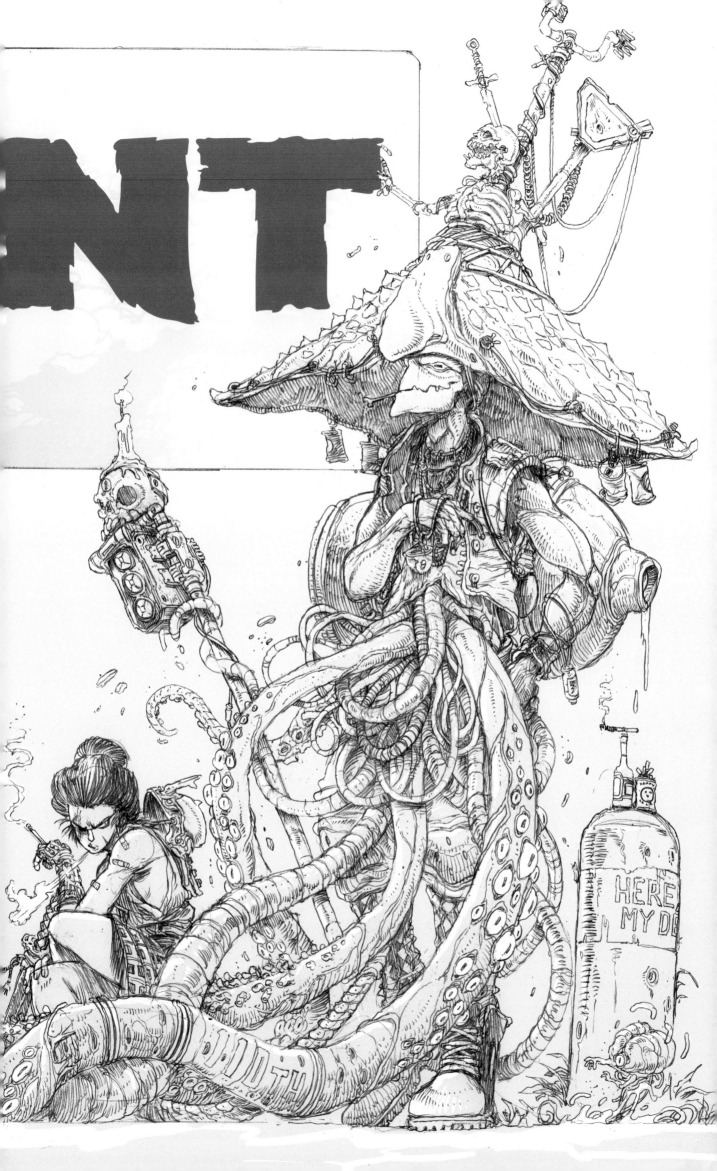

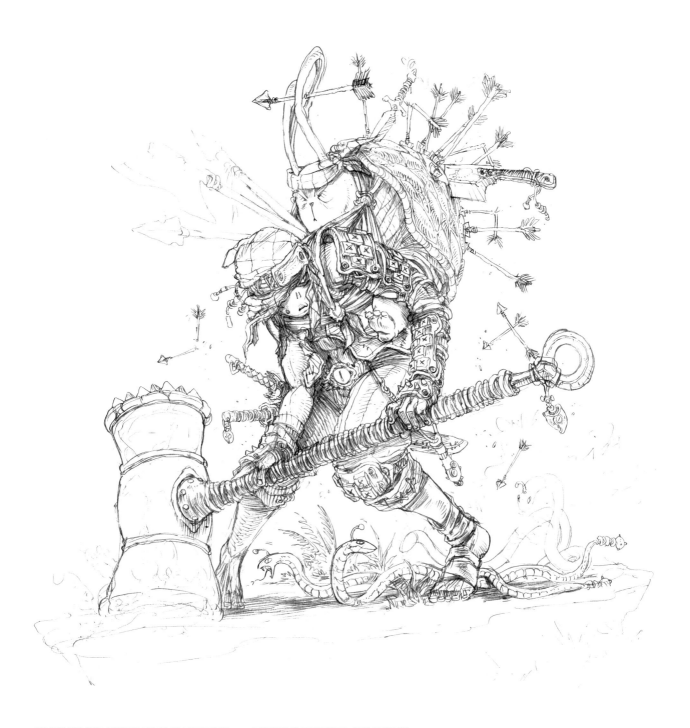

PUBLISHER MIKE RICHARDSON **EDITOR DANIEL CHABON**

ASSISTANT EDITORS CHUCK HOWITT AND BRETT ISRAEL

DESIGNER ETHAN KIMBERLING **DIGITAL ART TECHNICIAN ADAM PRUETT**

Published by Dark Horse Books
A division of Dark Horse Comics LLC
10956 SE Main Street
Milwaukie, OR 97222

First edition: May 2019
ISBN 978-1-50671-169-0
Digital ISBN 978-1-50671-170-6

10 9 8 7 6 5 4 3 2 1
Printed in China

Comic Shop Locator Service: comicshoplocator.com

INTRODUCTION

IKE MANY MISBEGOTTEN SPECIES ON OUR GREAT, GREEN EARTH, THE ELUSIVE **SPECKLED JAMES STOKOE** IS A CREATURE OF CONTRASTS AND CONTRADICTIONS.

THIS LURID SPECIMEN (tagged I.D. # JS09041985), STEADILY APPROACHING ITS MIDLIFE AT TIME OF DOCUMENTATION, IS NO EXCEPTION TO PARALLEL BREEDS FOUND IN MANY OTHER BIOMES.

MYEH!

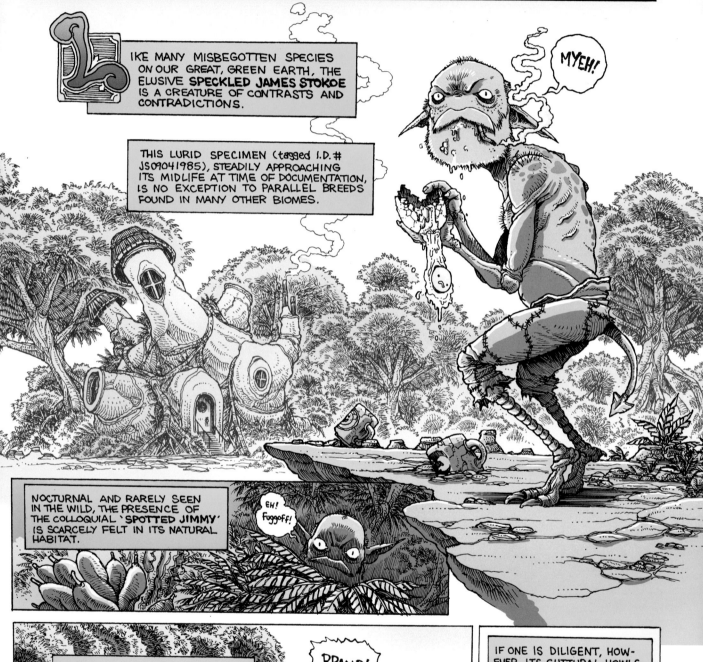

NOCTURNAL AND RARELY SEEN IN THE WILD, THE PRESENCE OF THE COLLOQUIAL `SPOTTED JIMMY' IS SCARCELY FELT IN ITS NATURAL HABITAT.

EH! Fuggoff!

OFTEN, A FEW SCATTERINGS OF NOVELTY FOOD WRAPPERS FOUND ALONG ITS HUNTING TRAILS IS THE ONLY EVIDENCE THAT THIS MYSTERIOUS SPECIES EVEN EXISTS.

BRAAAP!

IF ONE IS DILIGENT, HOWEVER, ITS GUTTURAL HOWLS CAN SOMETIMES BE HEARD IN THE EARLY HOURS OF THE MORNING.

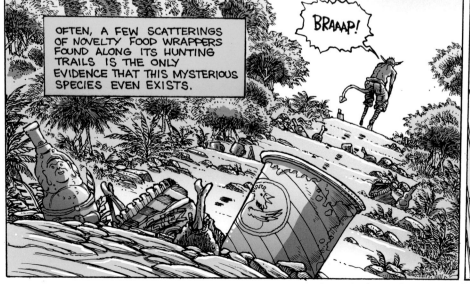

SPOTTED JIMMY
@HeGotSpots

DONNIE YEN!!!!!!!!!!!!!!!!!!
!!!!!!!!!!!!!!!!

3:21 AM Oct 7th 2018

3 Rts 14 Likes

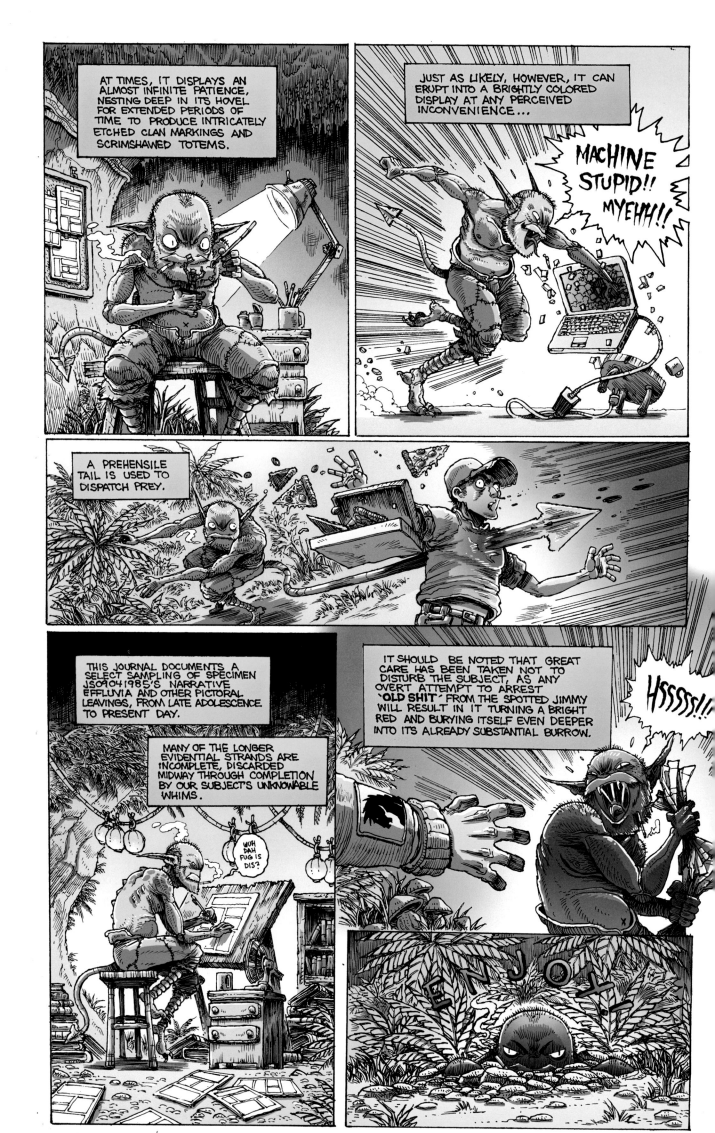

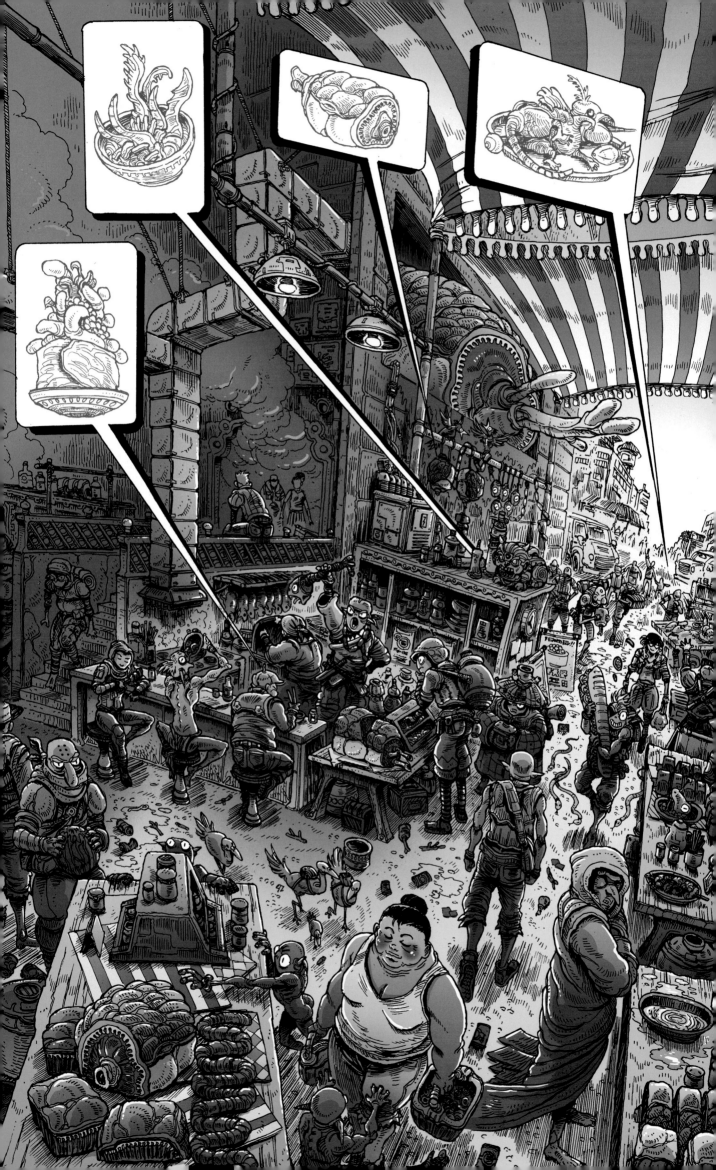

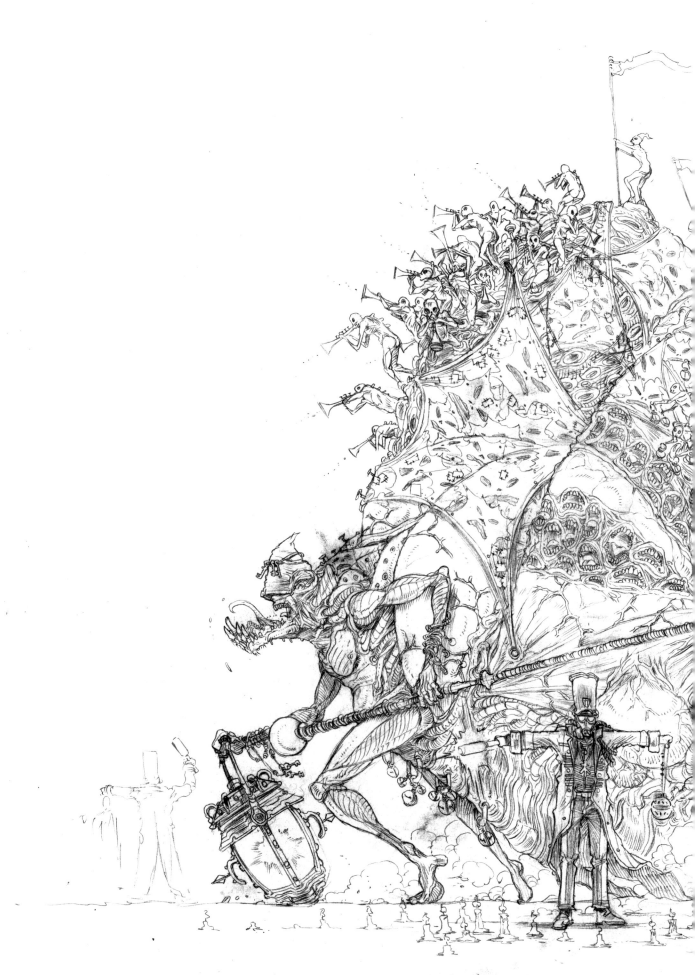

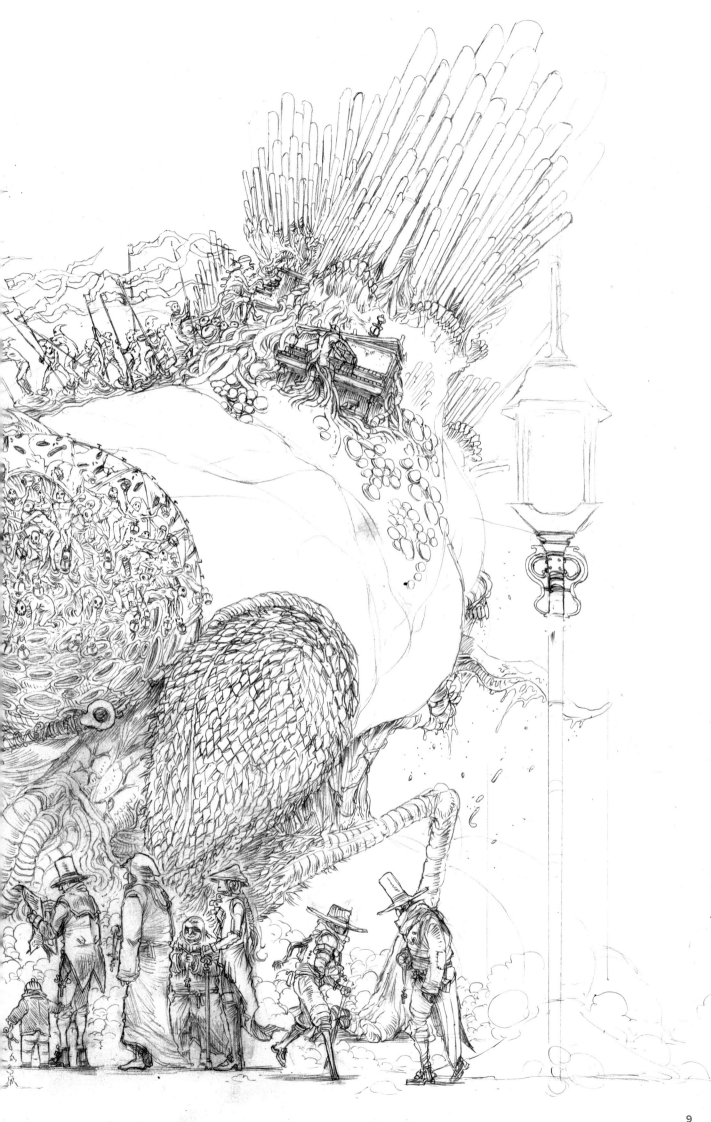

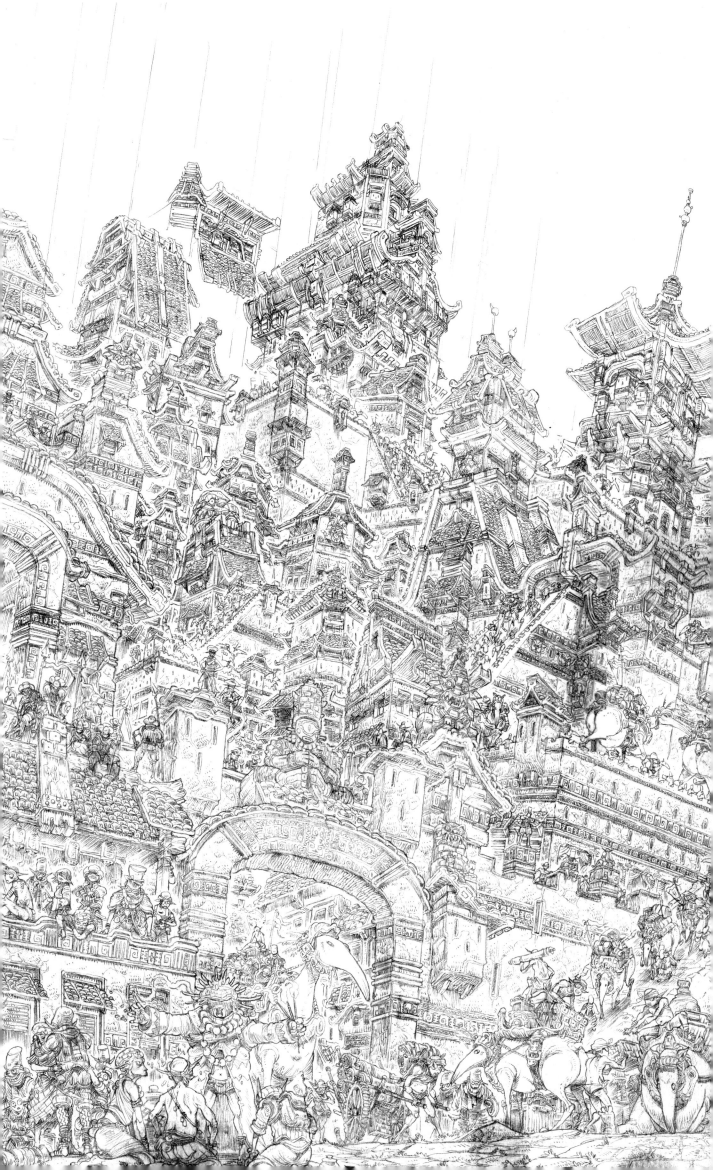

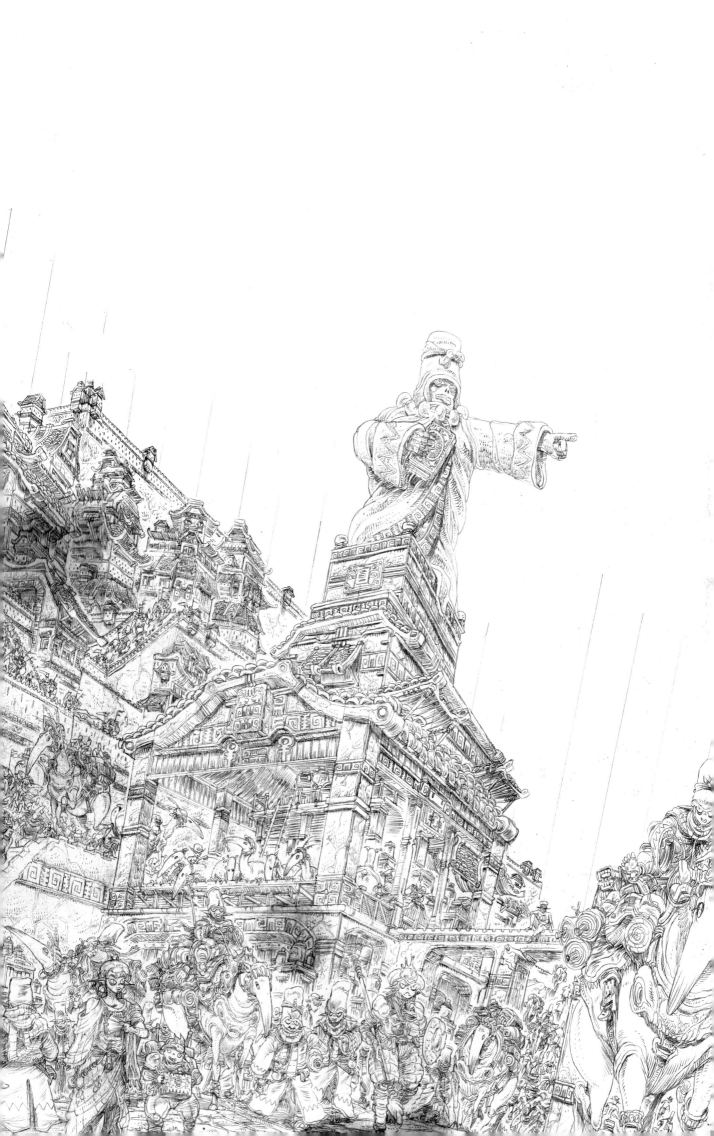

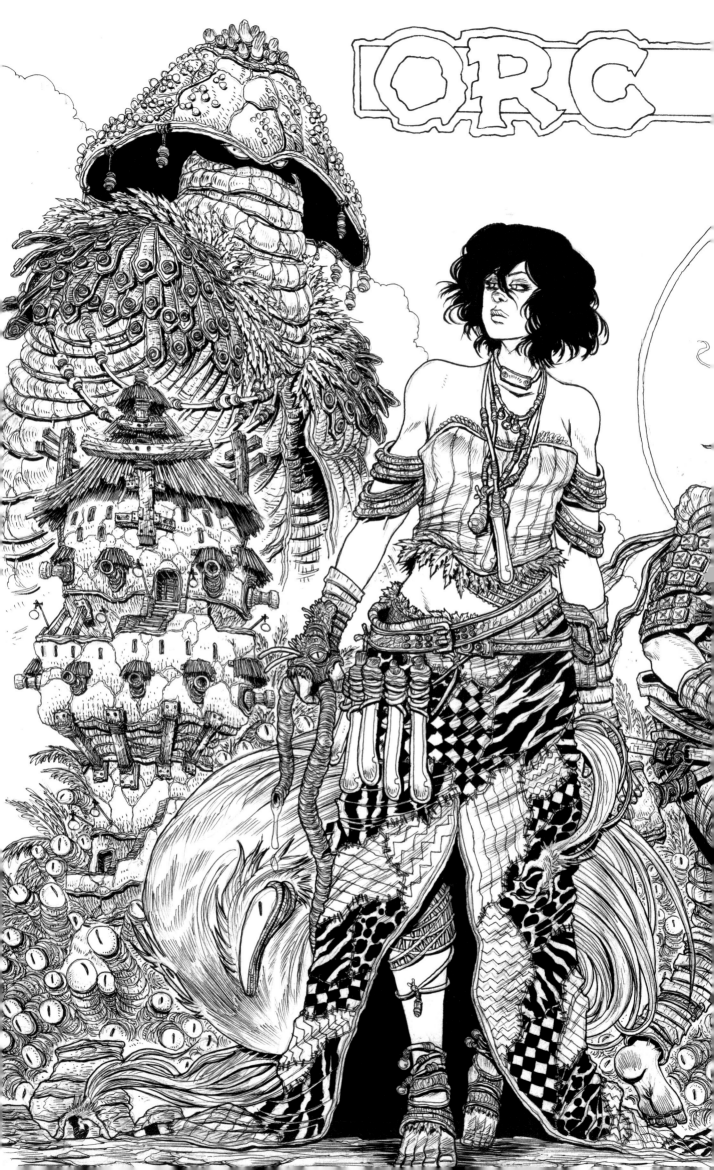

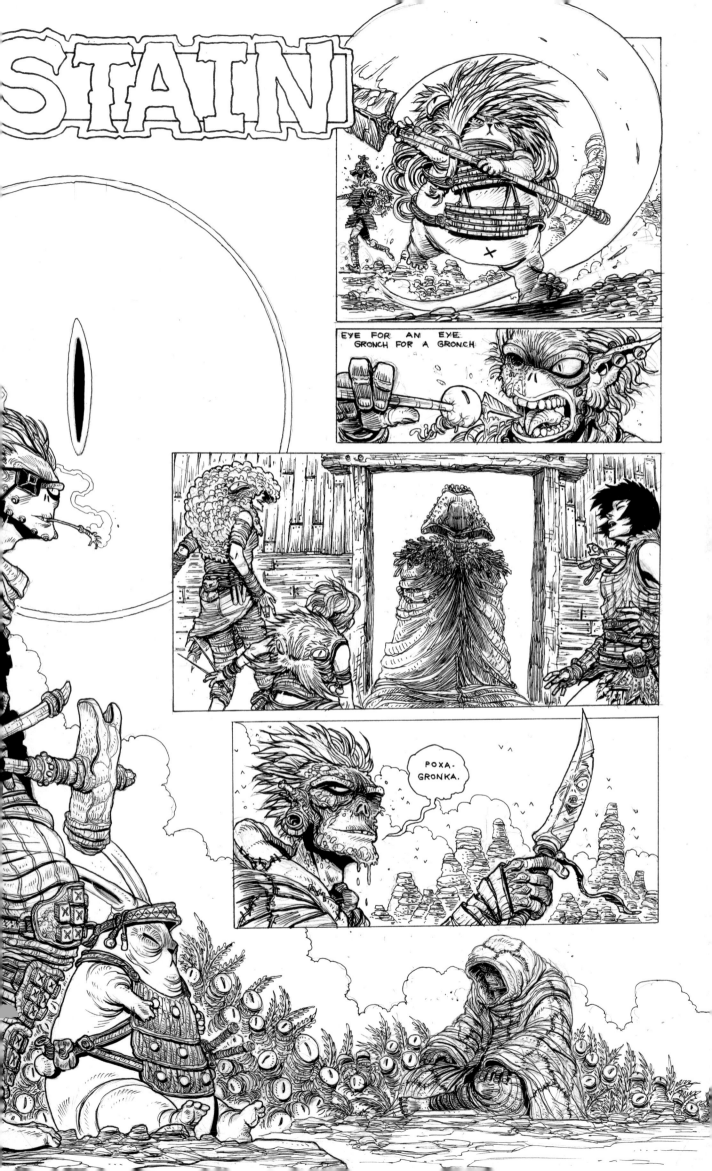

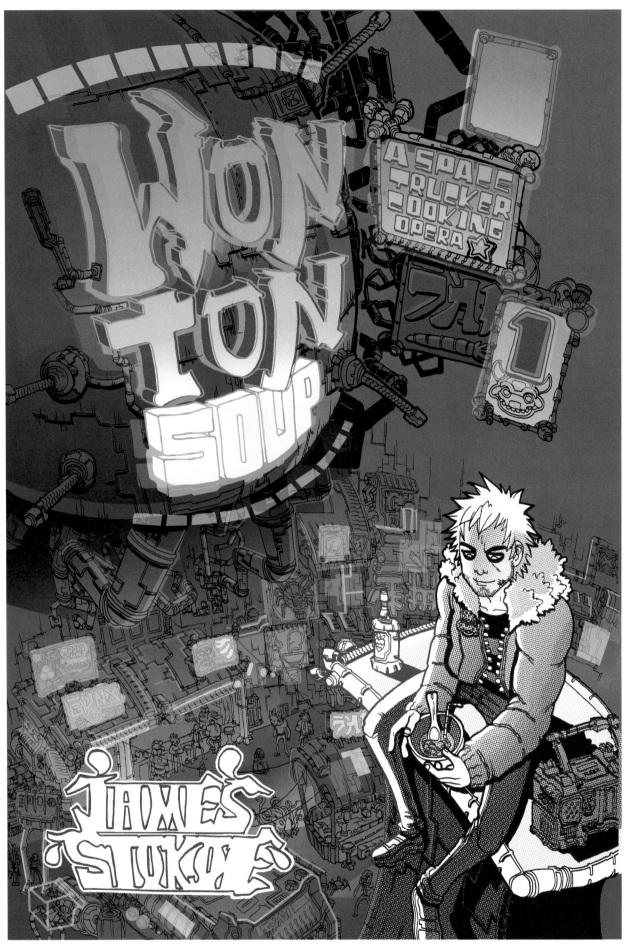

The following pages feature art from *Wonton Soup*, published by Oni Press, and *War Wonton Soup*, previously unpublished.

Text and illustrations of *Wonton Soup*™ © 2019 Jame Stokoe.

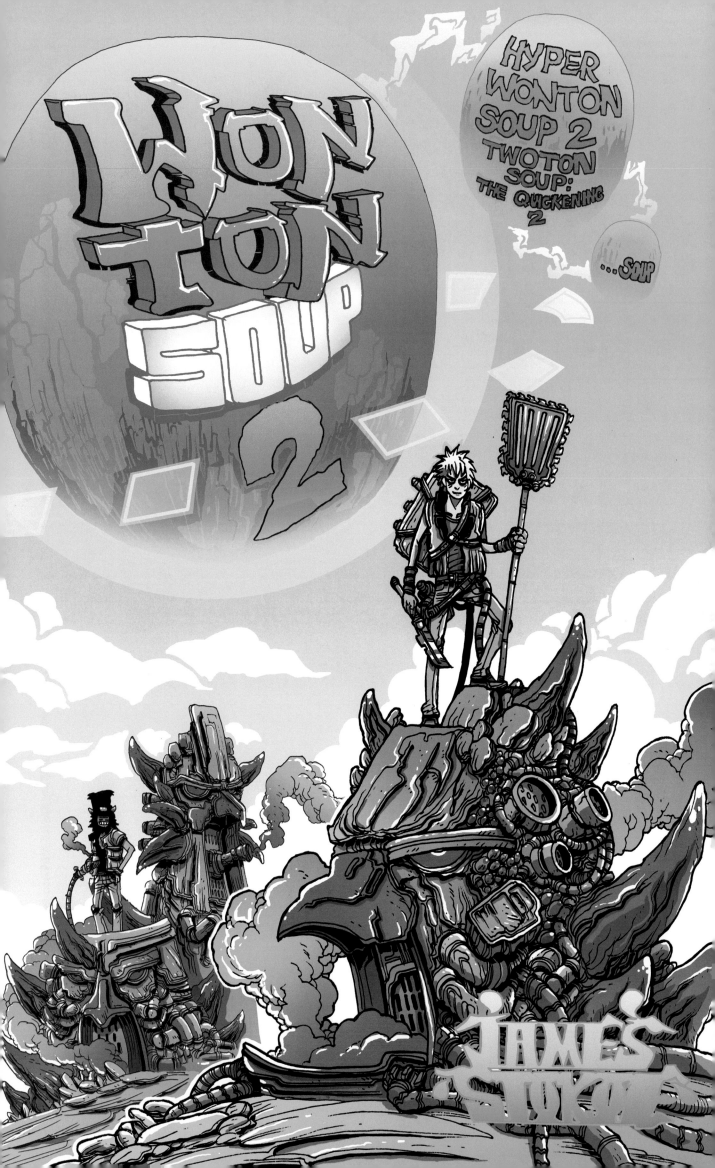

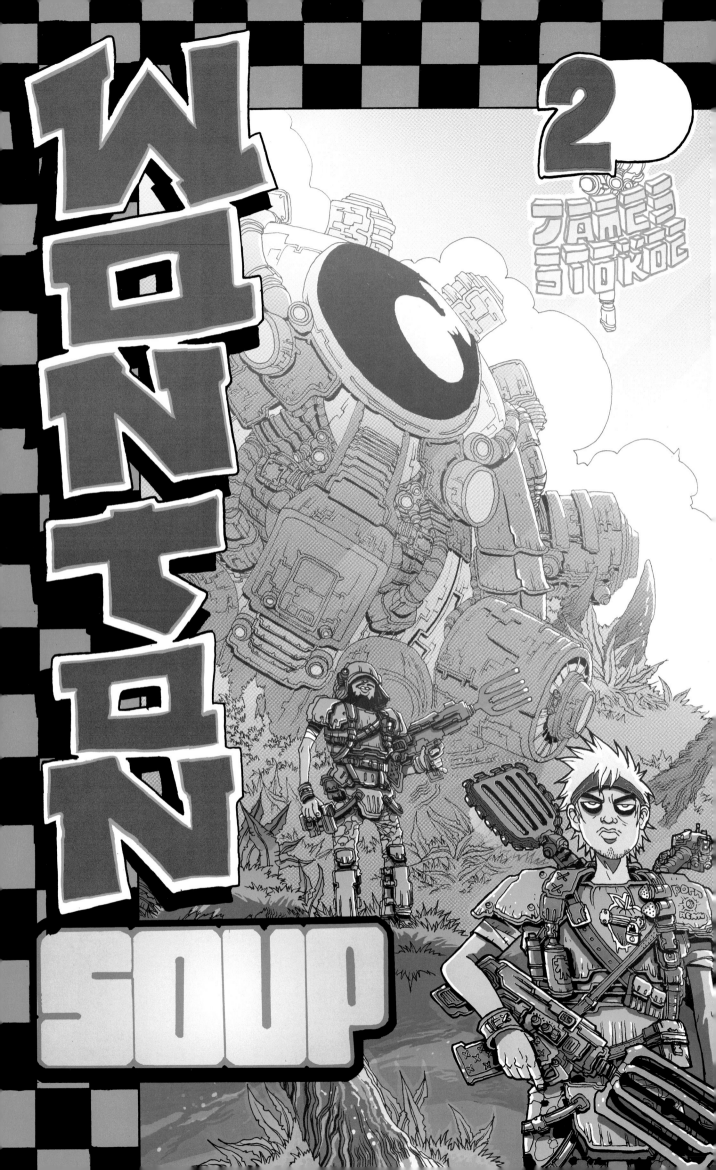

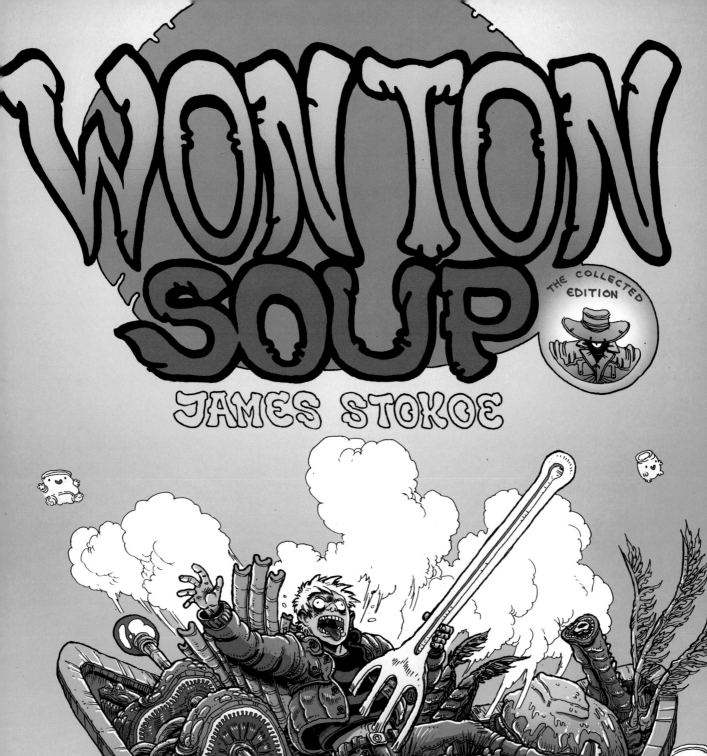
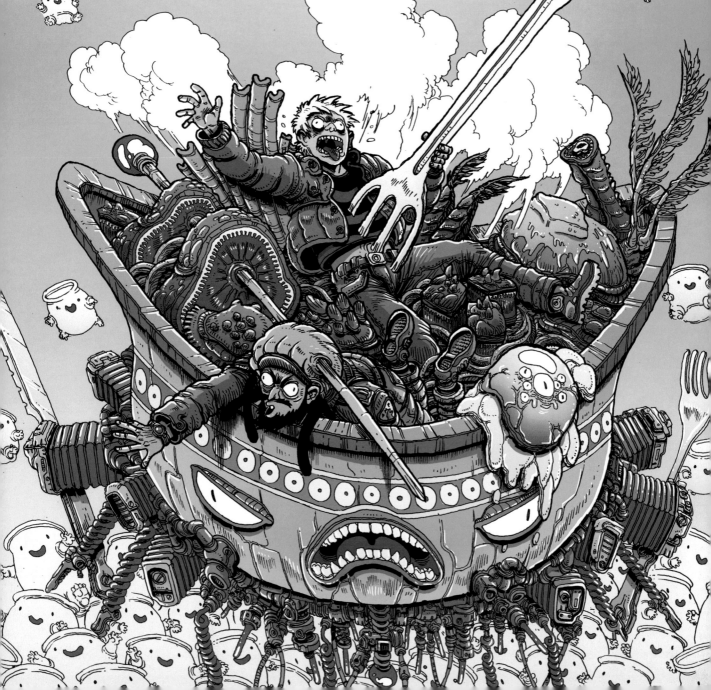

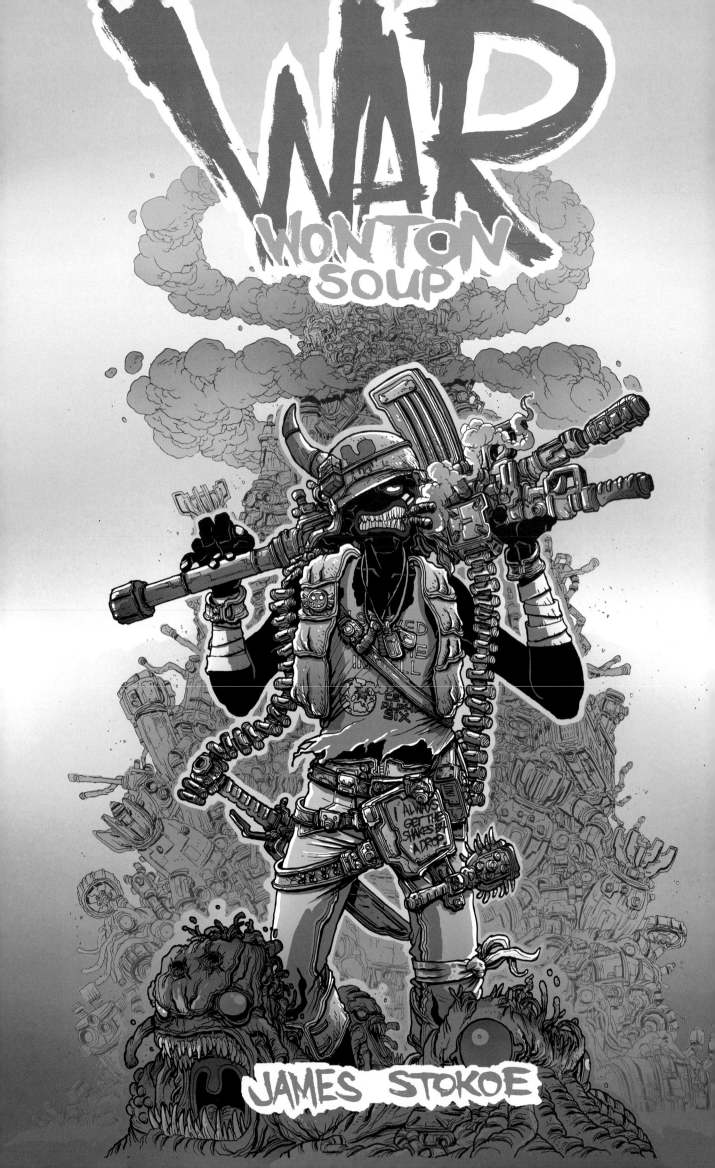

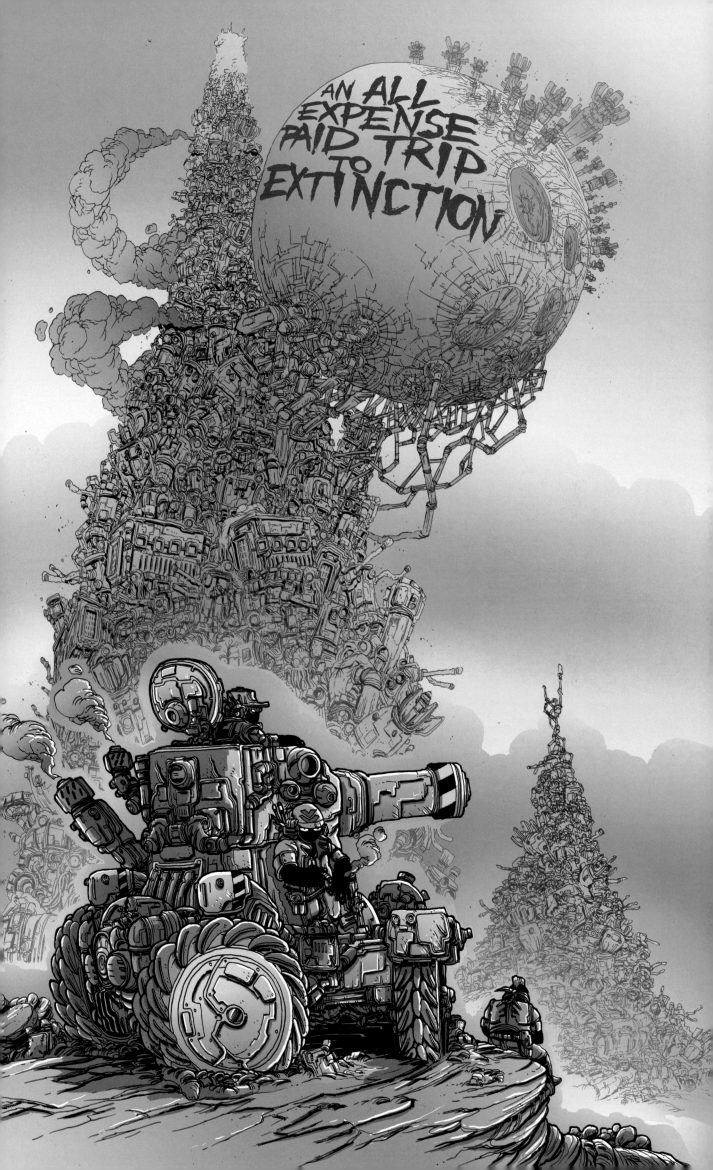

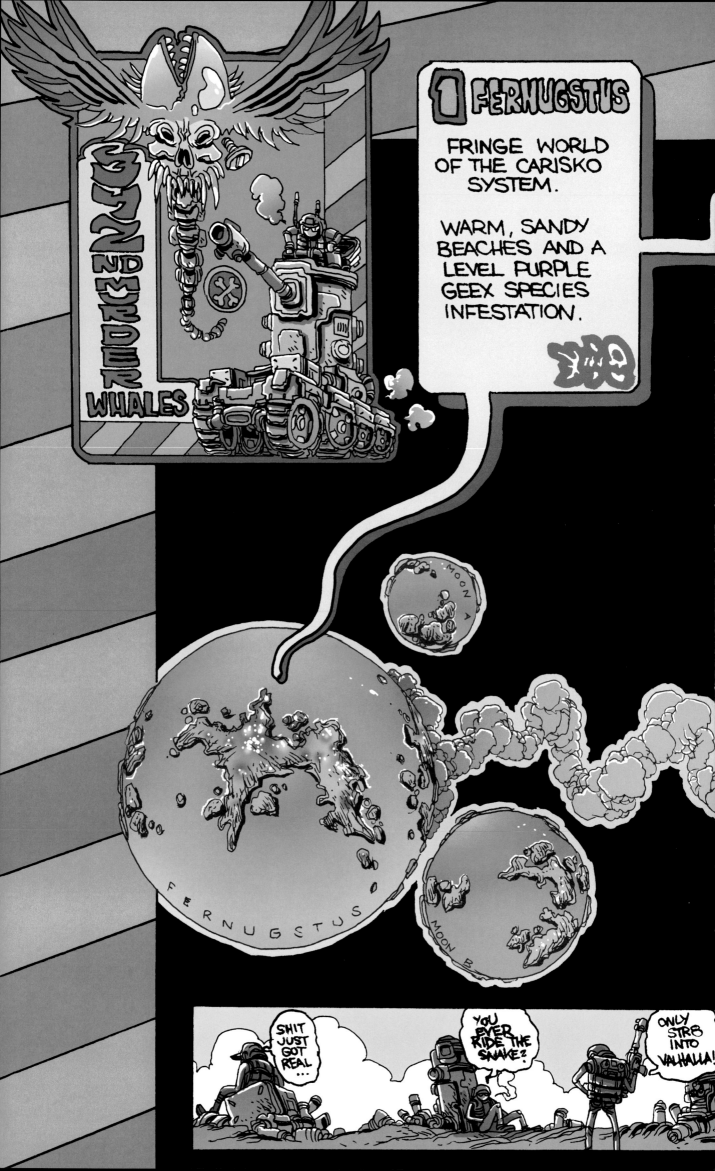

 30,425

SITE OF THE 483RD GSMC-GEEX WAR.

GSMC ARMORED KORP LANDS PLANETSIDE. 2 WEEKS LATER ENTIRE SURFACE IS COVERED IN 30 FEET OF BURNT METAL.

GEEX POPULATION REDUCED BY 3/4.

 30,426

INFANTRY LANDS TO MOP UP REMAINING GEEX...

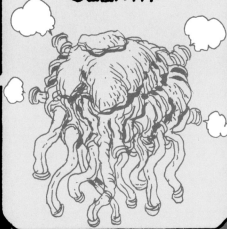

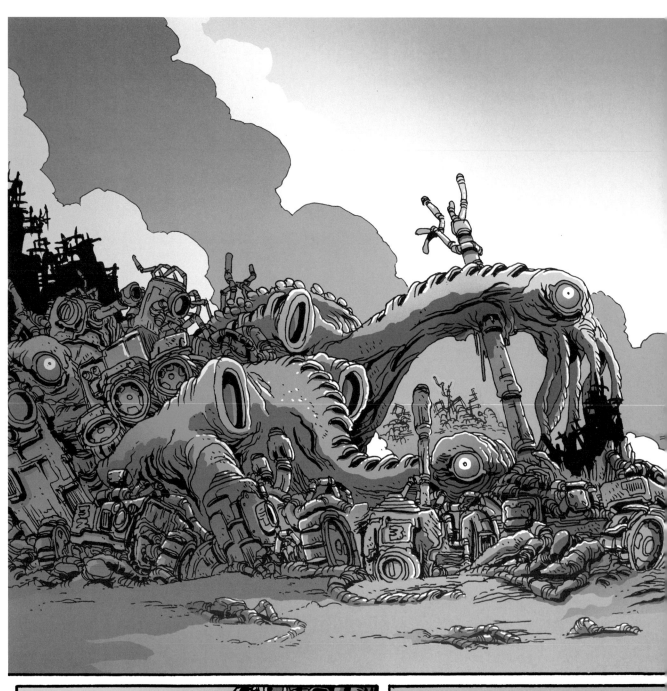

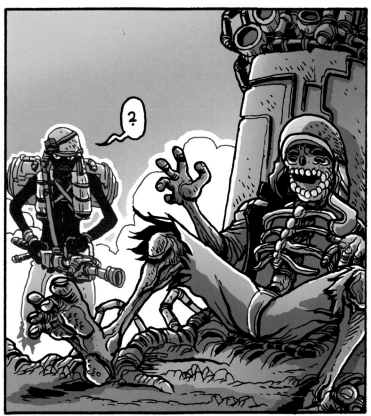

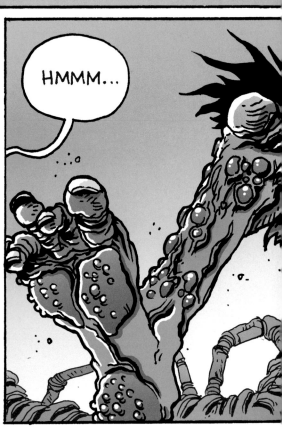

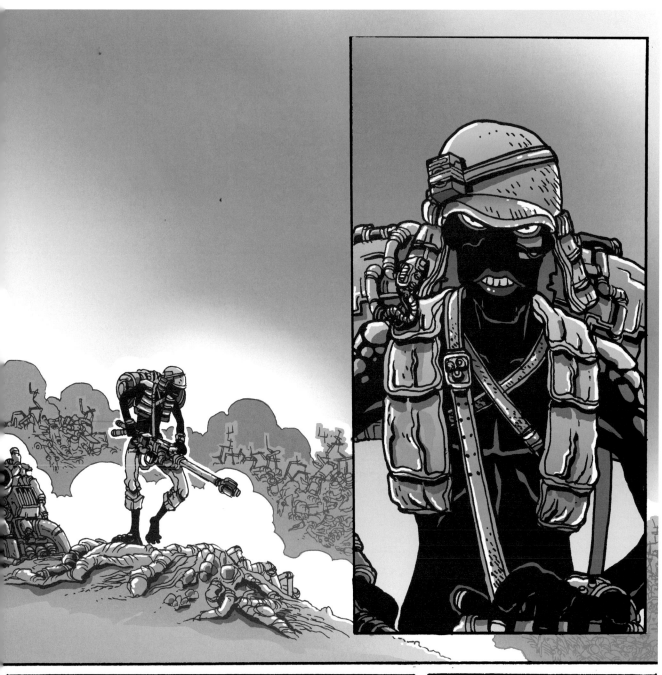

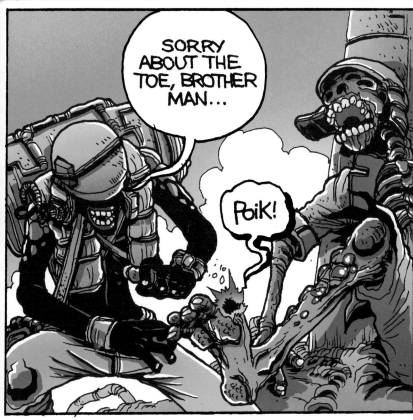

SORRY ABOUT THE TOE, BROTHER MAN...

Poik!

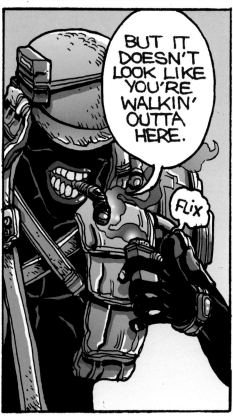

BUT IT DOESN'T LOOK LIKE YOU'RE WALKIN' OUTTA HERE.

Flix

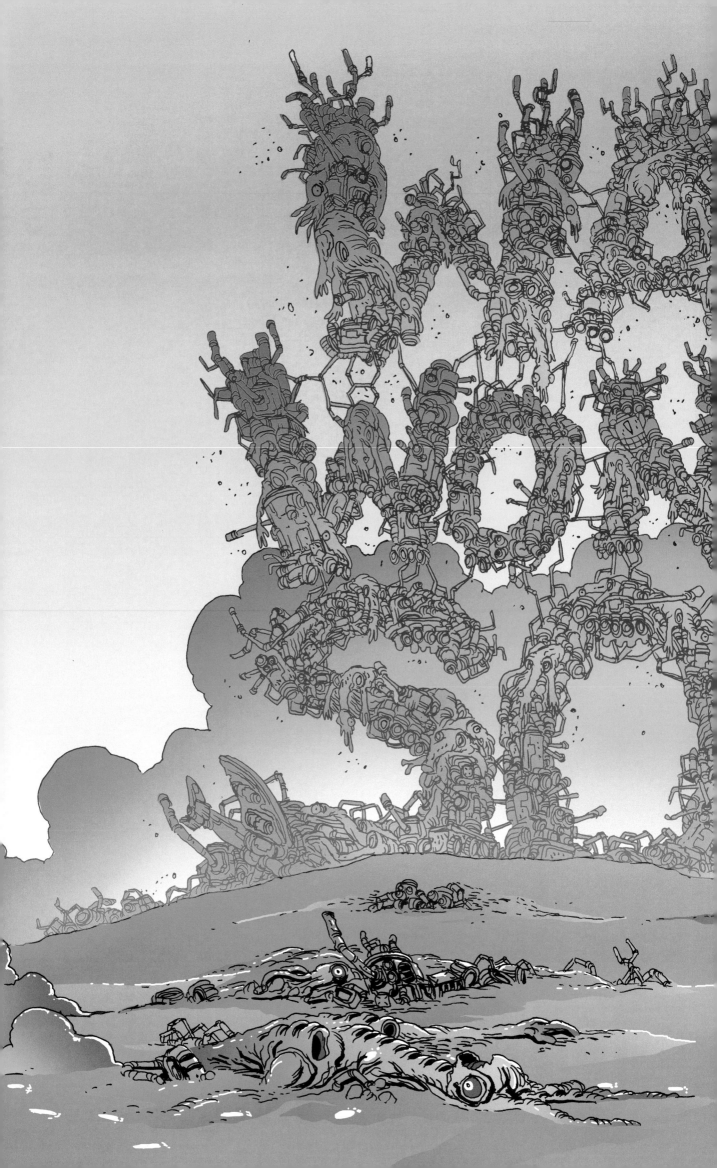

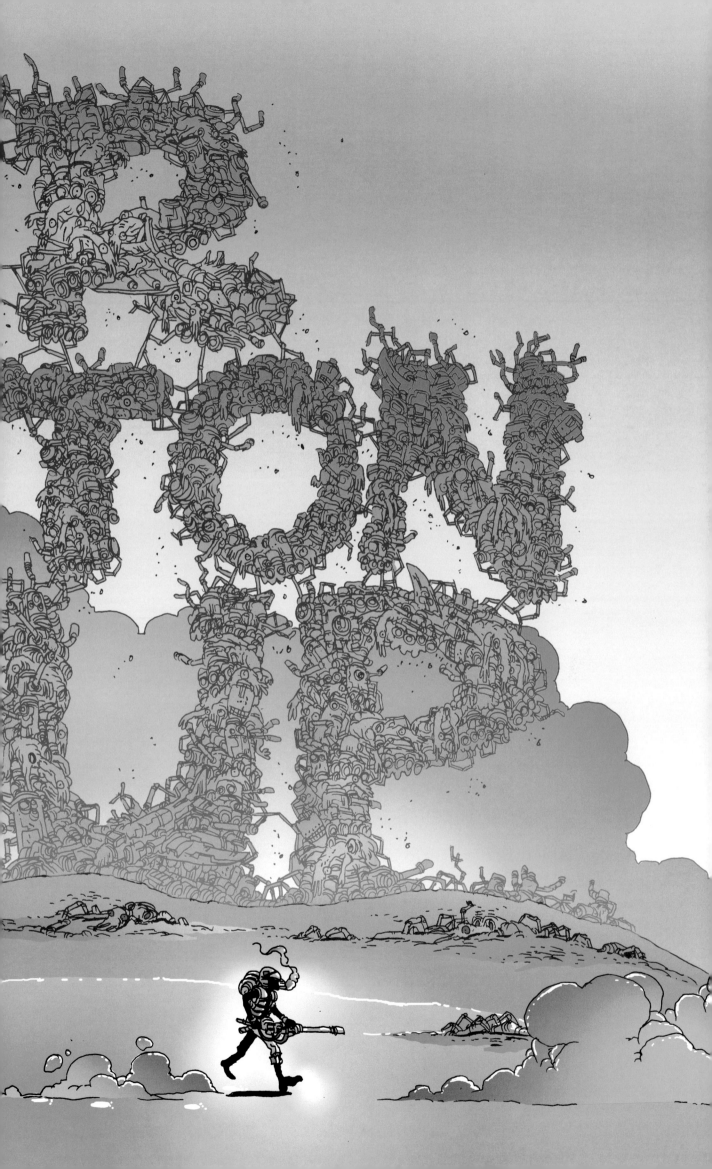

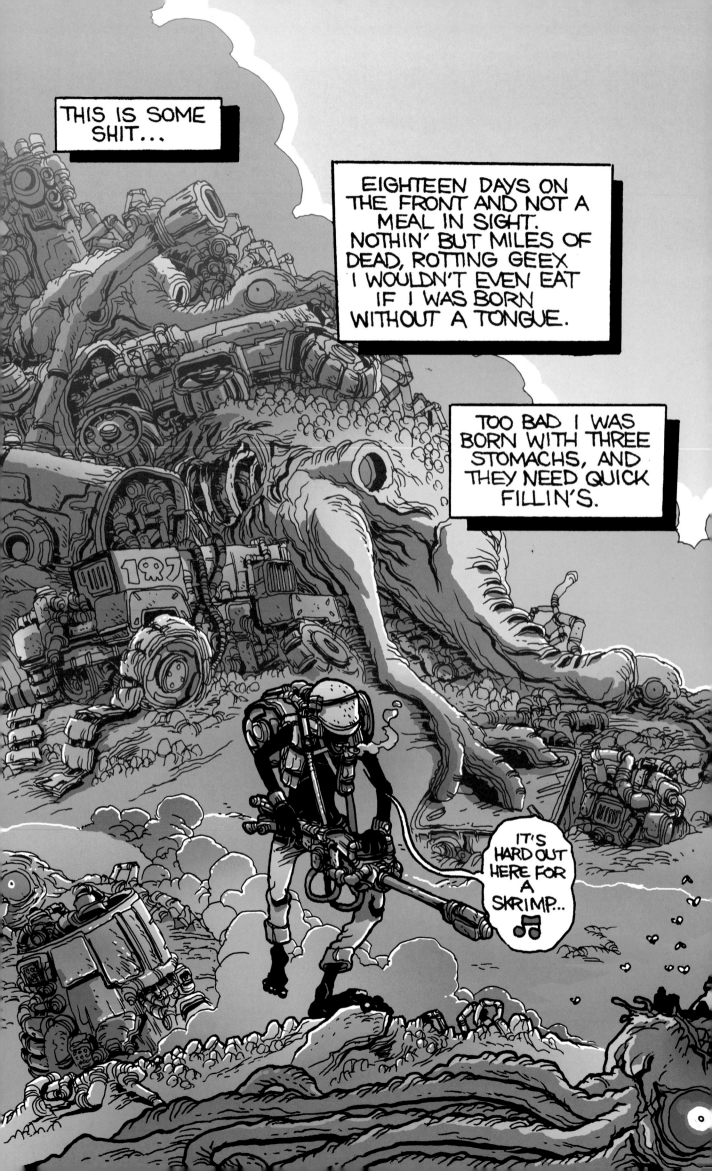

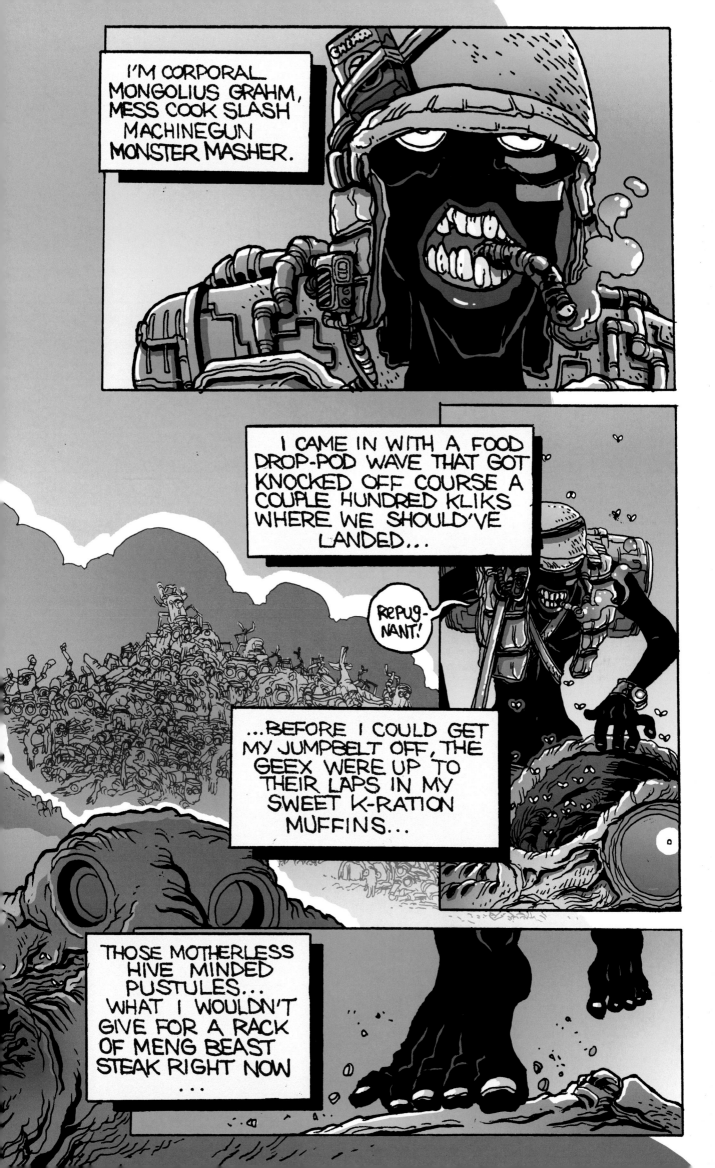

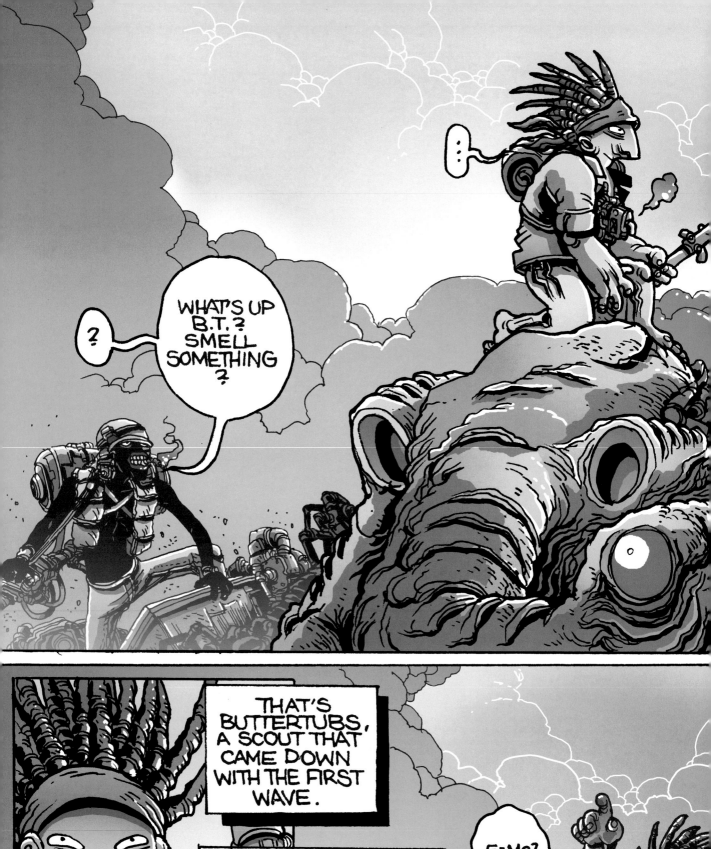
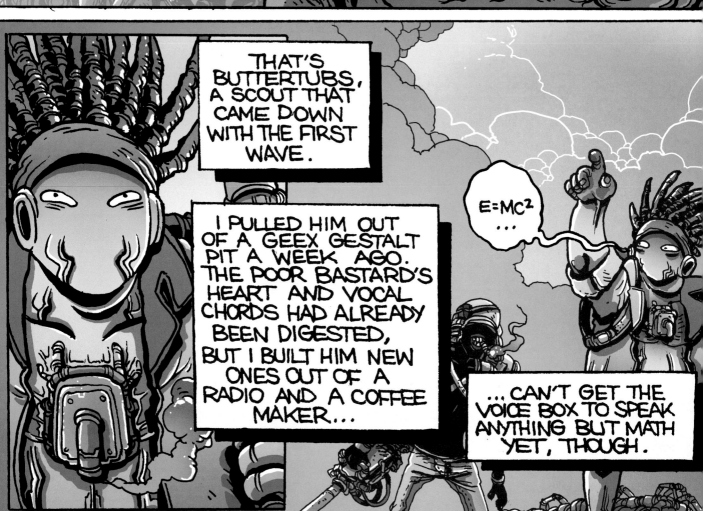

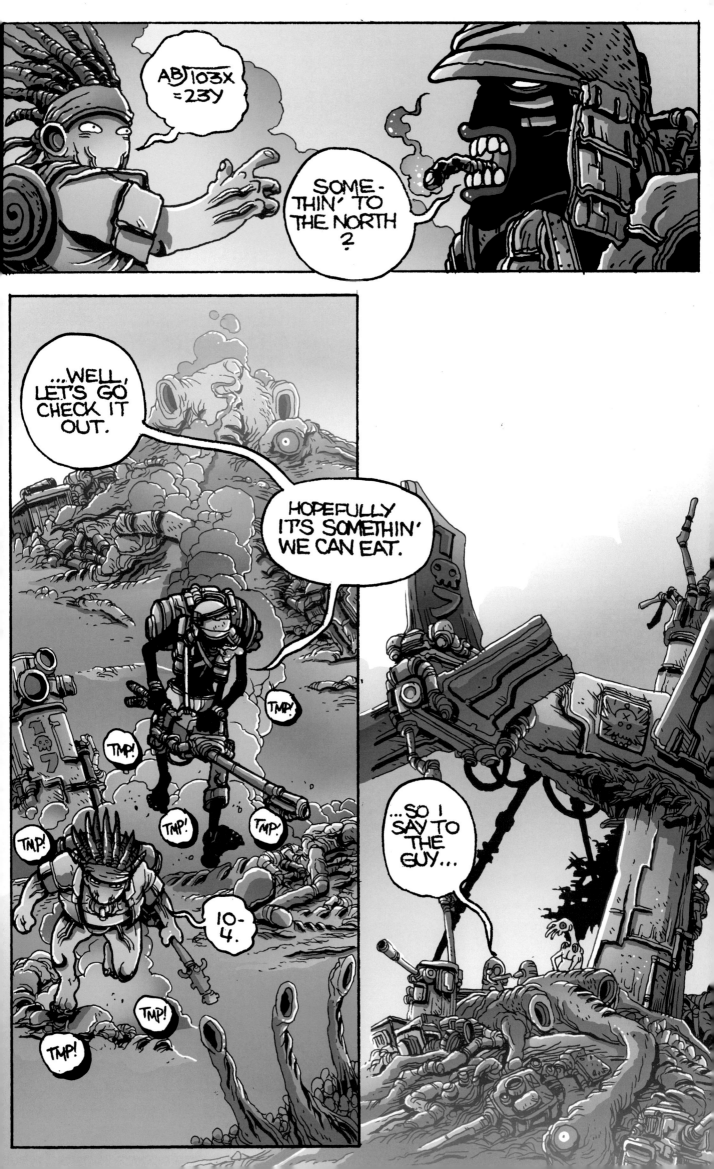

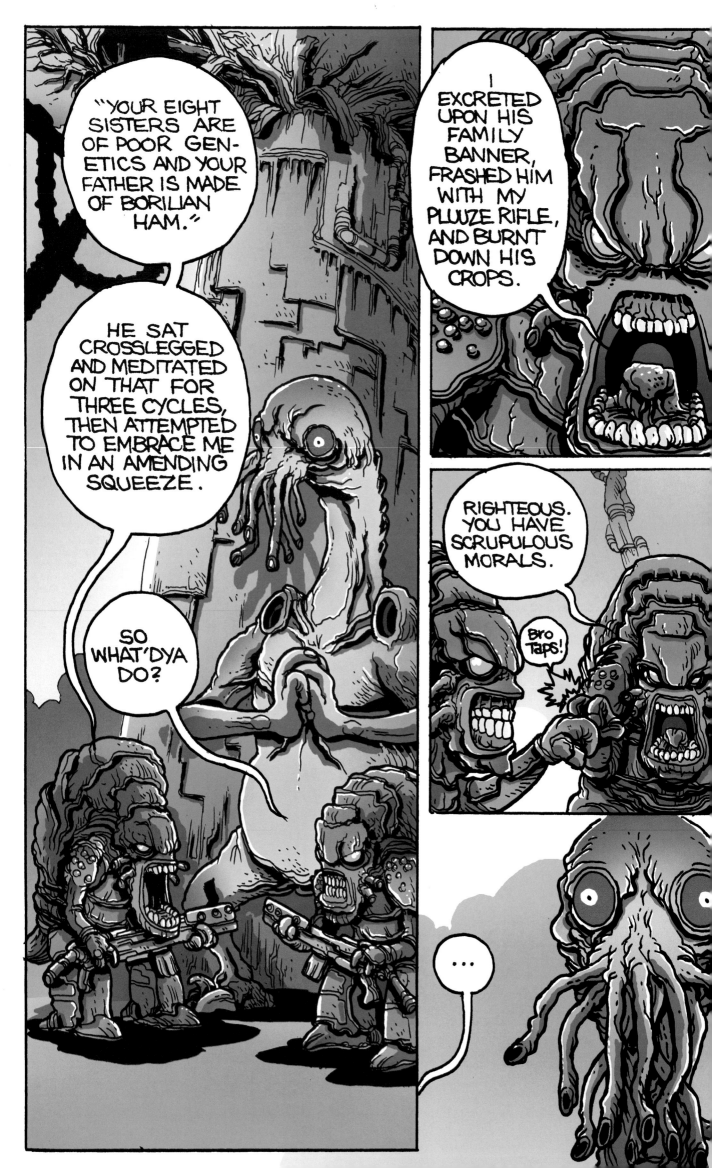

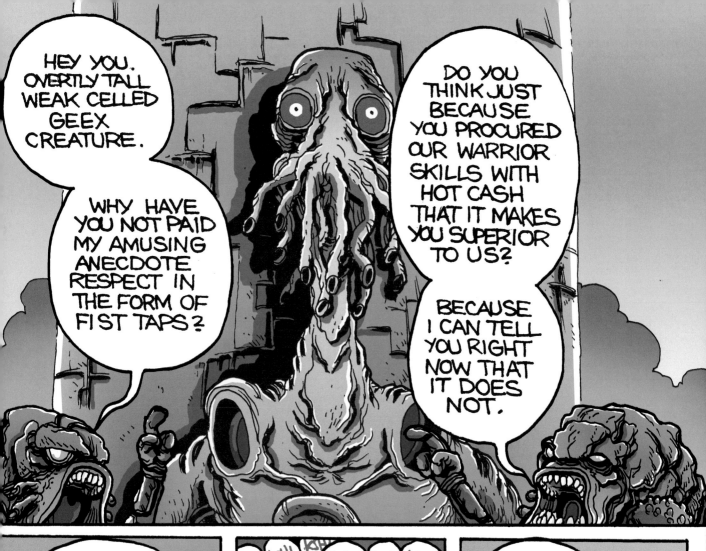

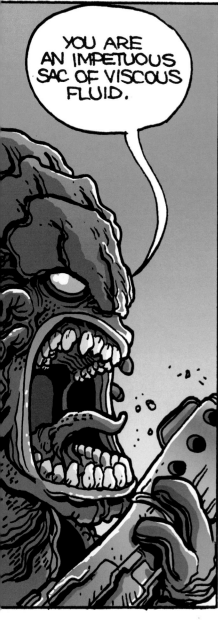

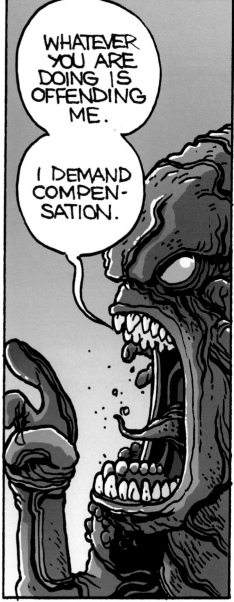

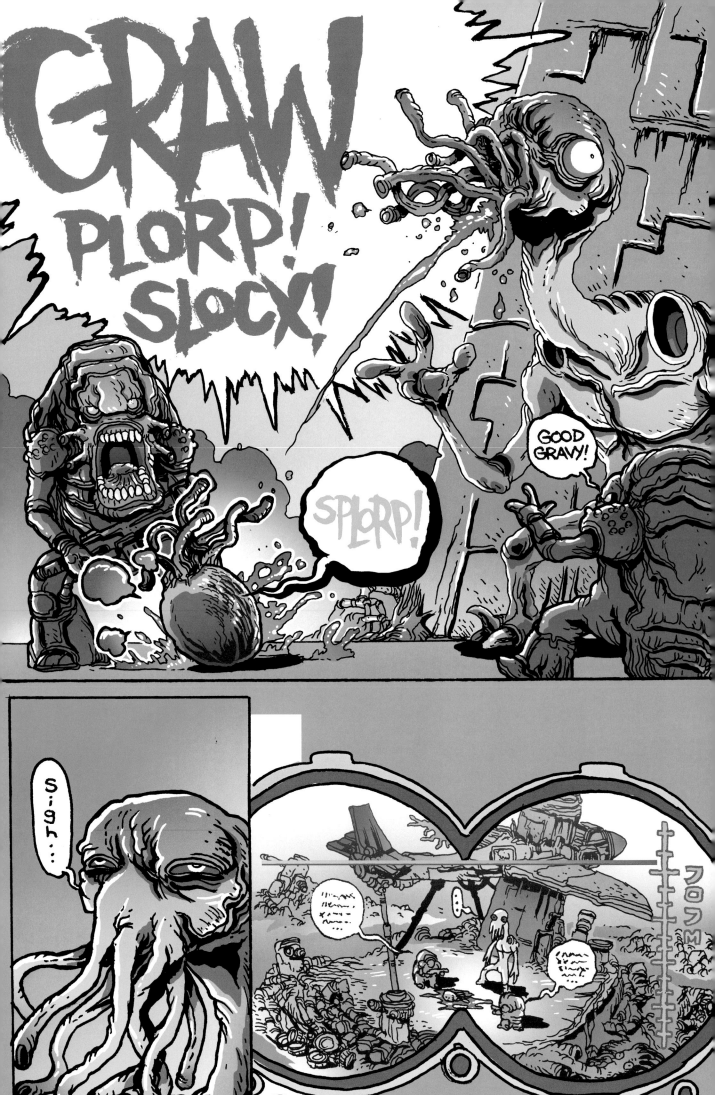

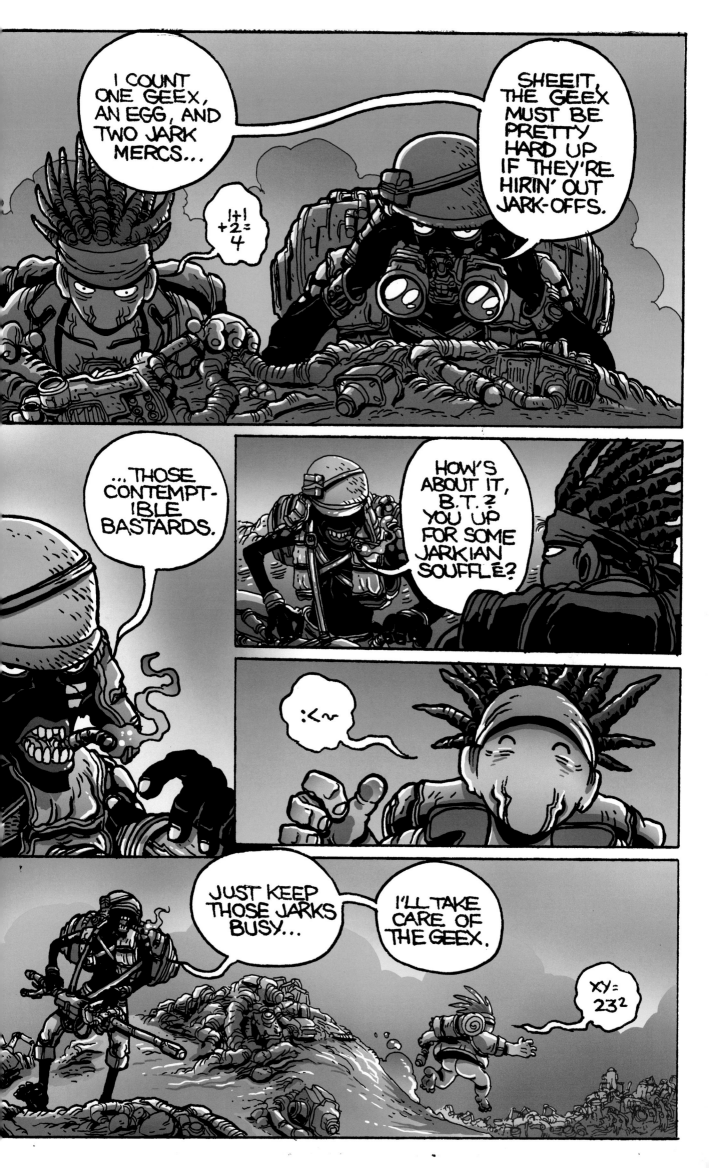

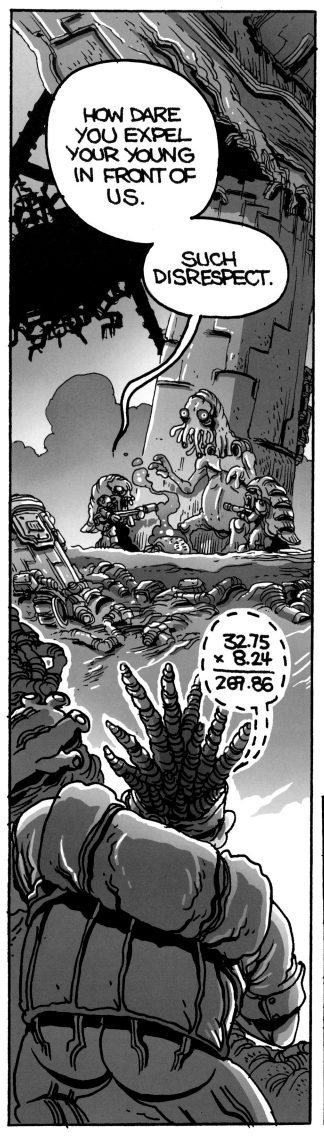
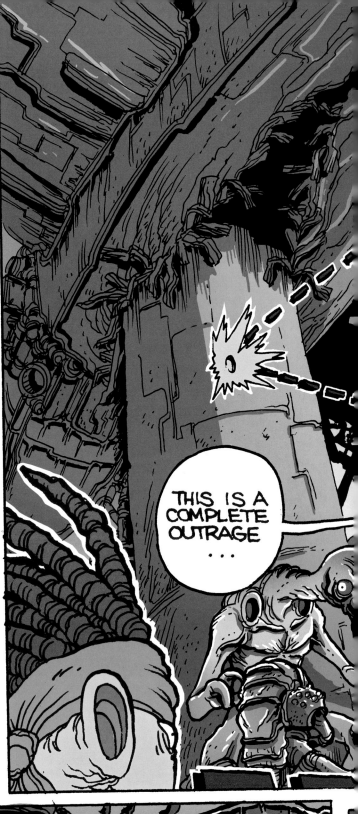
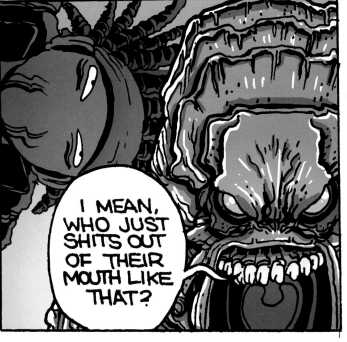

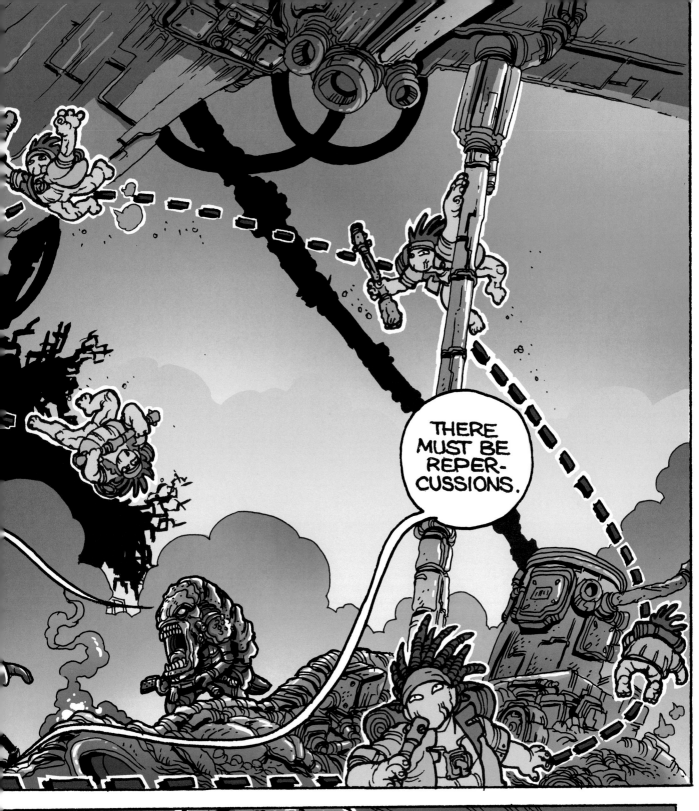

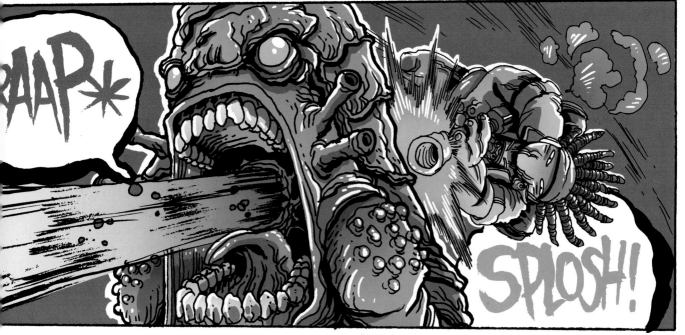

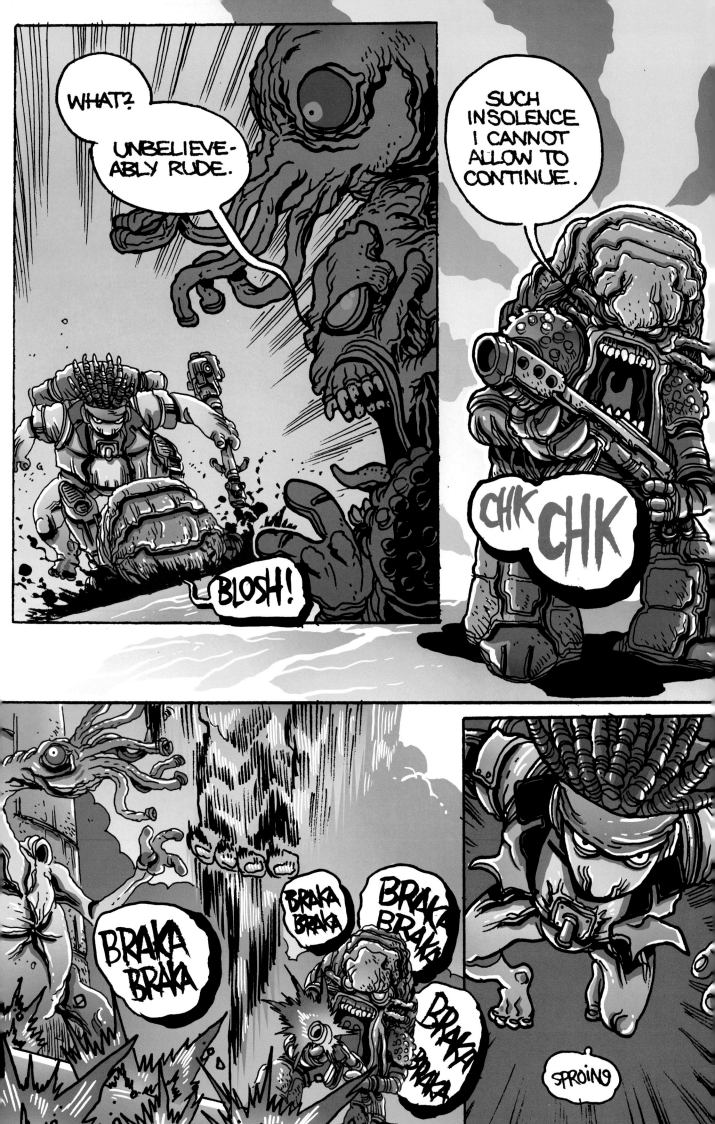

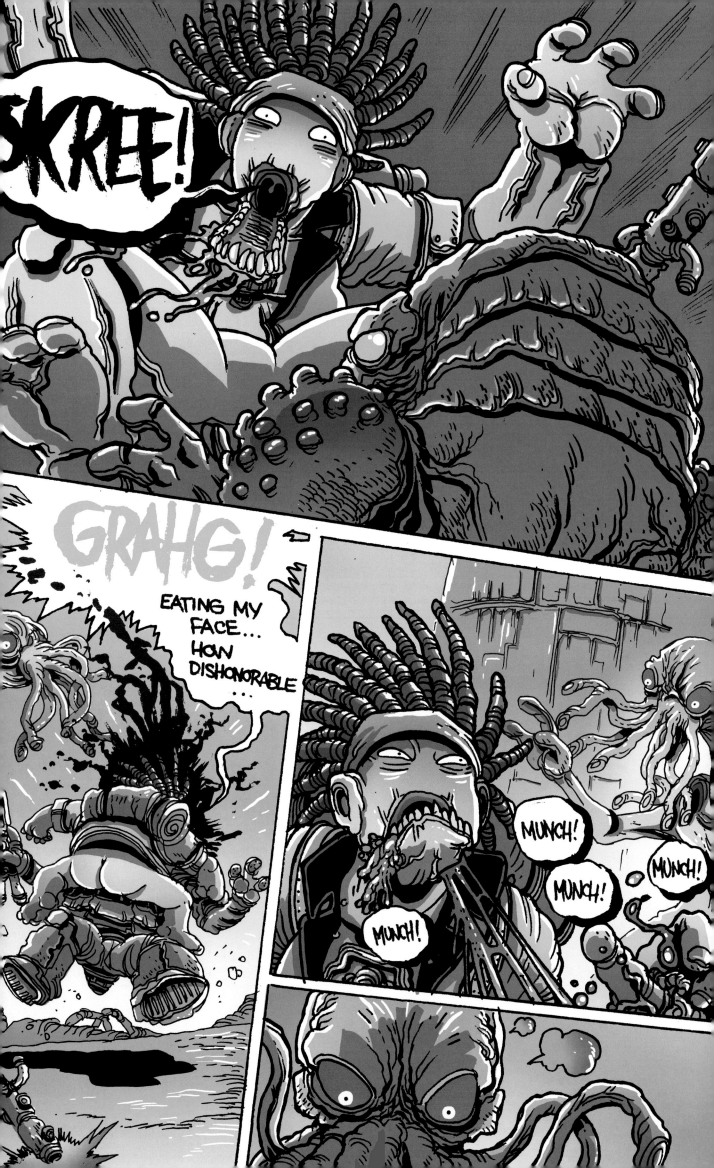

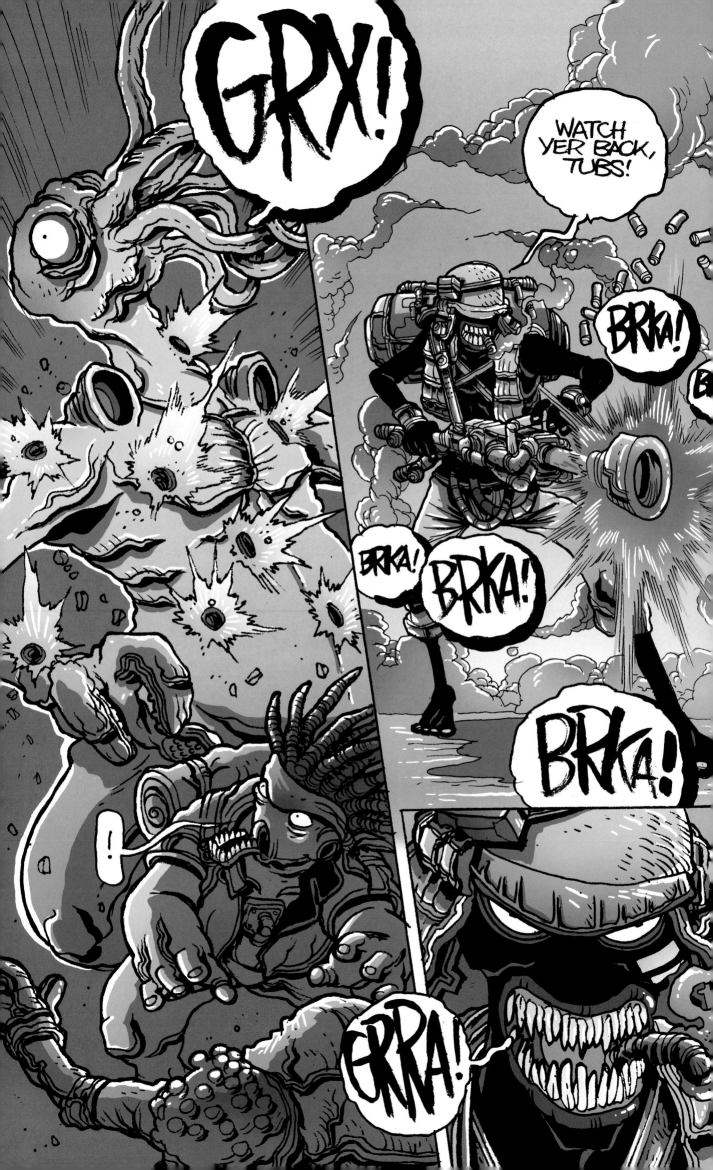

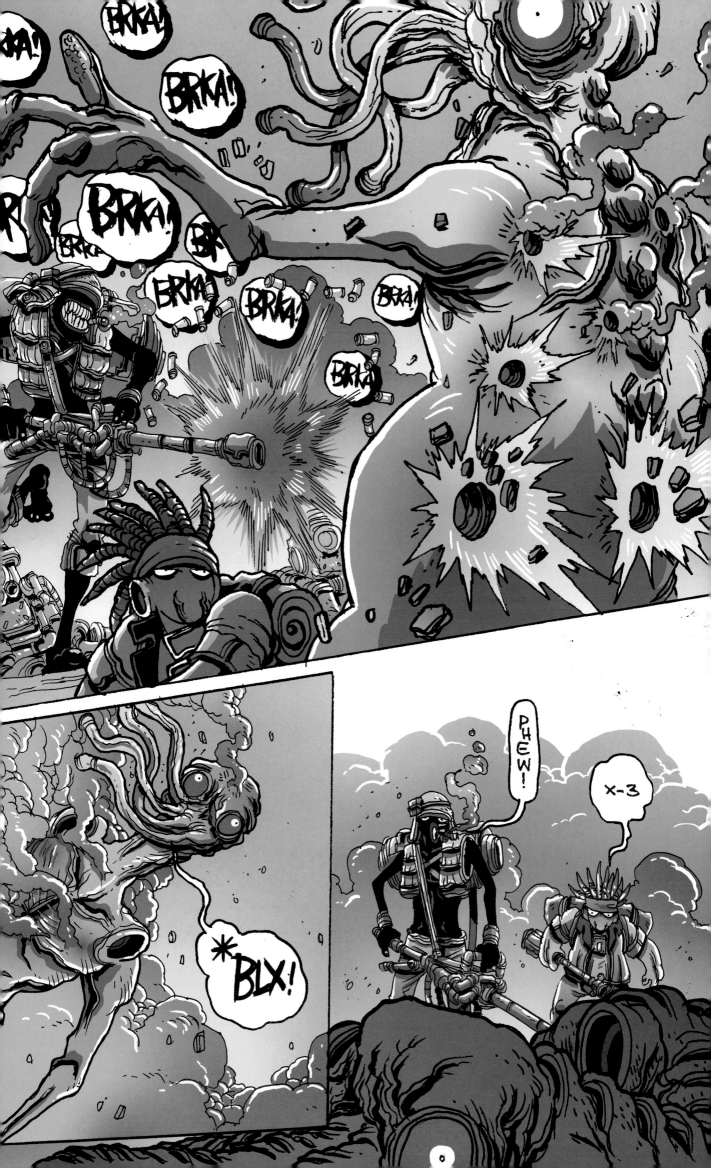

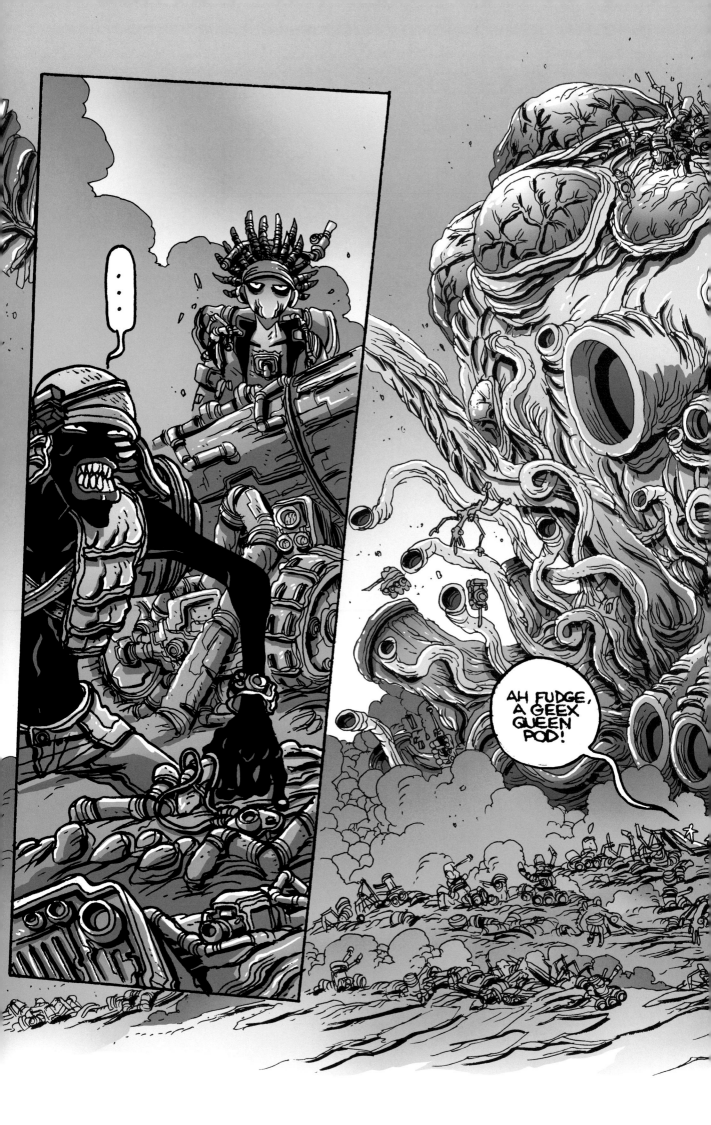

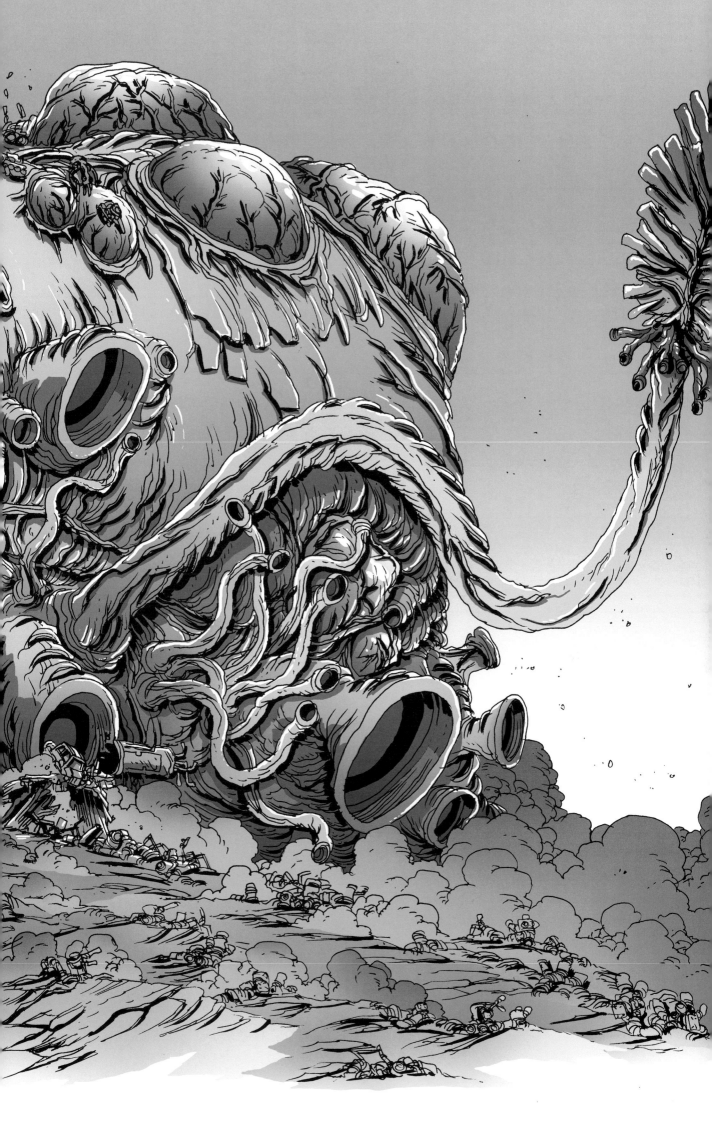

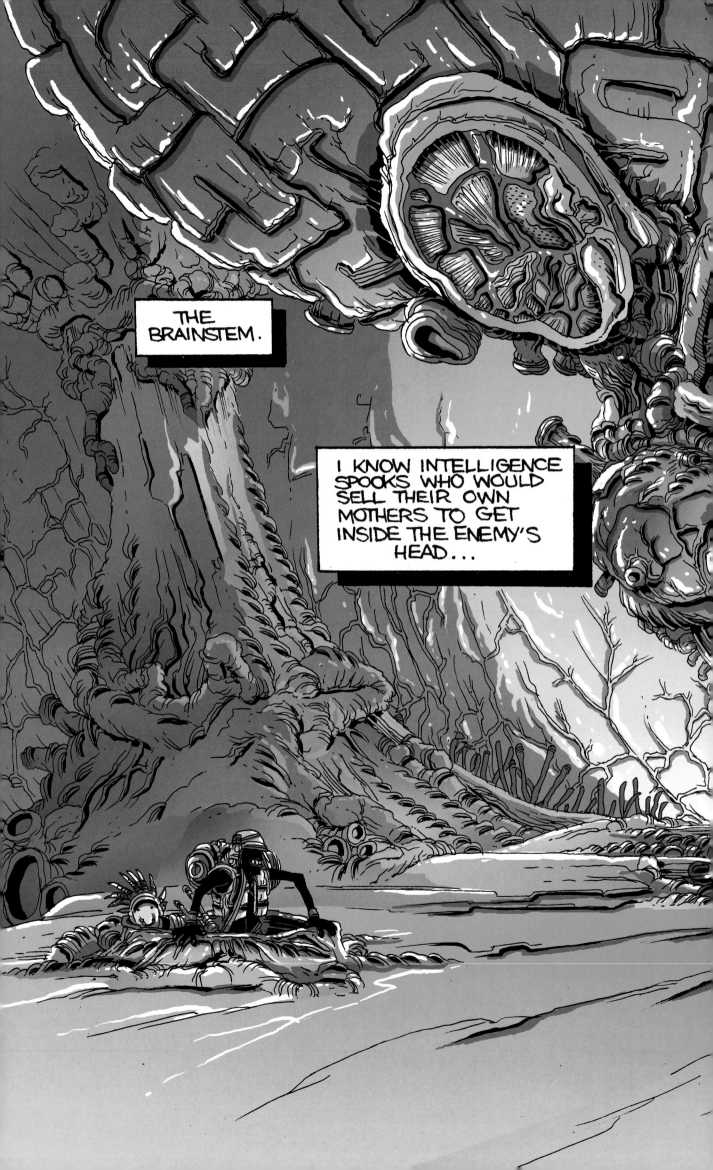

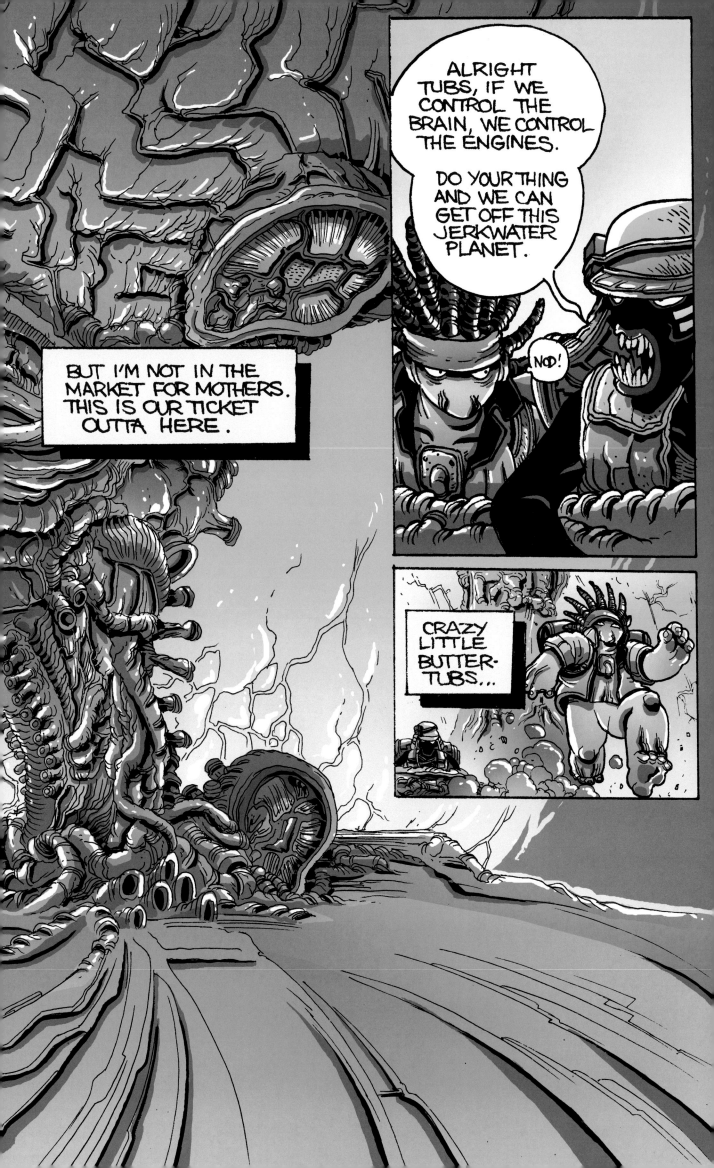

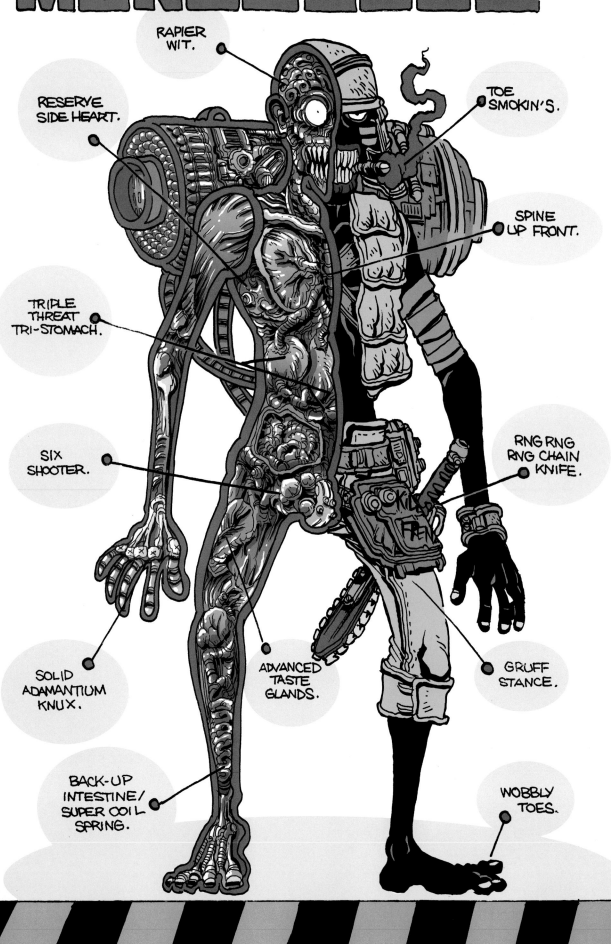

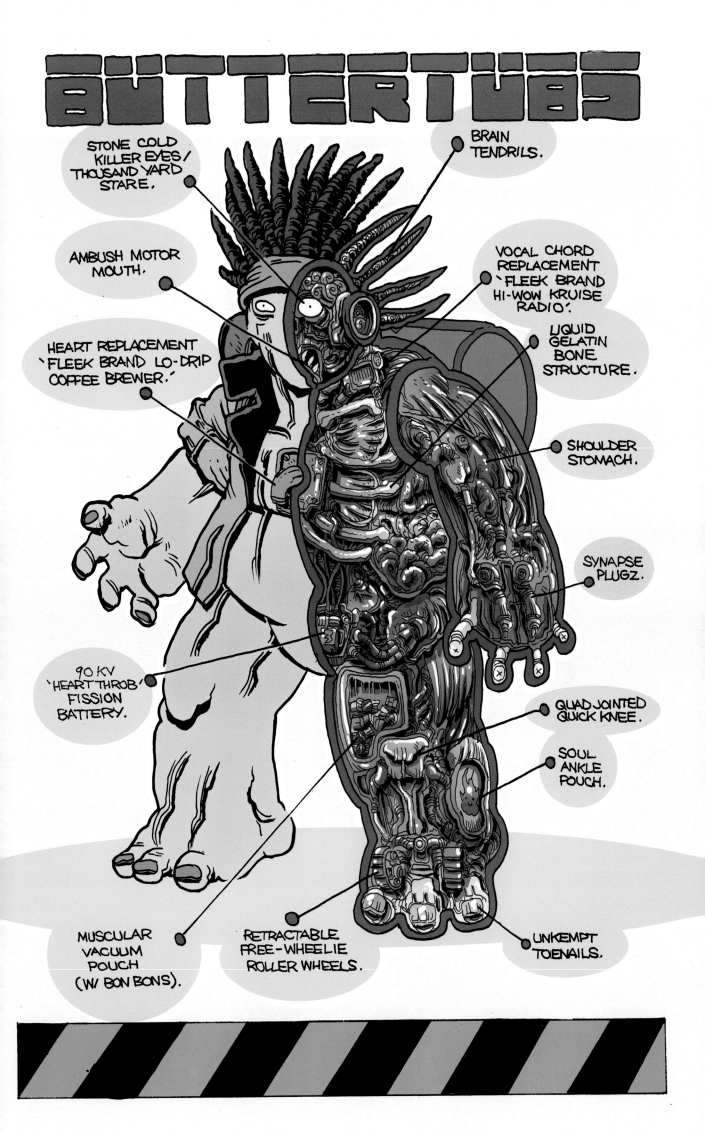

BUTTERTUBS

STONE COLD KILLER EYES / THOUSAND YARD STARE.

BRAIN TENDRILS.

AMBUSH MOTOR MOUTH.

VOCAL CHORD REPLACEMENT 'FLEEK BRAND HI-WOW KRUISE RADIO'.

HEART REPLACEMENT 'FLEEK BRAND LO-DRIP COFFEE BREWER.'

LIQUID GELATIN BONE STRUCTURE.

SHOULDER STOMACH.

SYNAPSE PLUGZ.

90 KV 'HEART THROB' FISSION BATTERY.

QUAD JOINTED QUICK KNEE.

SOUL ANKLE POUCH.

MUSCULAR VACUUM POUCH (W/ BON BONS).

RETRACTABLE FREE-WHEELIE ROLLER WHEELS.

UNKEMPT TOENAILS.

JARKIAN

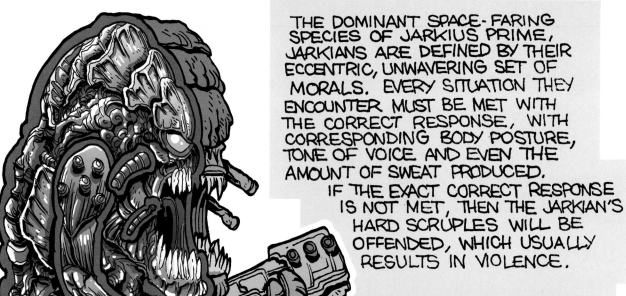

THE DOMINANT SPACE-FARING SPECIES OF JARKIUS PRIME, JARKIANS ARE DEFINED BY THEIR ECCENTRIC, UNWAVERING SET OF MORALS. EVERY SITUATION THEY ENCOUNTER MUST BE MET WITH THE CORRECT RESPONSE, WITH CORRESPONDING BODY POSTURE, TONE OF VOICE, AND EVEN THE AMOUNT OF SWEAT PRODUCED.

IF THE EXACT CORRECT RESPONSE IS NOT MET, THEN THE JARKIAN'S HARD SCRUPLES WILL BE OFFENDED, WHICH USUALLY RESULTS IN VIOLENCE.

BECAUSE OF THE UNIVERSE'S MISUNDERSTANDING OF JARKIANS, THEY ARE SEEN AS RUTHLESS, AMORAL KILLERS, OFTEN BEING HIRED OUT AS THIRD PARTY MERCENARIES.

EXAMPLE: A.

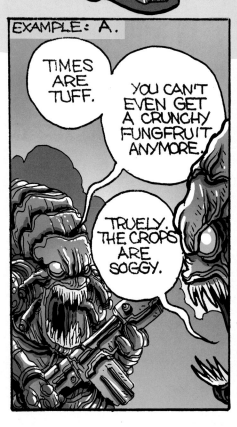

TIMES ARE TUFF.

YOU CAN'T EVEN GET A CRUNCHY FUNGFRUIT ANYMORE.

TRUELY. THE CROPS ARE SOGGY.

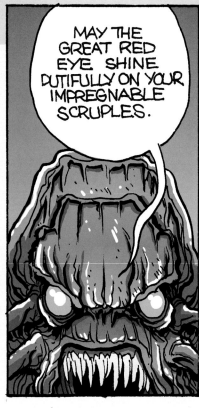

MAY THE GREAT RED EYE SHINE DUTIFULLY ON YOUR IMPREGNABLE SCRUPLES.

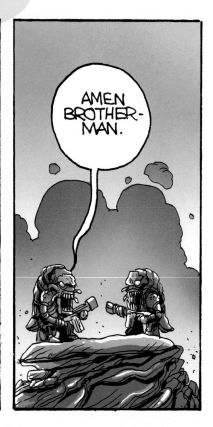

AMEN BROTHER-MAN.

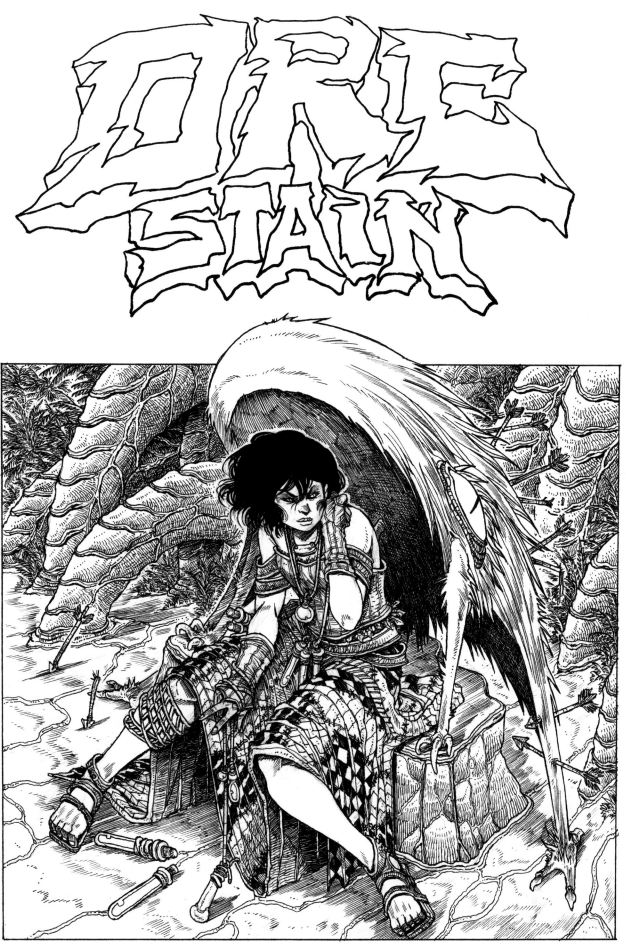

The following pages feature art from *Orc Stain*, published by Image Comics.

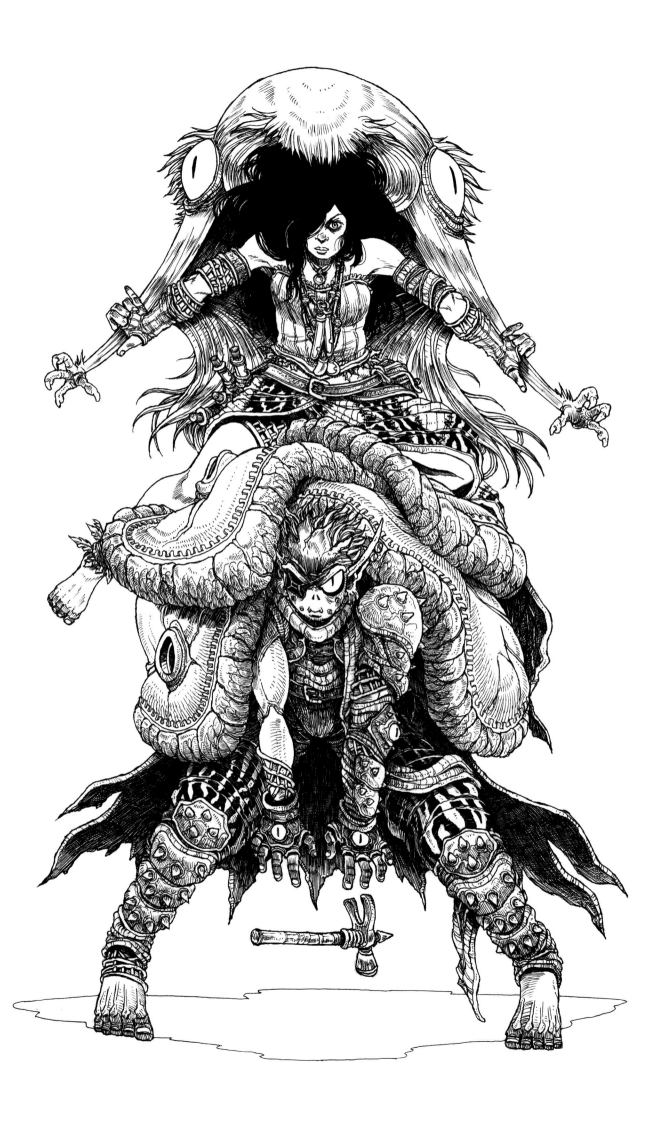

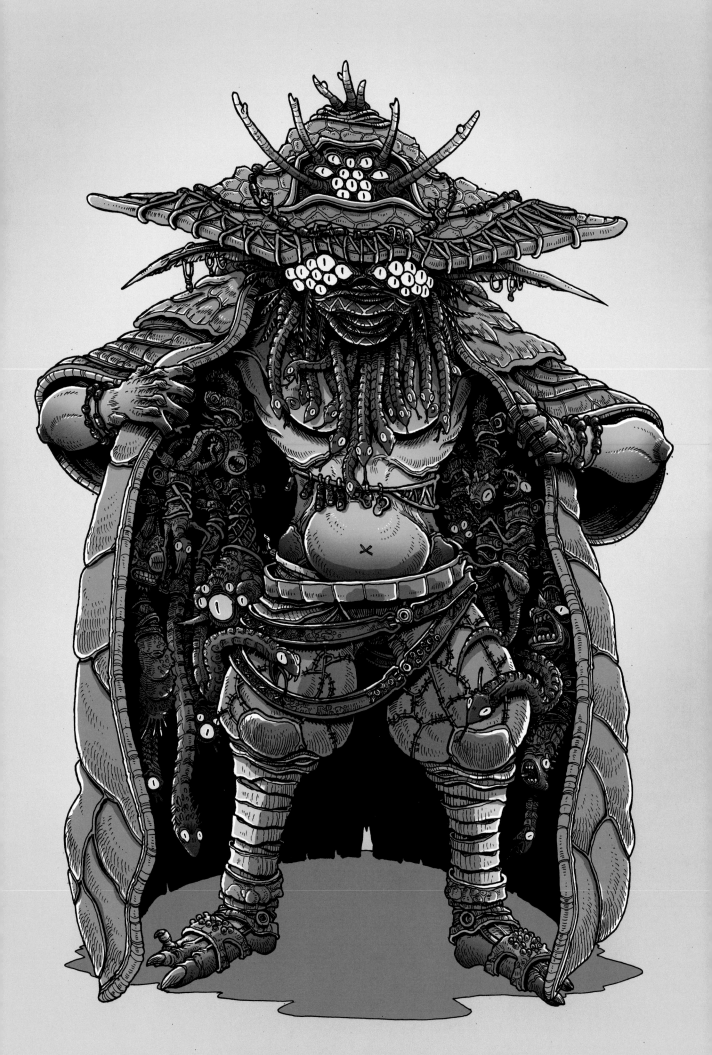

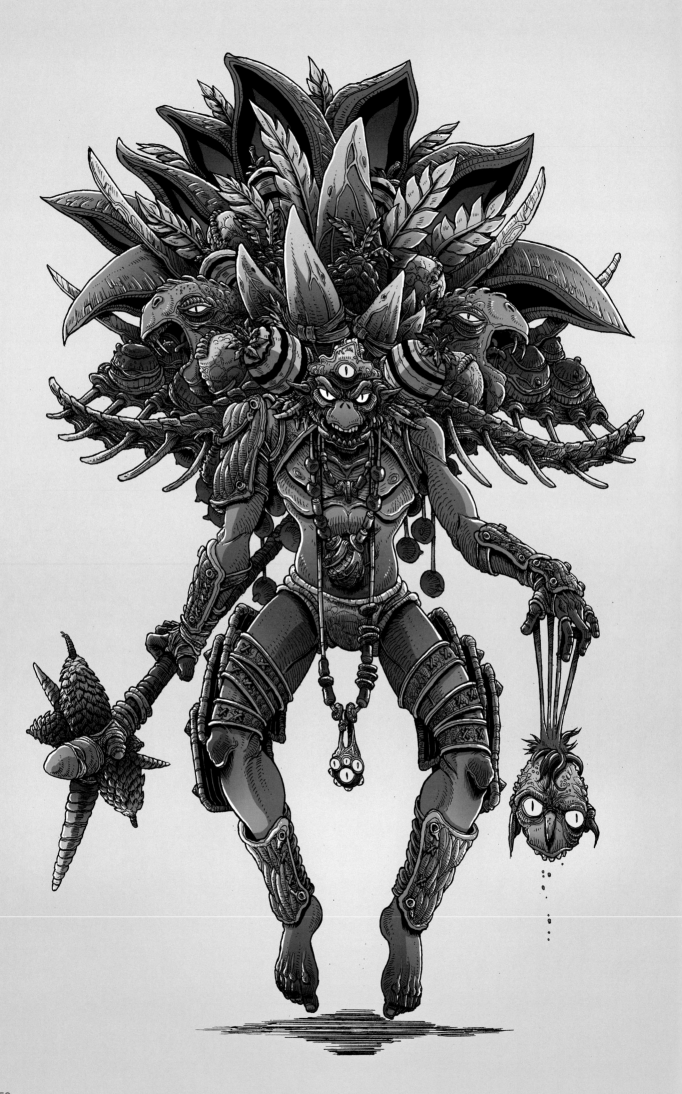

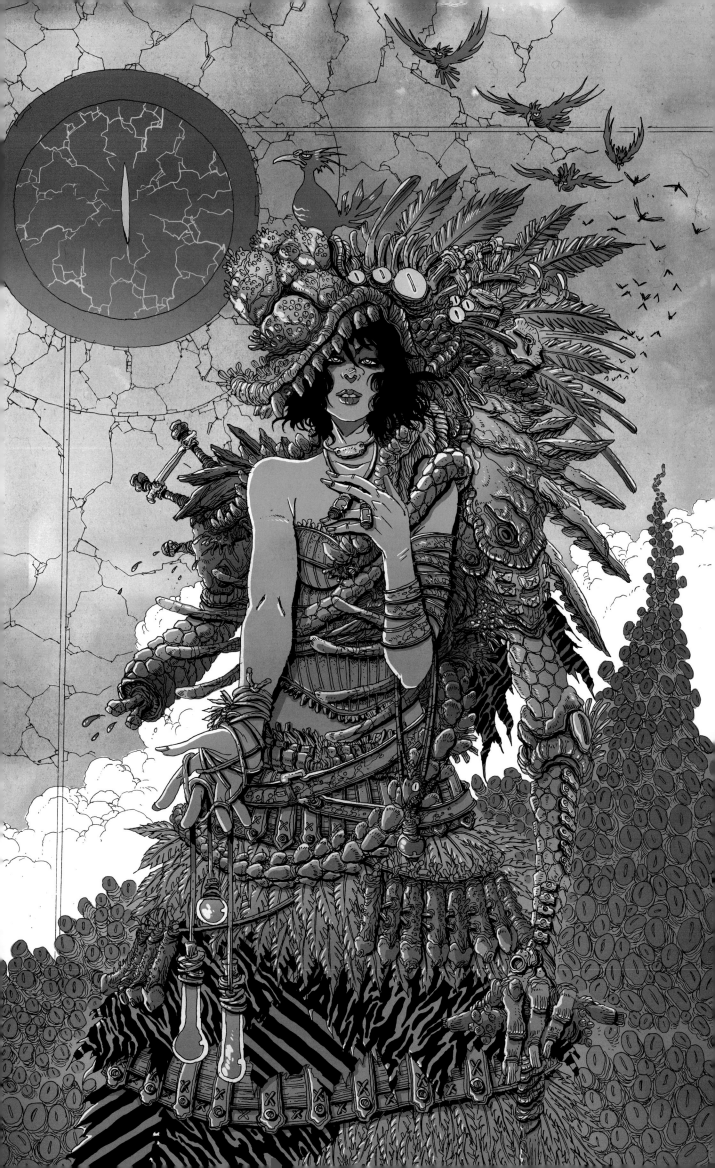

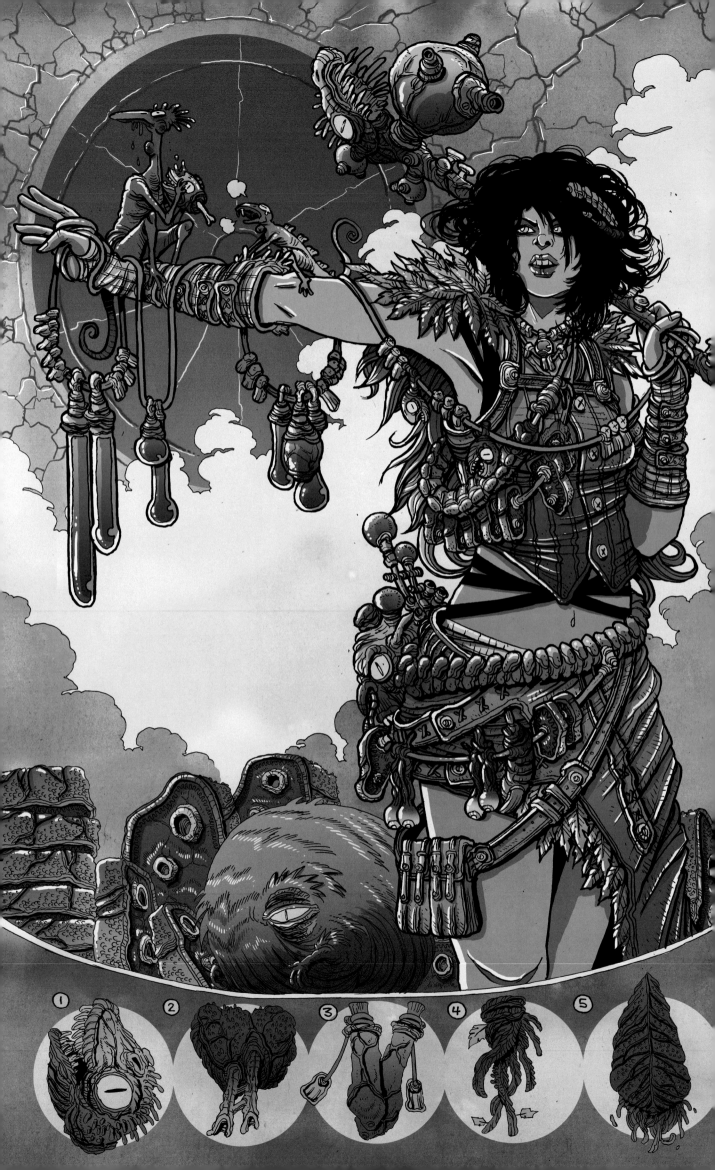

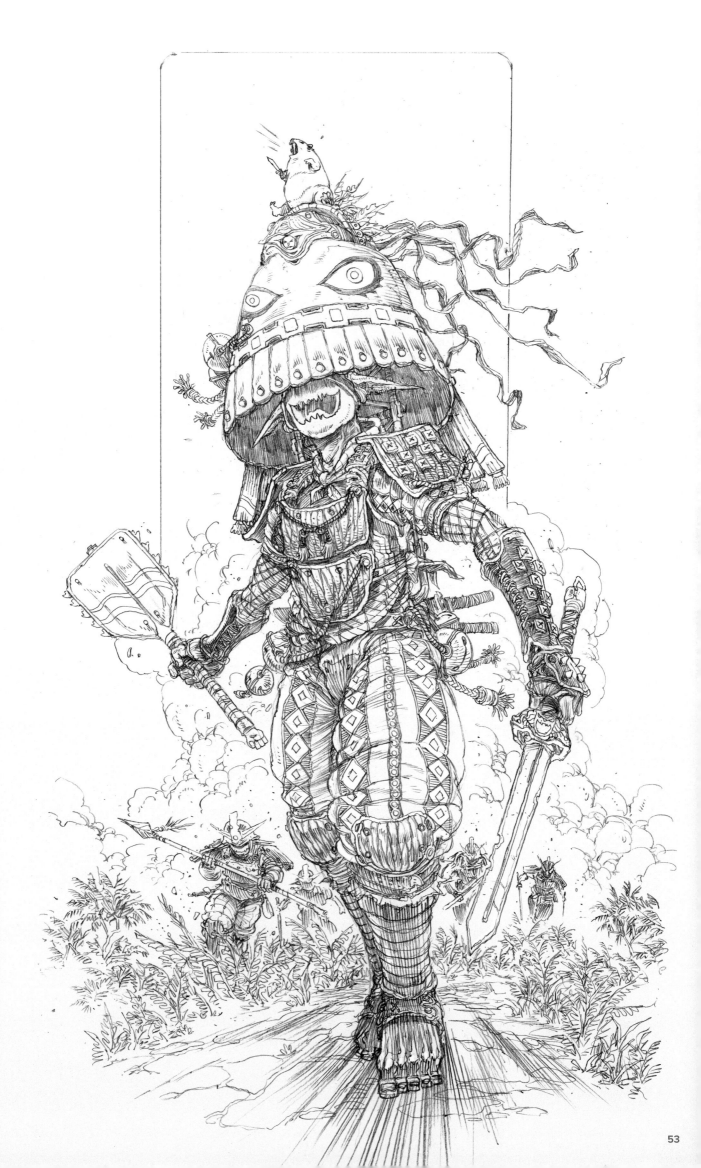

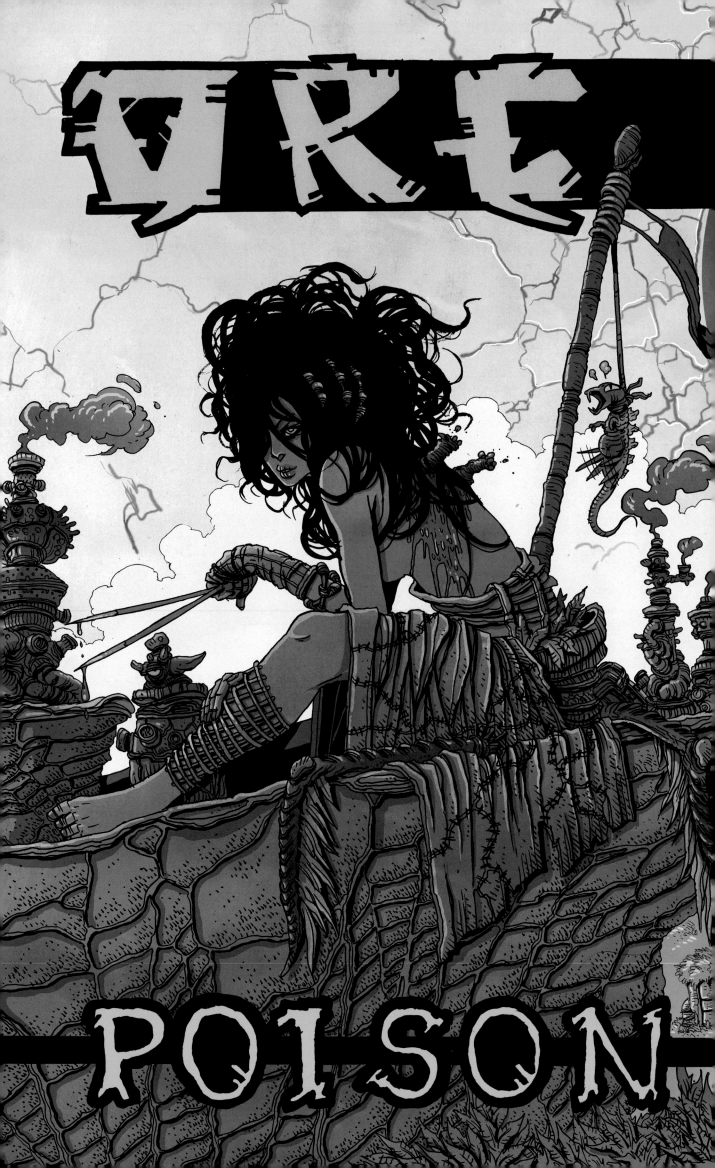

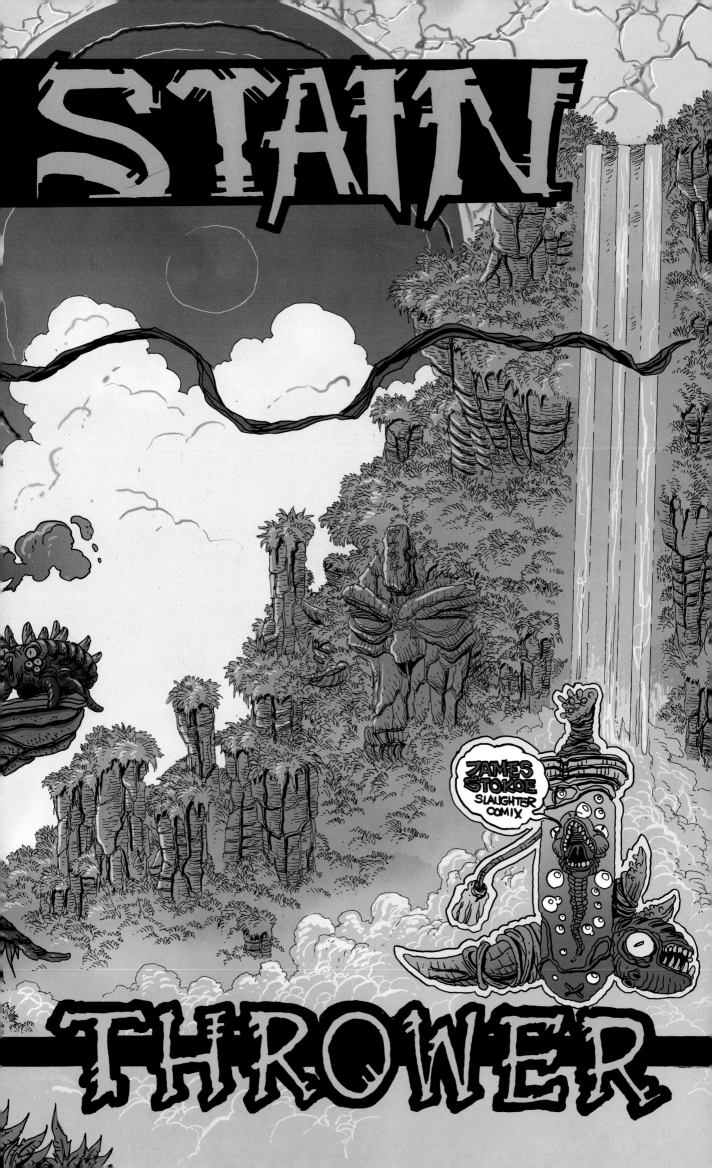

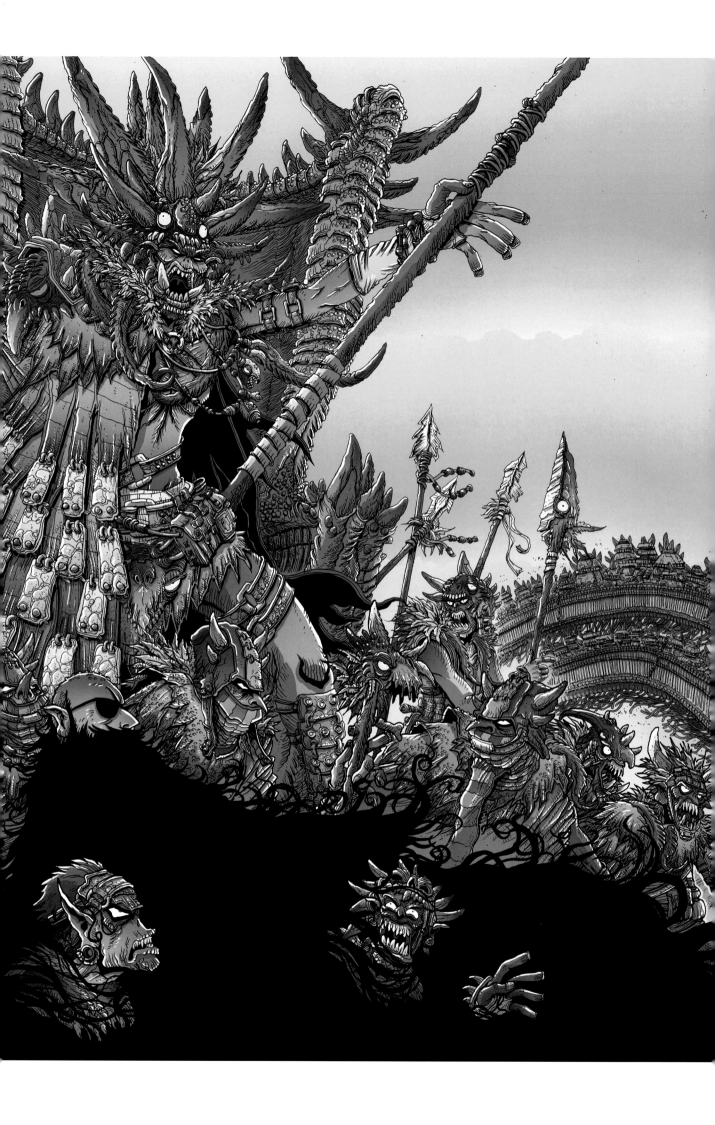

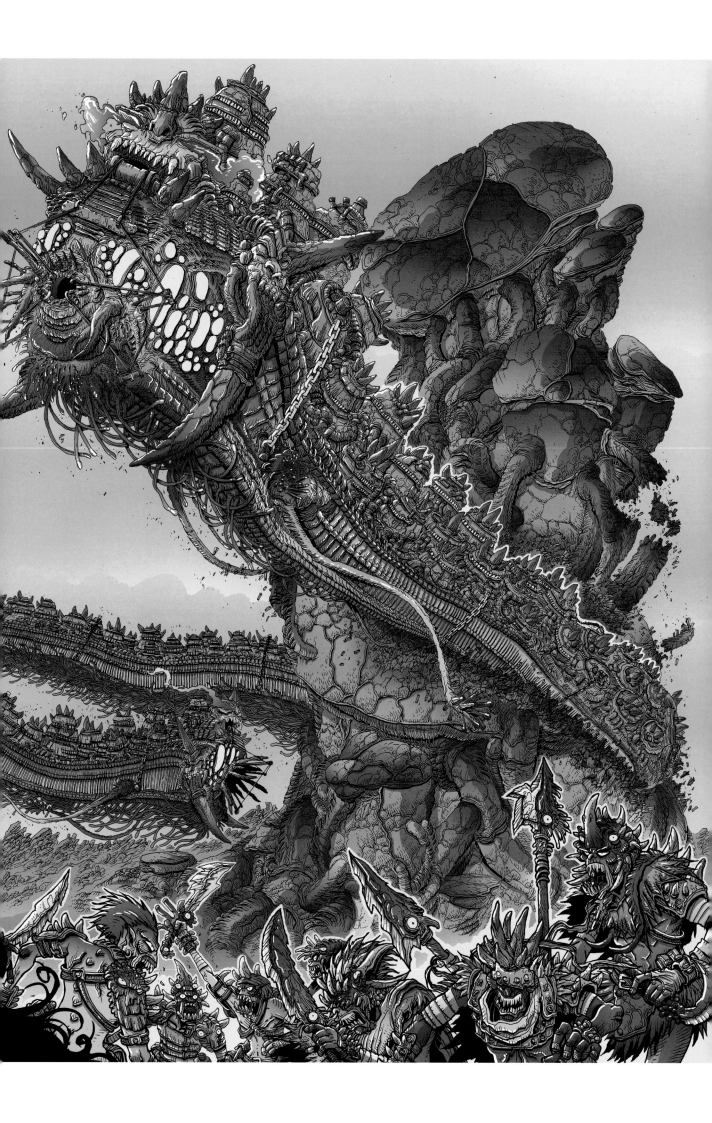

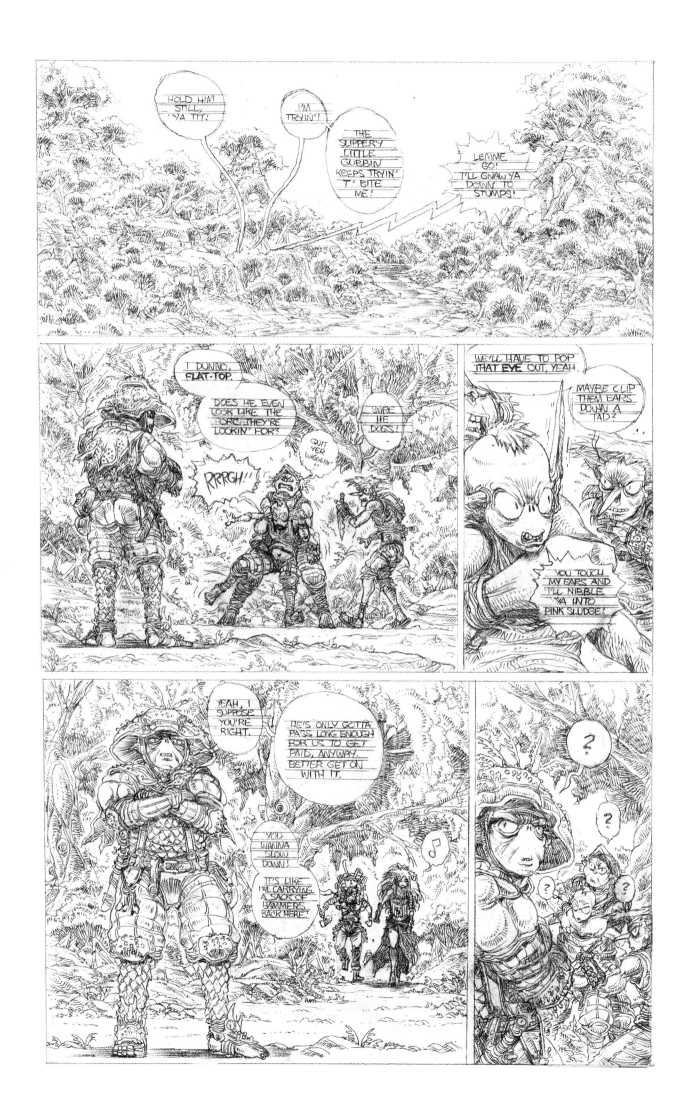

58

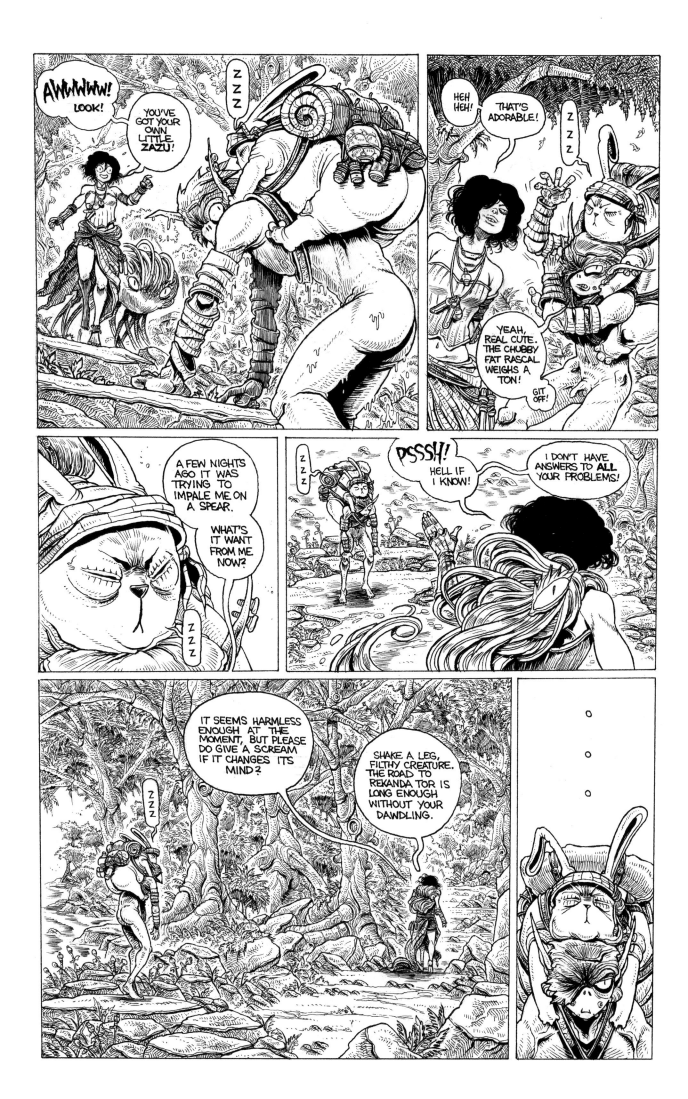

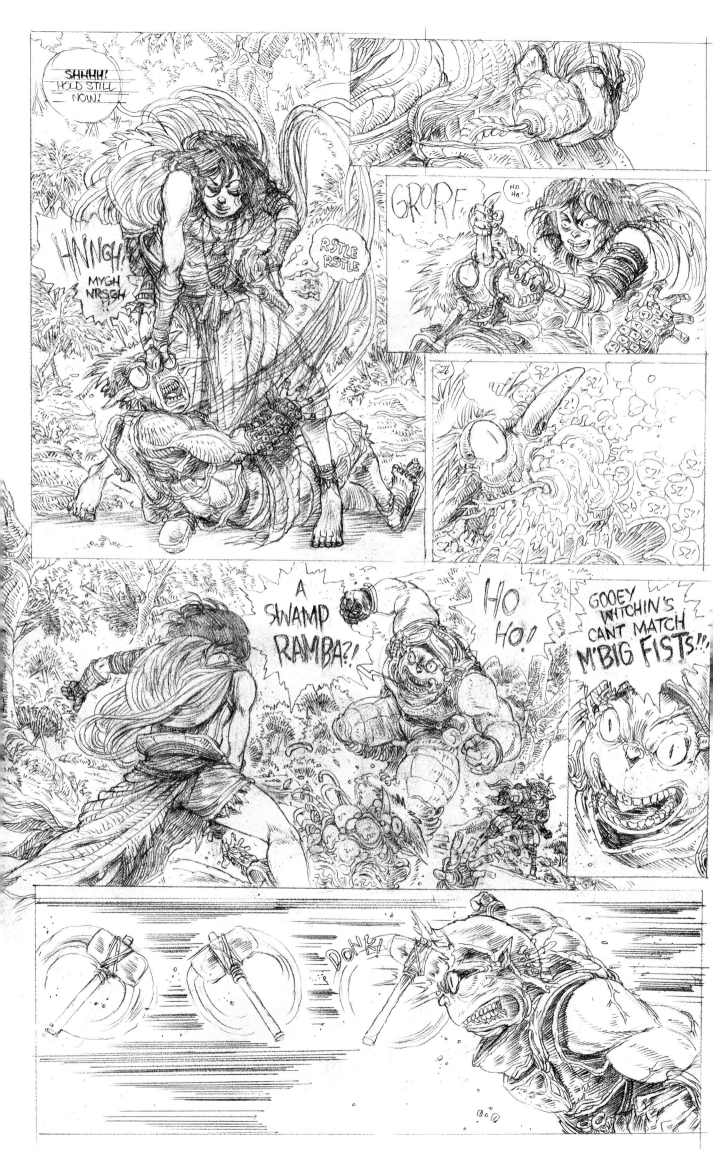

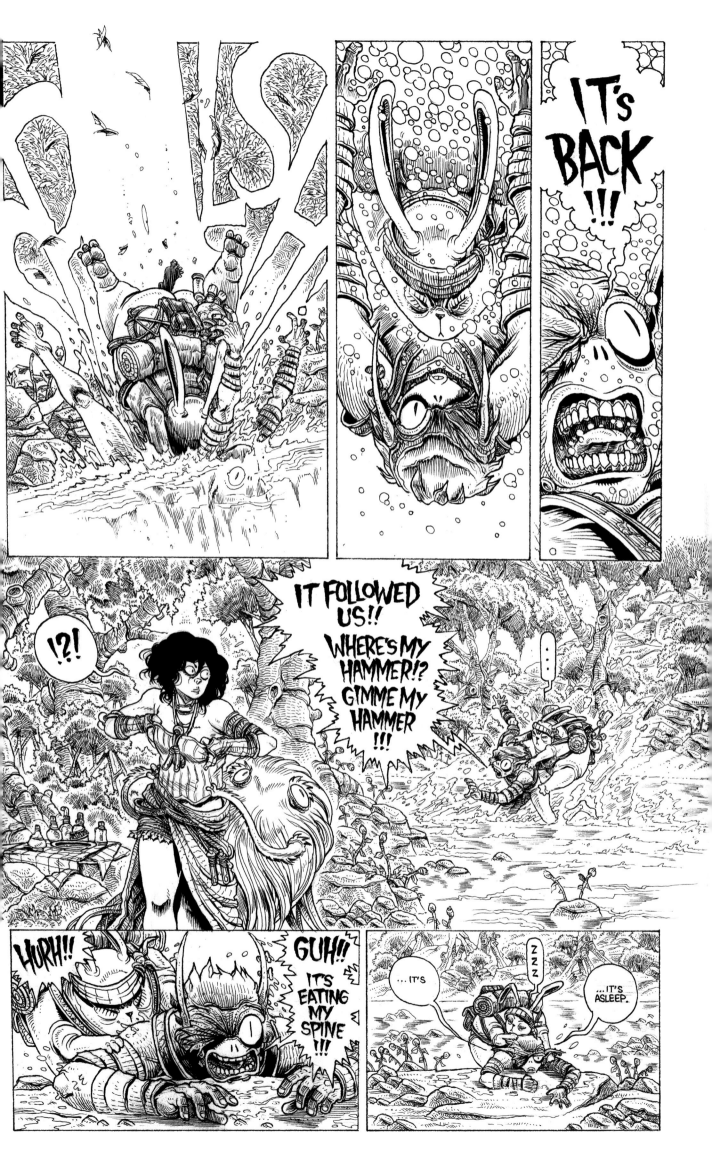

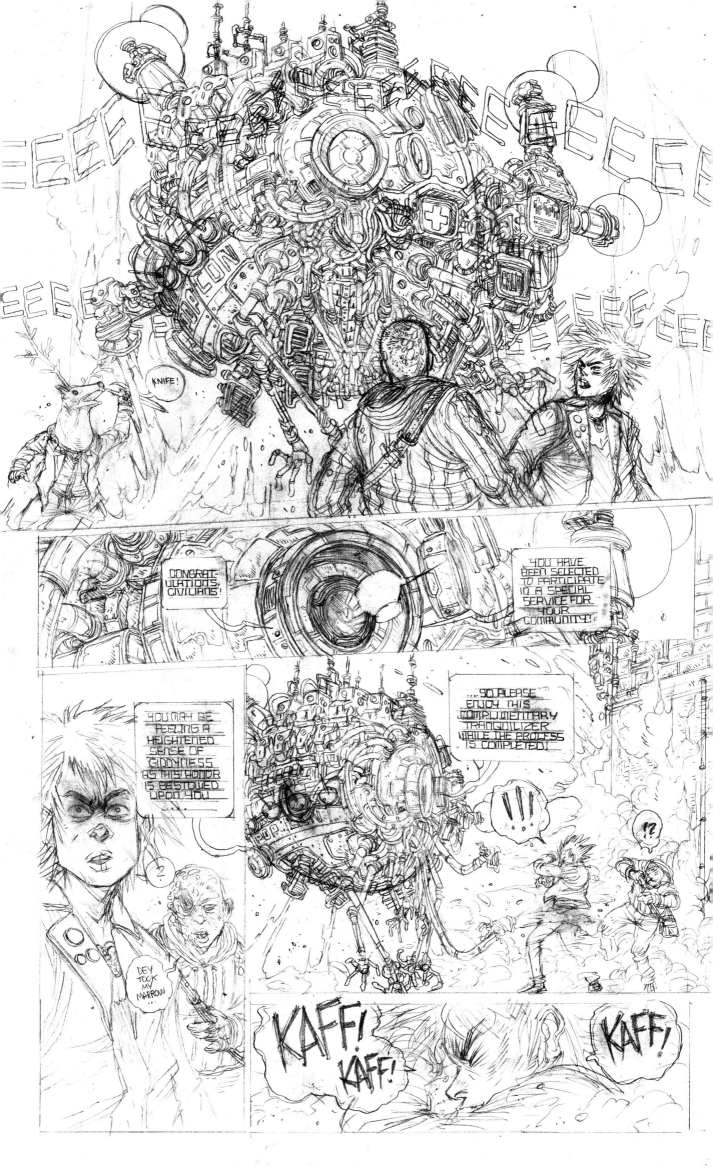

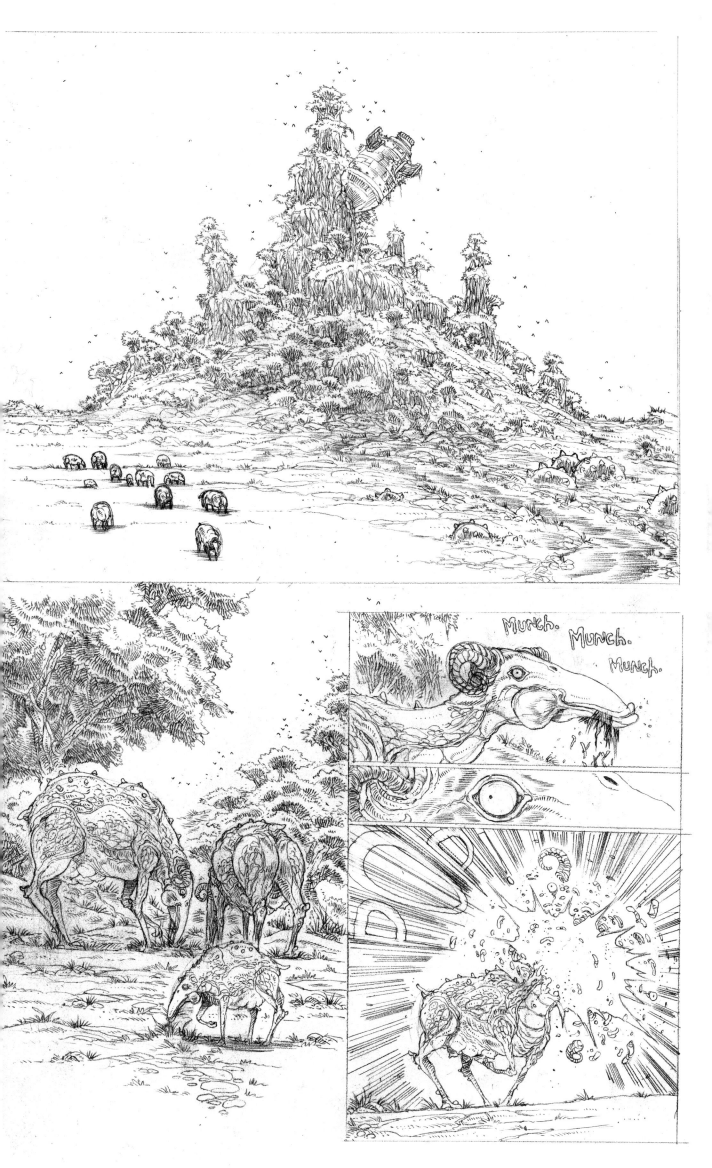

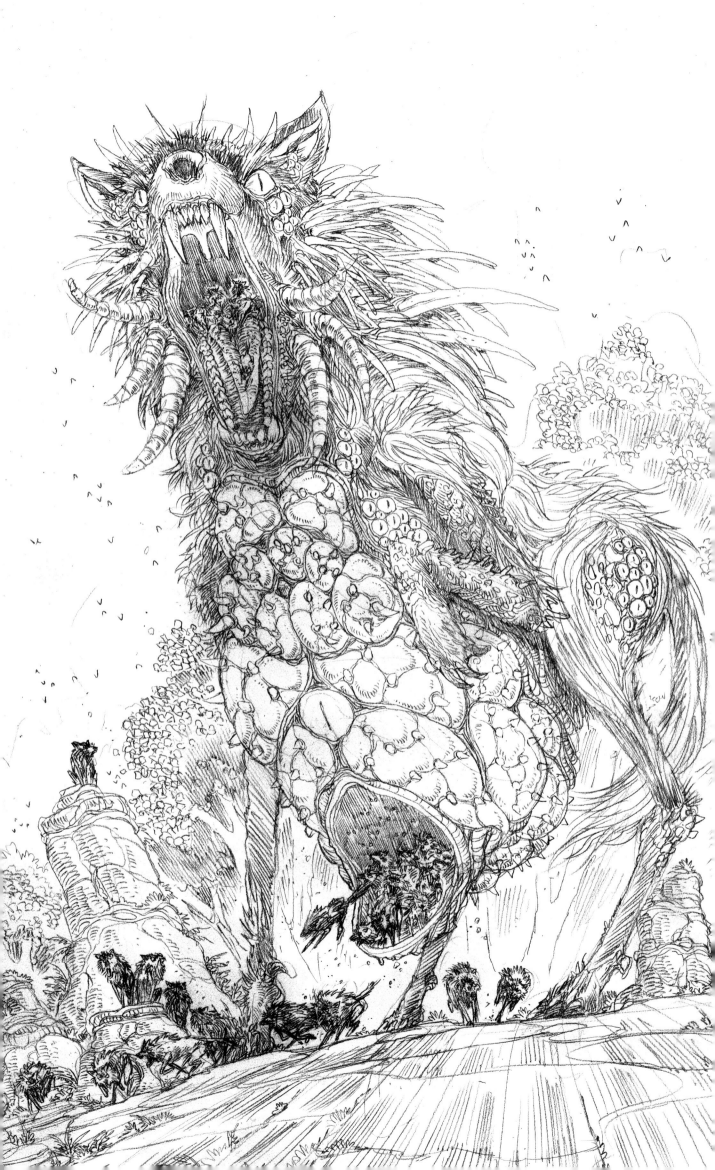

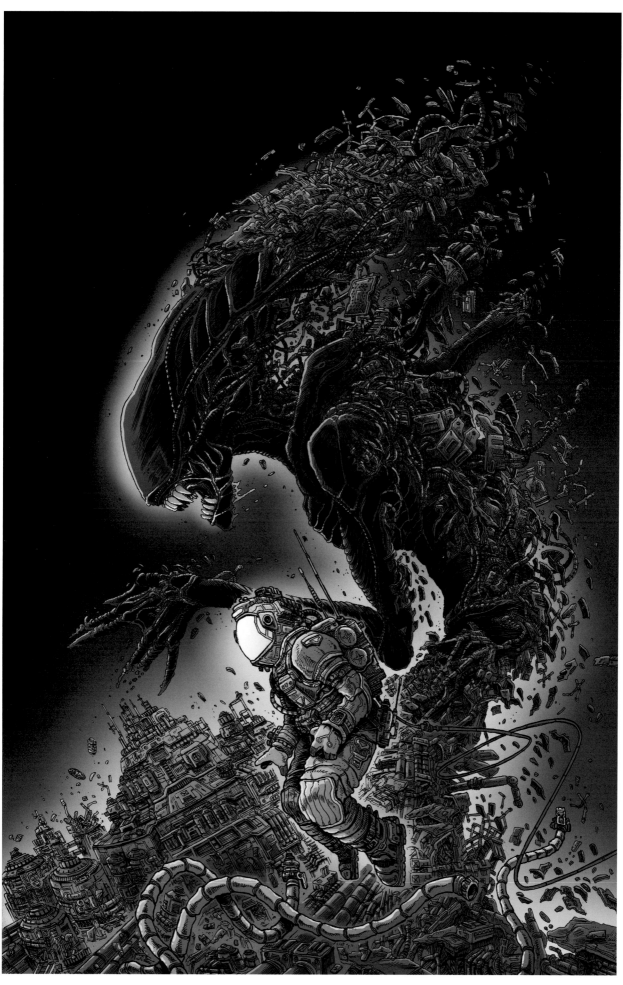

The following pages feature art from *Aliens: Dead Orbit*, published by Dark Horse Comics.

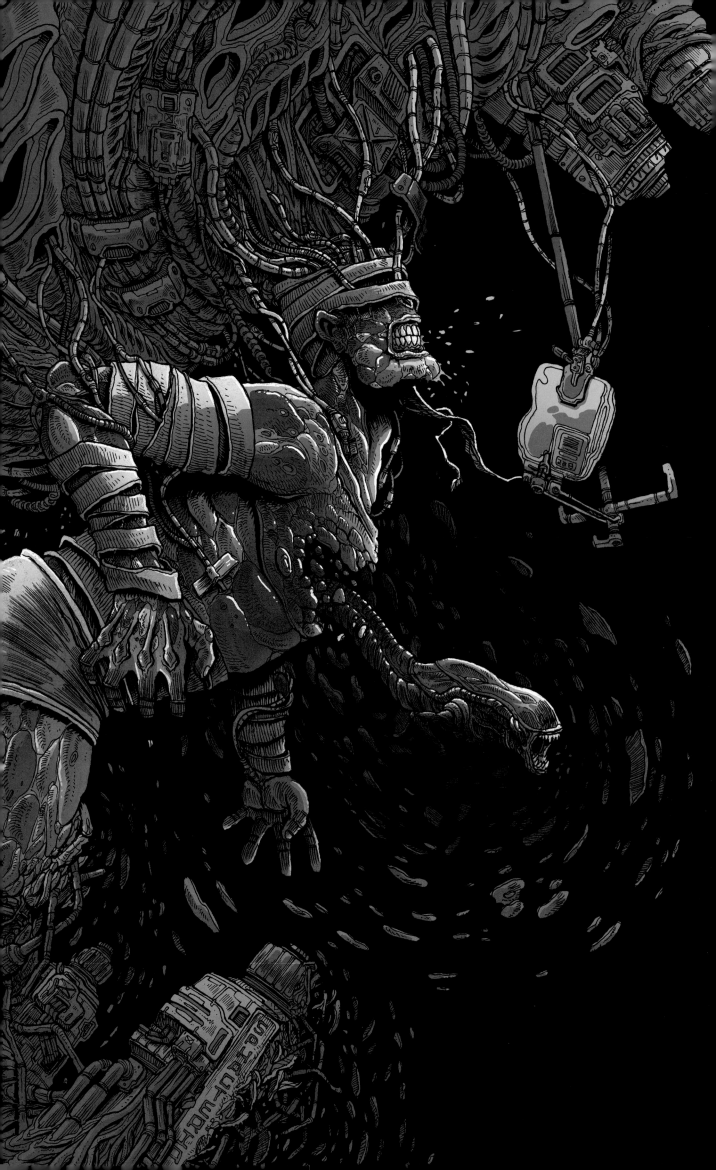

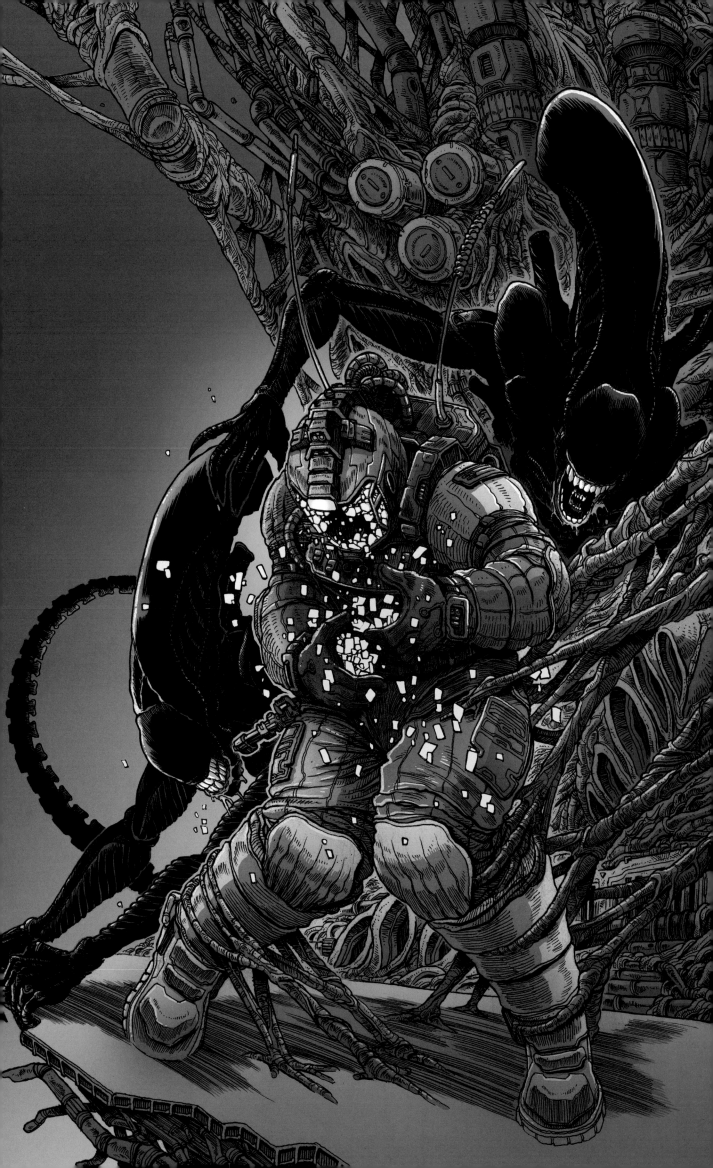

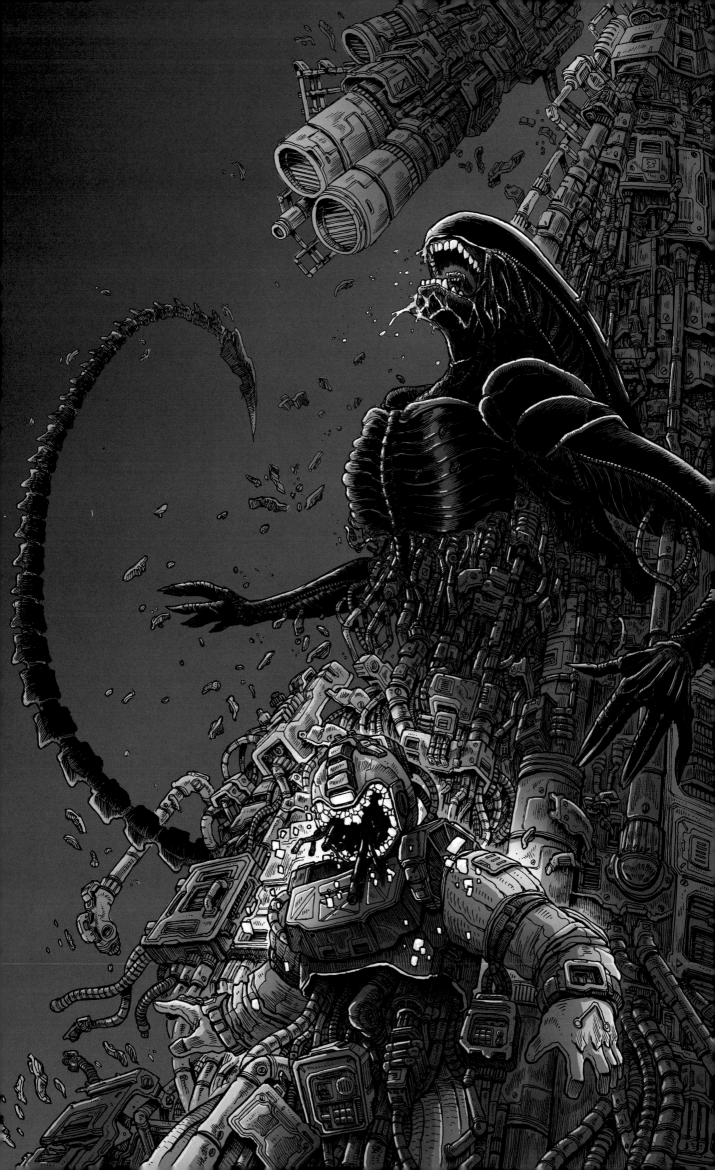

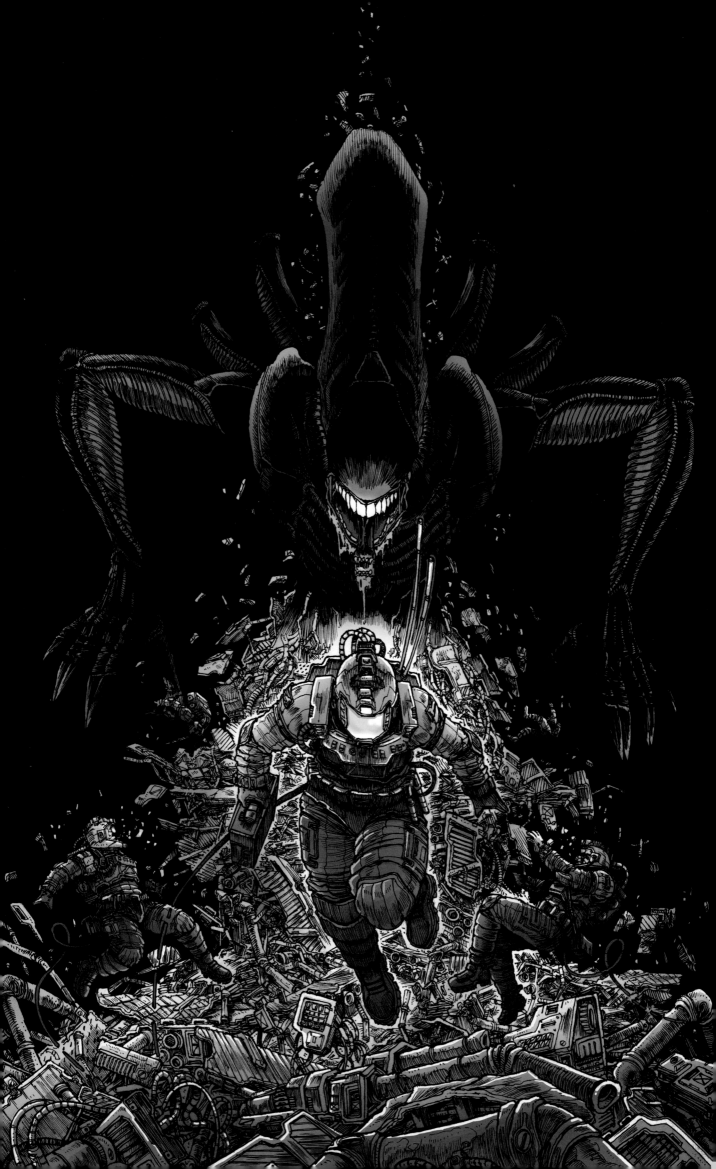

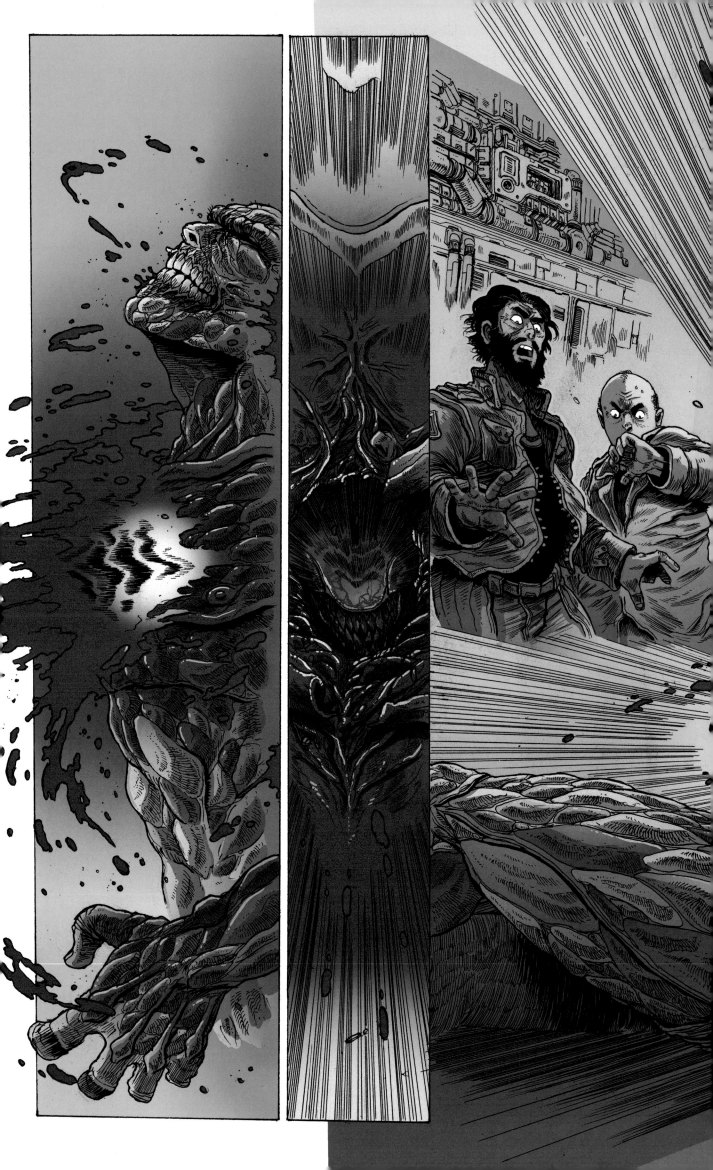

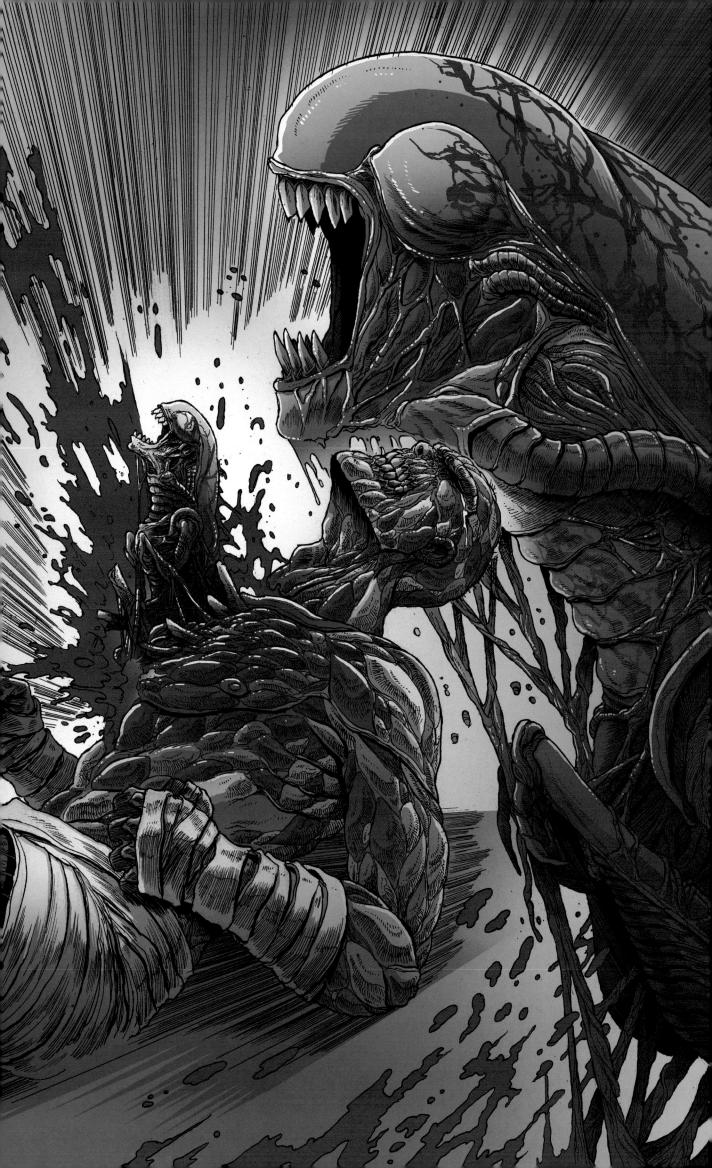

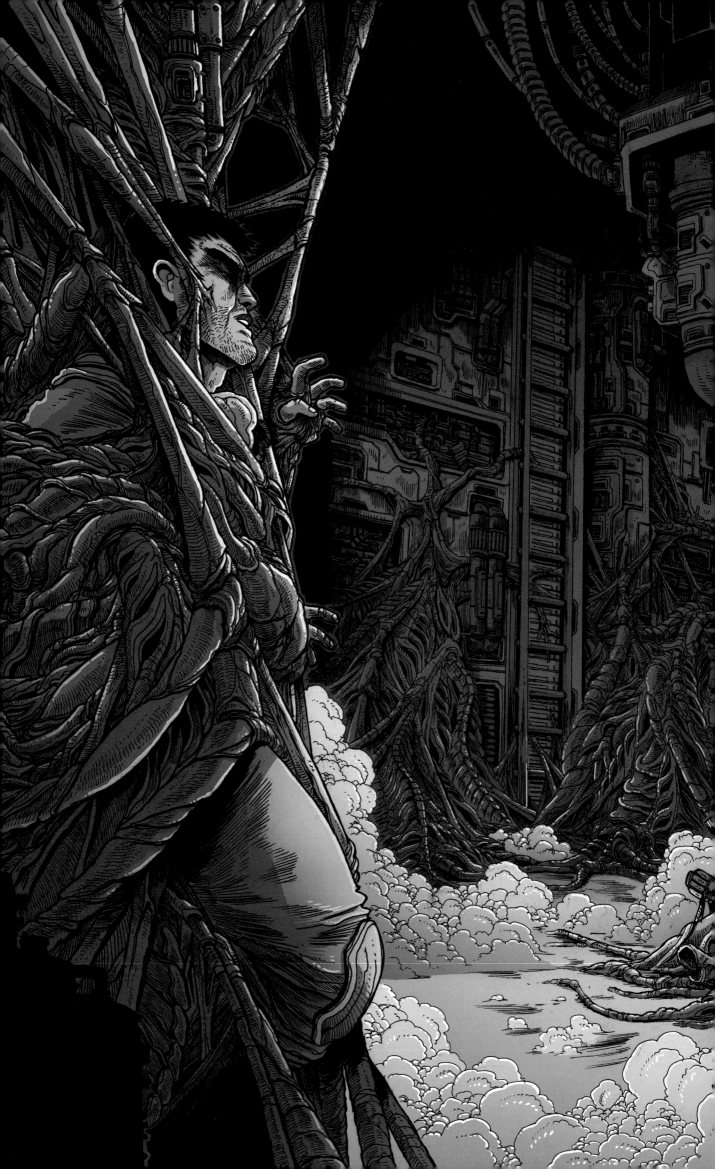

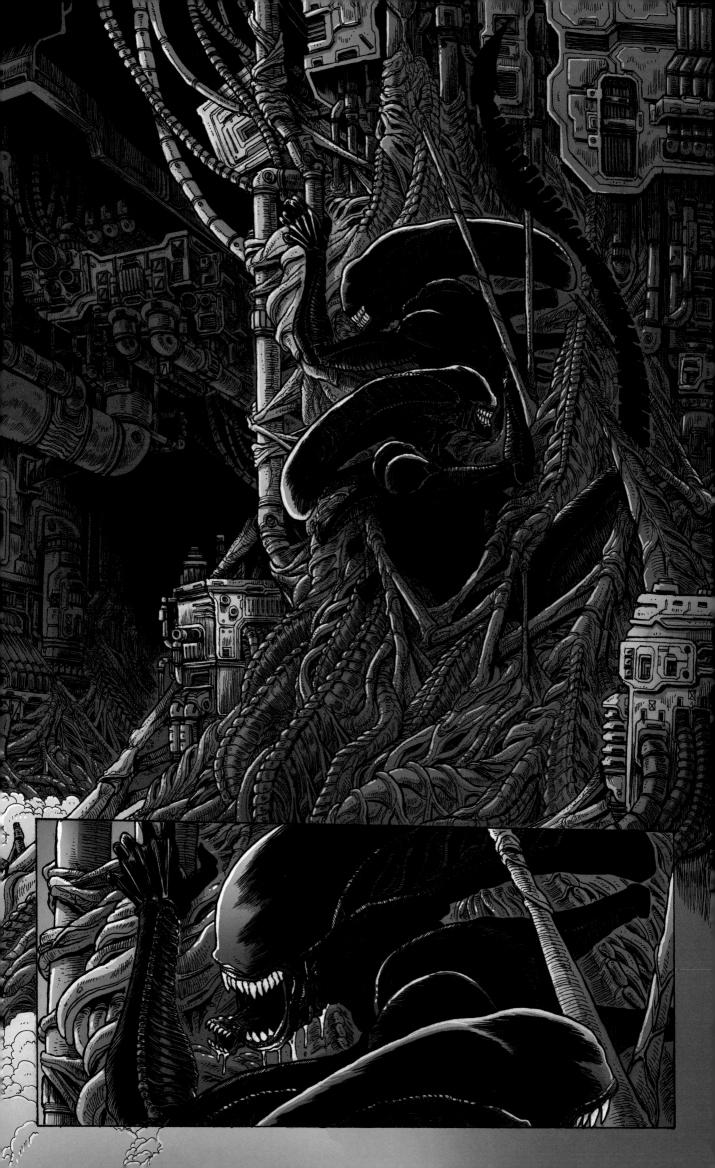

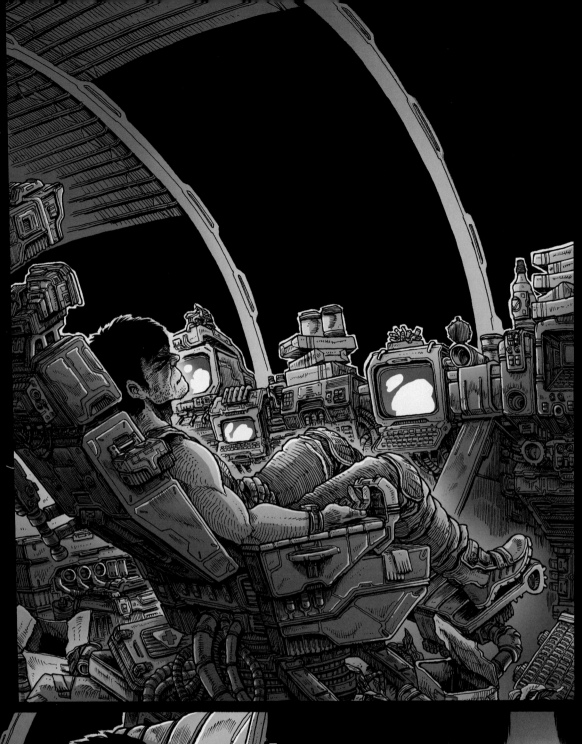

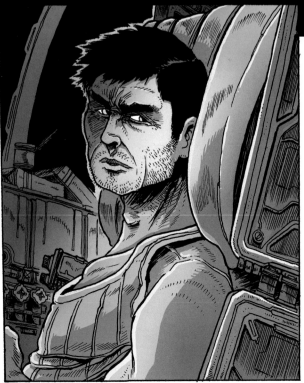

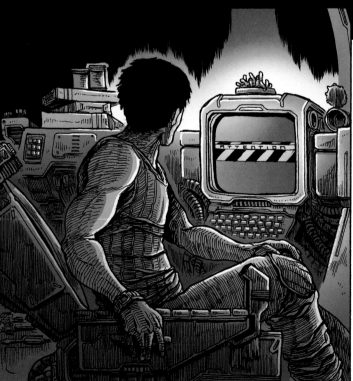

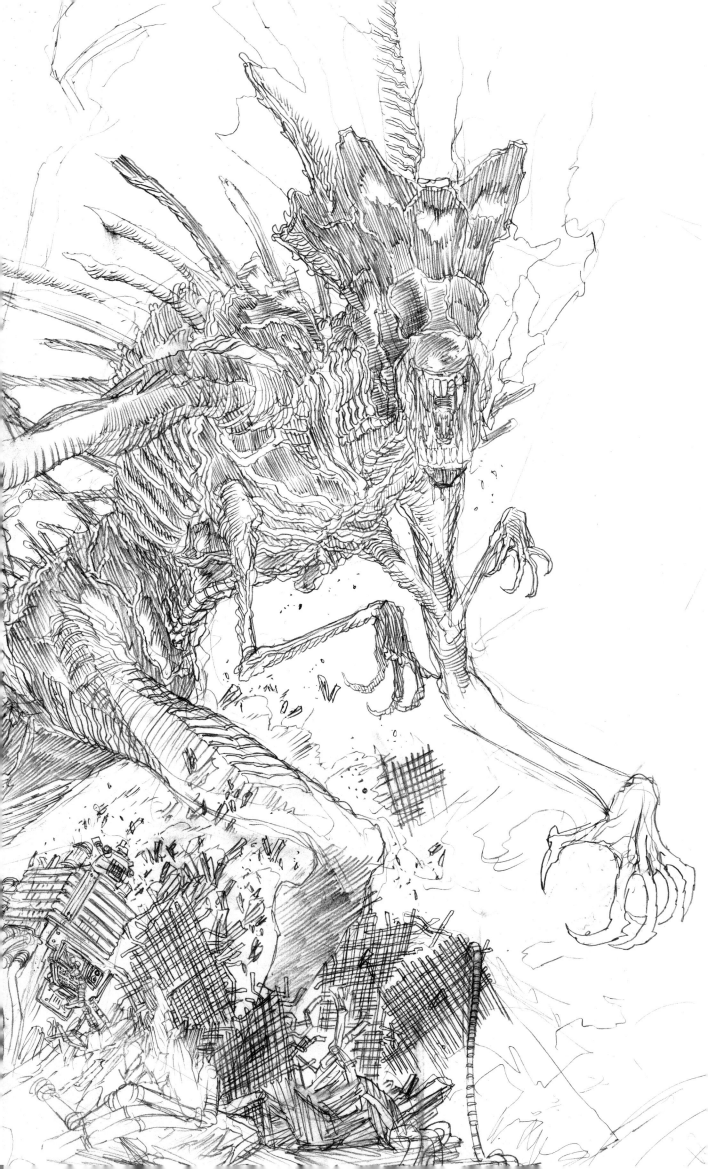

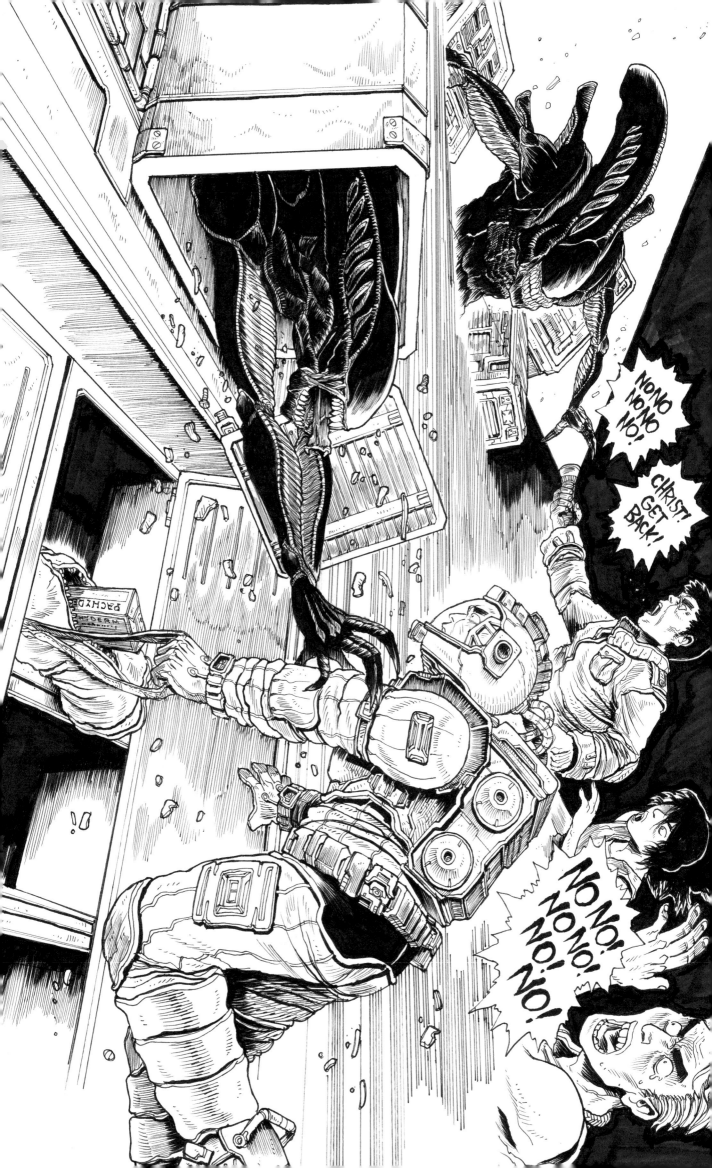

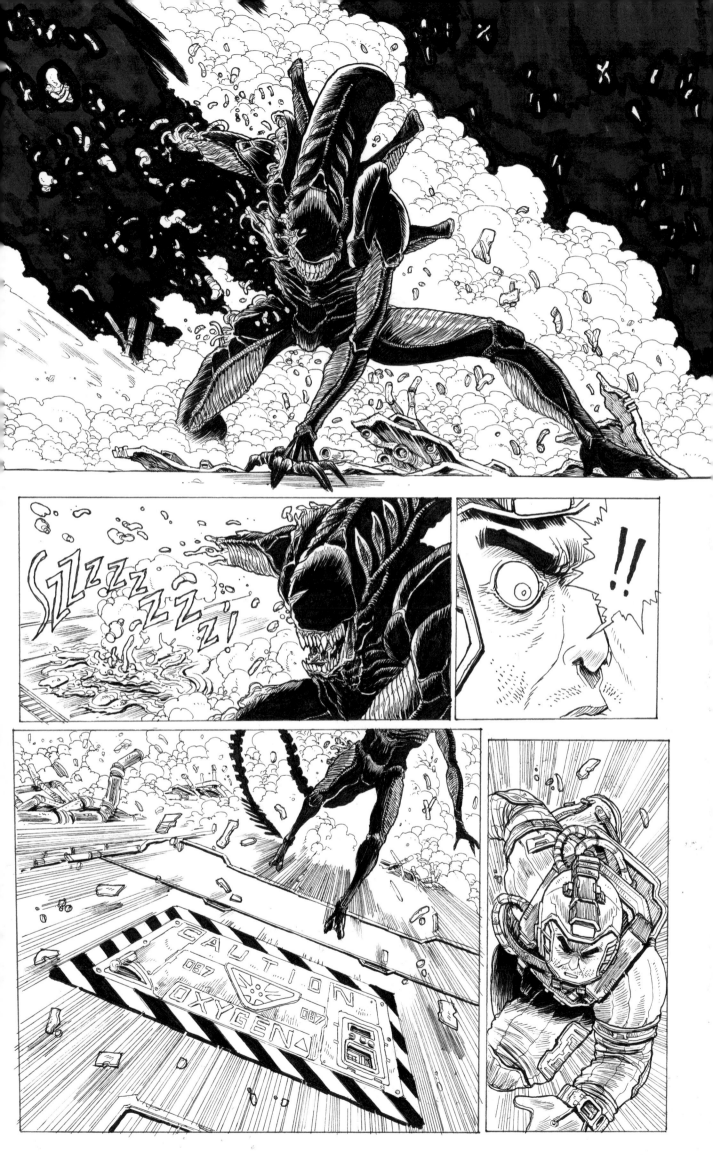

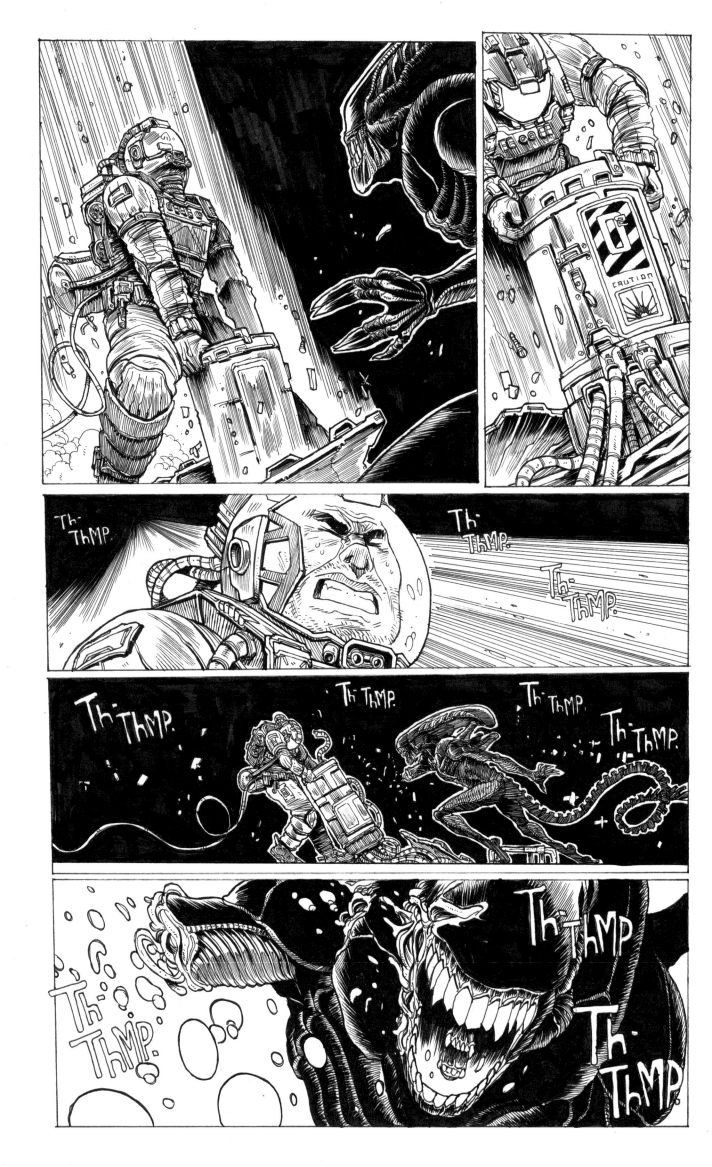

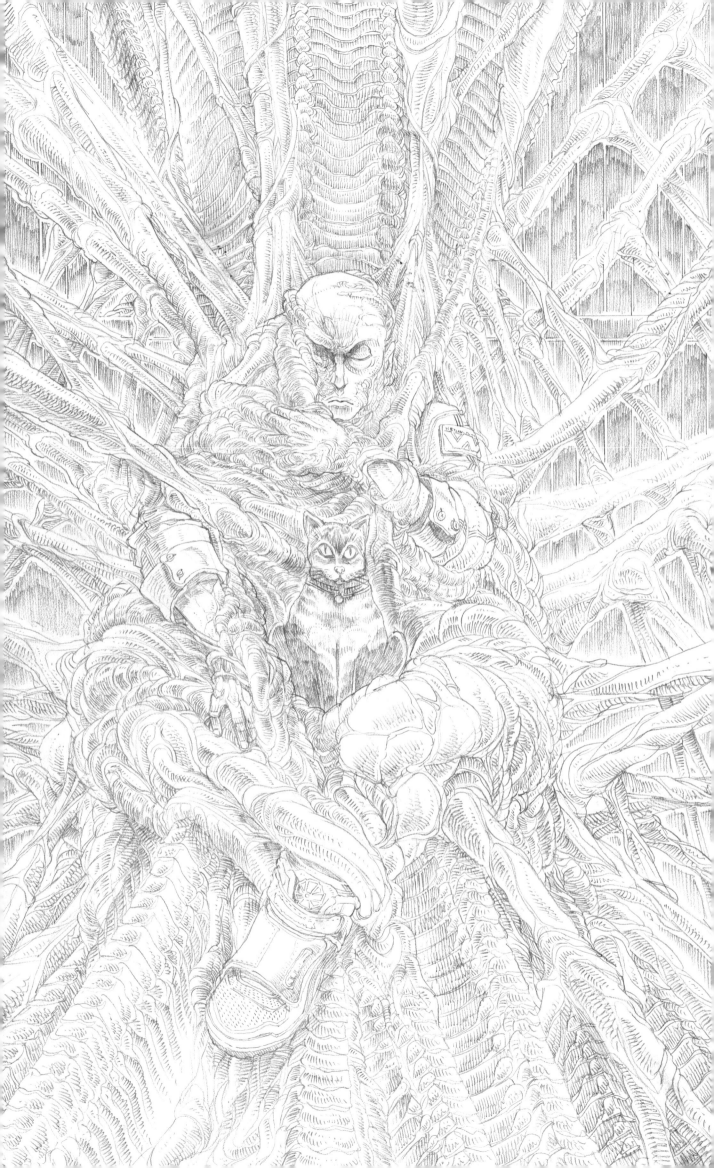

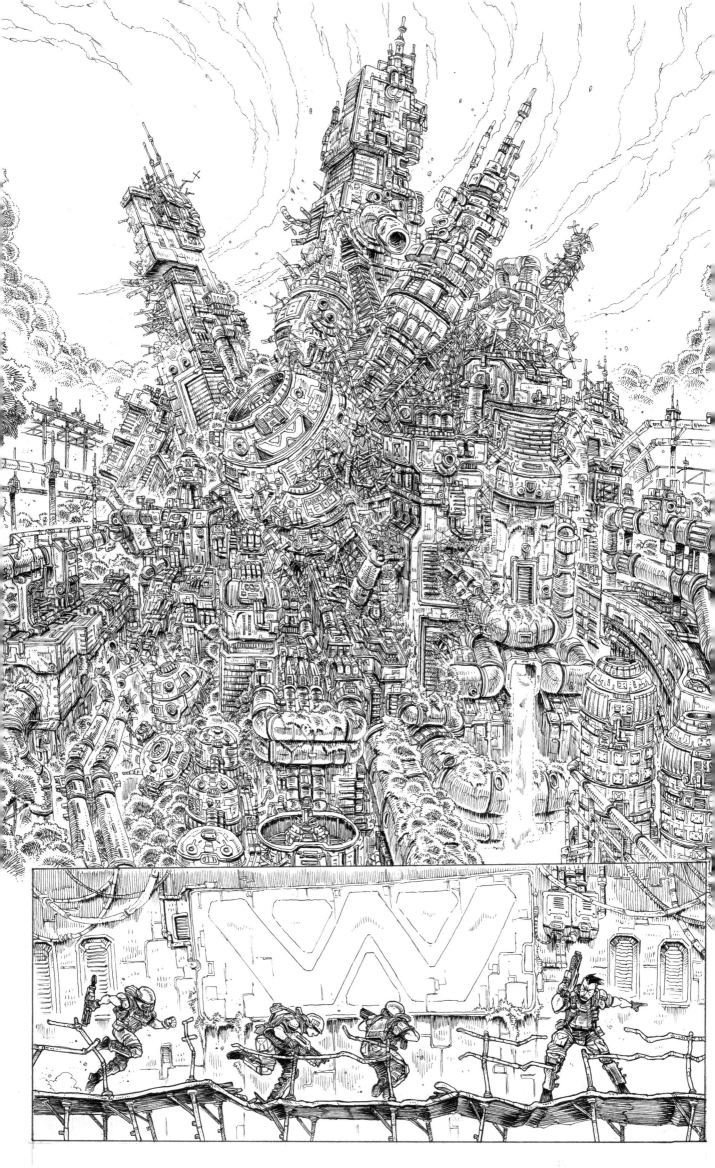

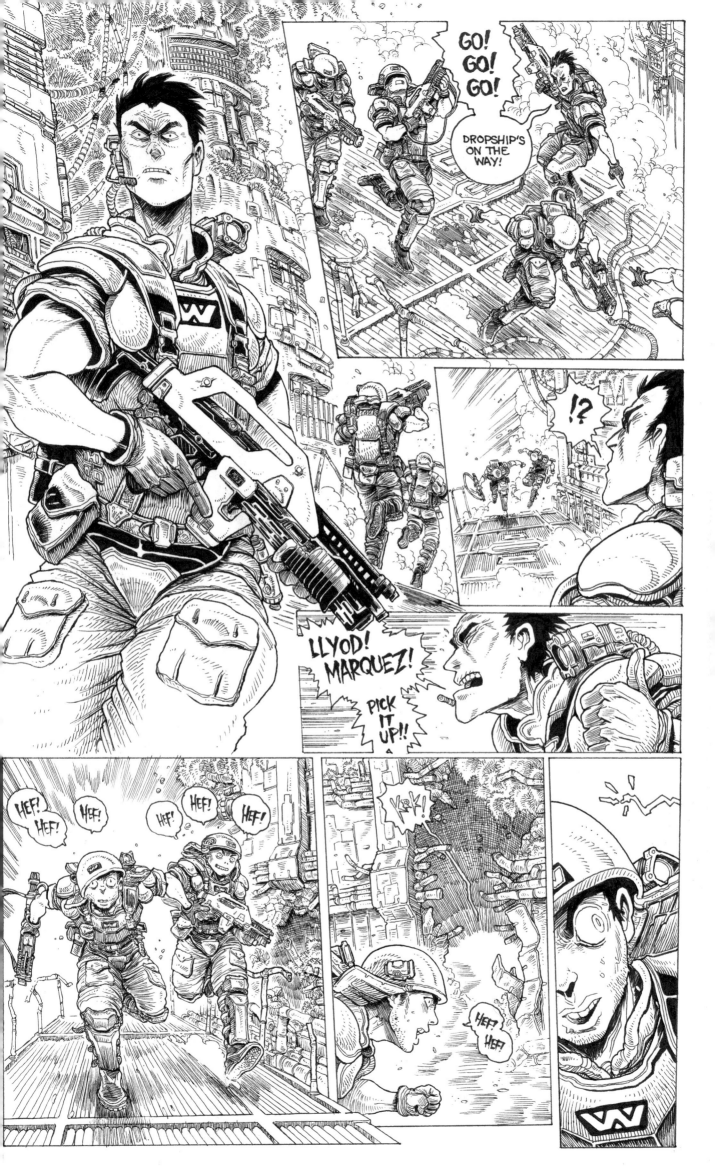

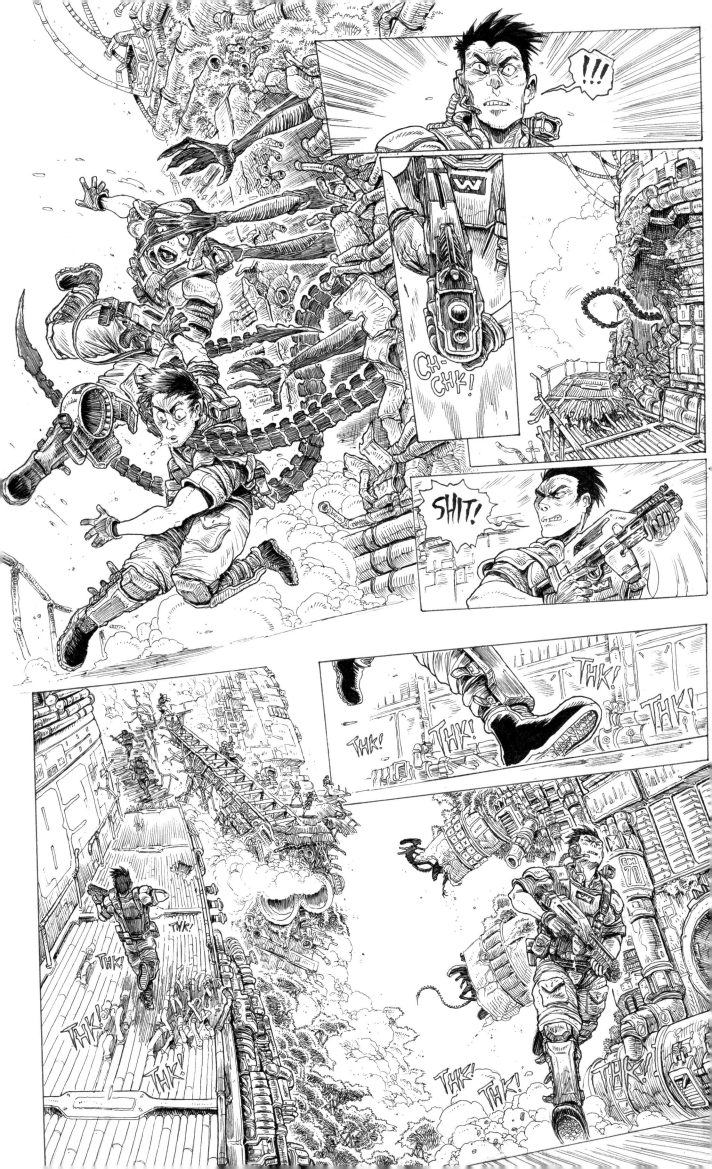

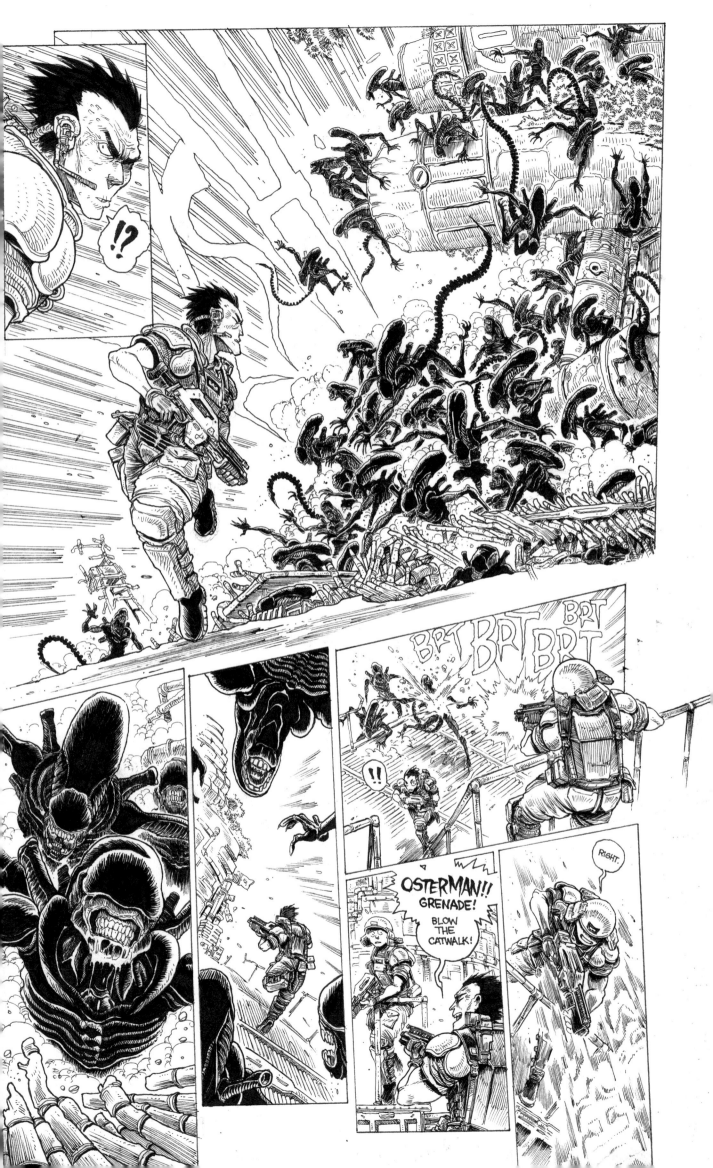

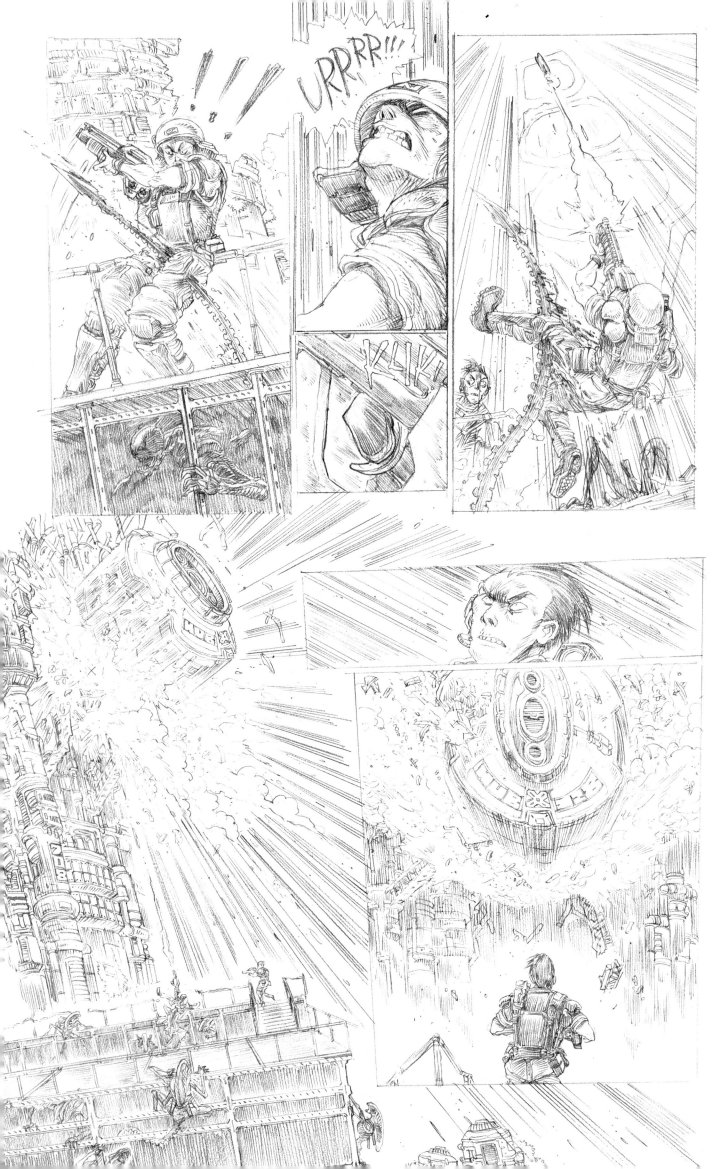

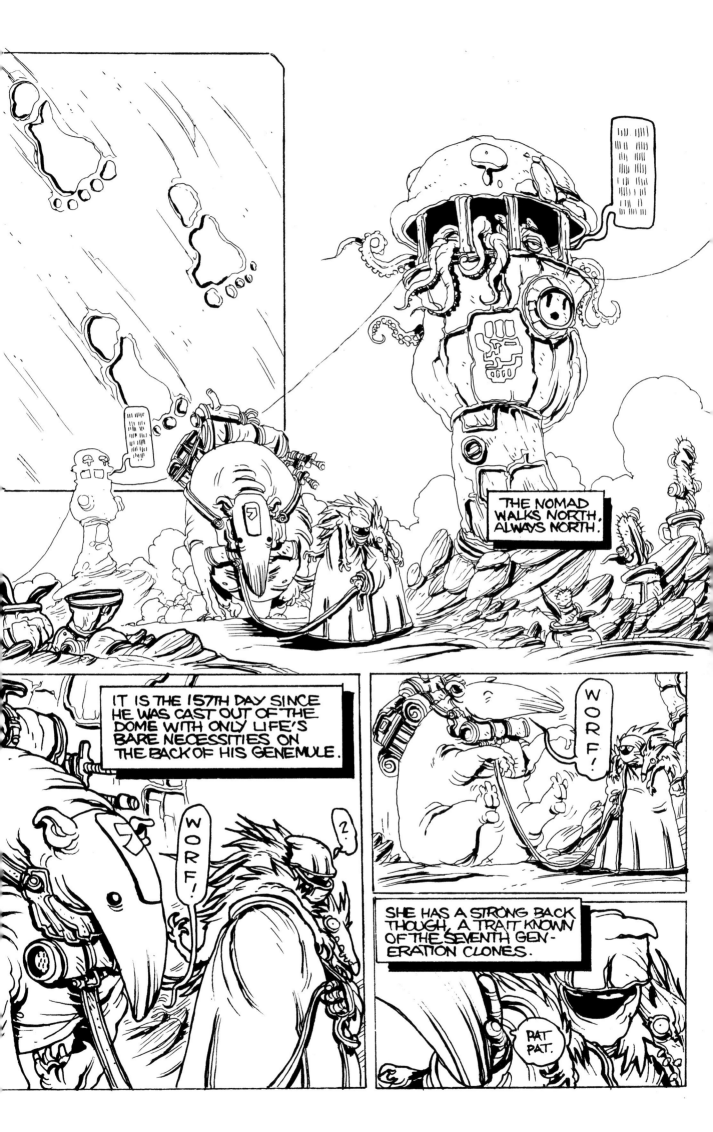

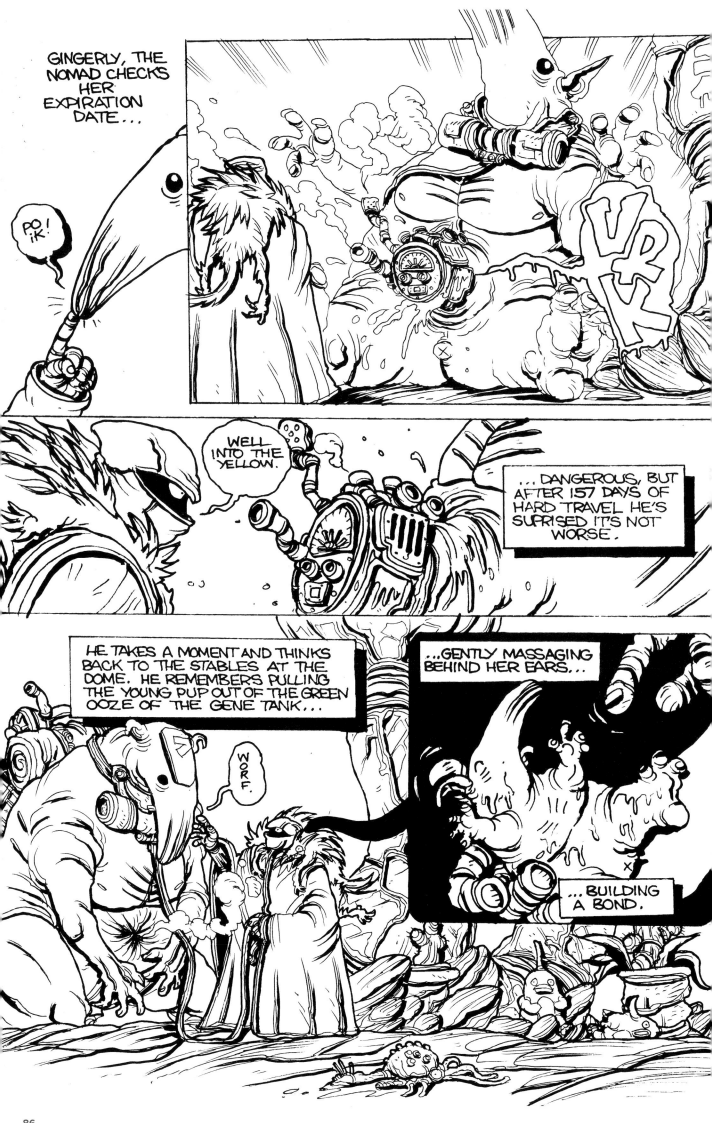

GINGERLY, THE NOMAD CHECKS HER EXPIRATION DATE...

PO IK!

WELL INTO THE YELLOW.

...DANGEROUS, BUT AFTER 157 DAYS OF HARD TRAVEL HE'S SUPRISED IT'S NOT WORSE.

HE TAKES A MOMENT AND THINKS BACK TO THE STABLES AT THE DOME. HE REMEMBERS PULLING THE YOUNG PUP OUT OF THE GREEN OOZE OF THE GENE TANK...

WORF.

...GENTLY MASSAGING BEHIND HER EARS,...

...BUILDING A BOND.

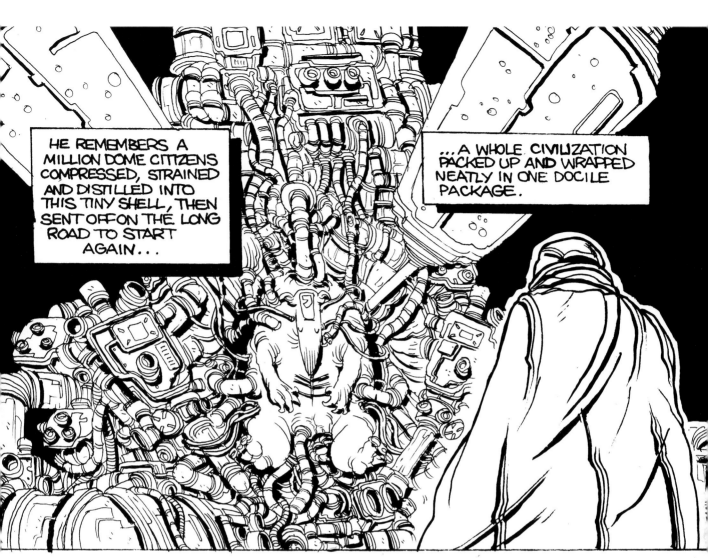

HE REMEMBERS A MILLION DOME CITIZENS COMPRESSED, STRAINED AND DISTILLED INTO THIS TINY SHELL, THEN SENT OFF ON THE LONG ROAD TO START AGAIN...

...A WHOLE CIVILIZATION PACKED UP AND WRAPPED NEATLY IN ONE DOCILE PACKAGE.

WORF!

* scritch scratch *

PRECIOUS GEEZIE.

THE MULE IS EVERY-THING. PAST, PRESENT AND FUTURE.

WORF!

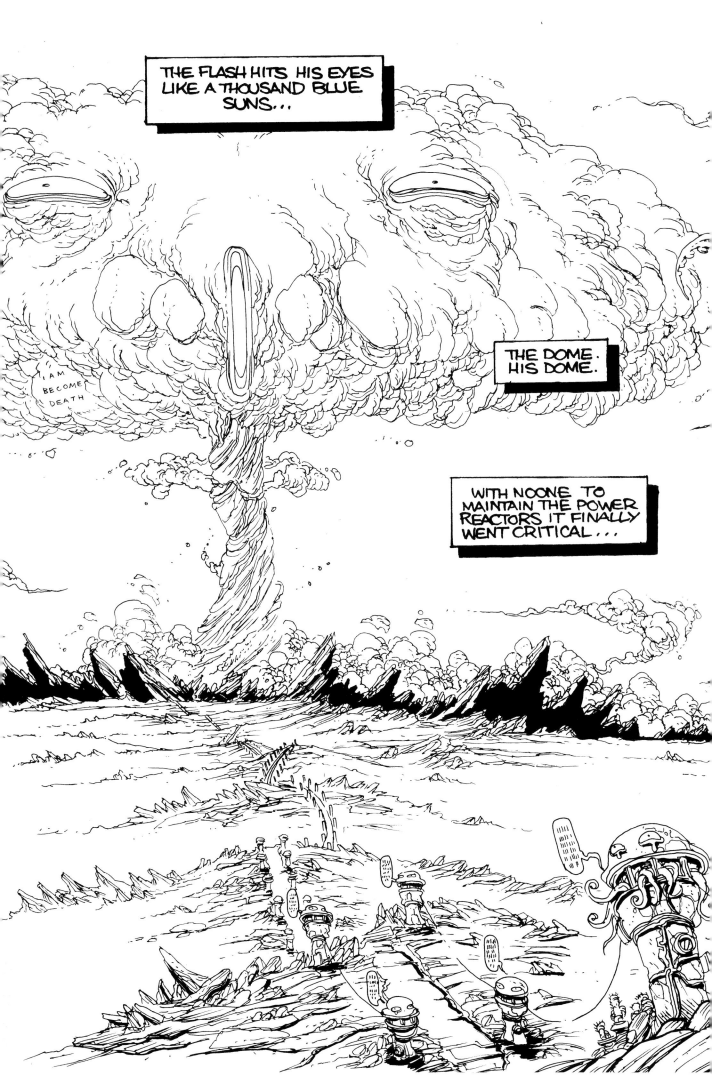

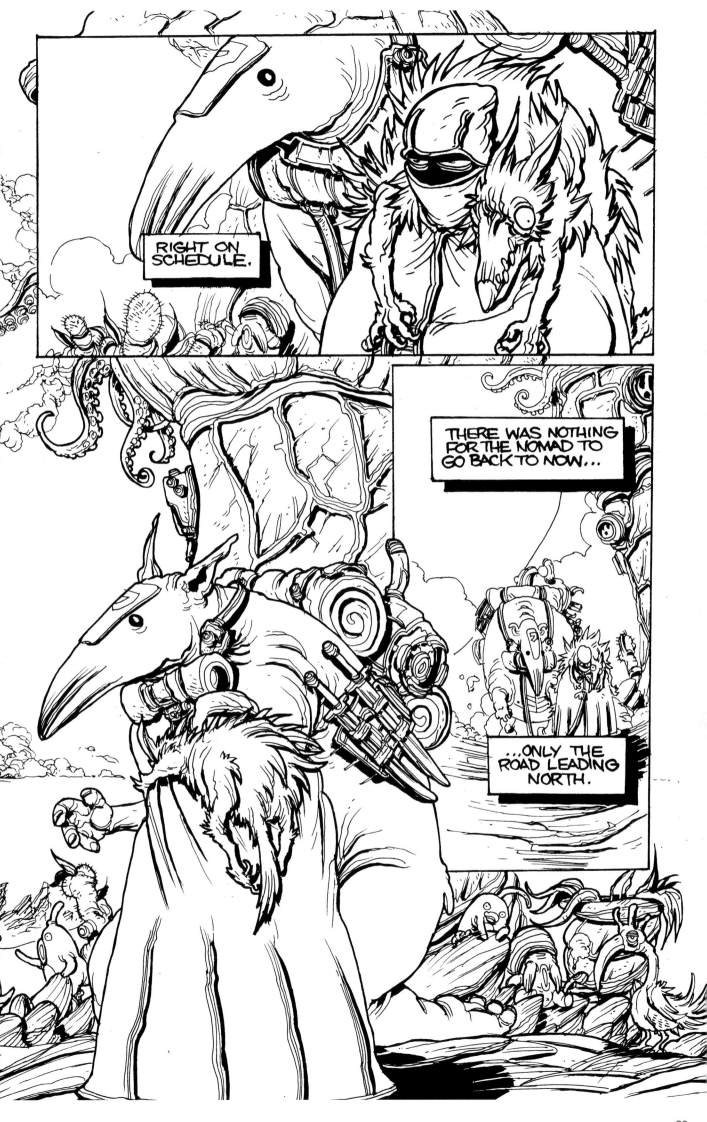

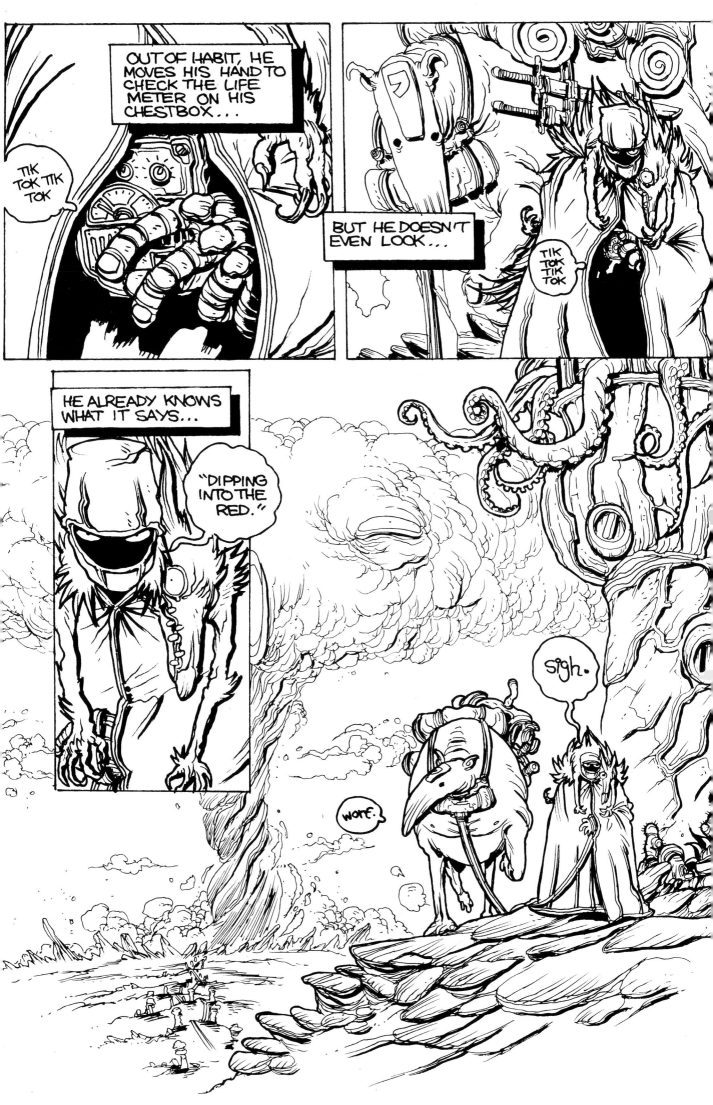

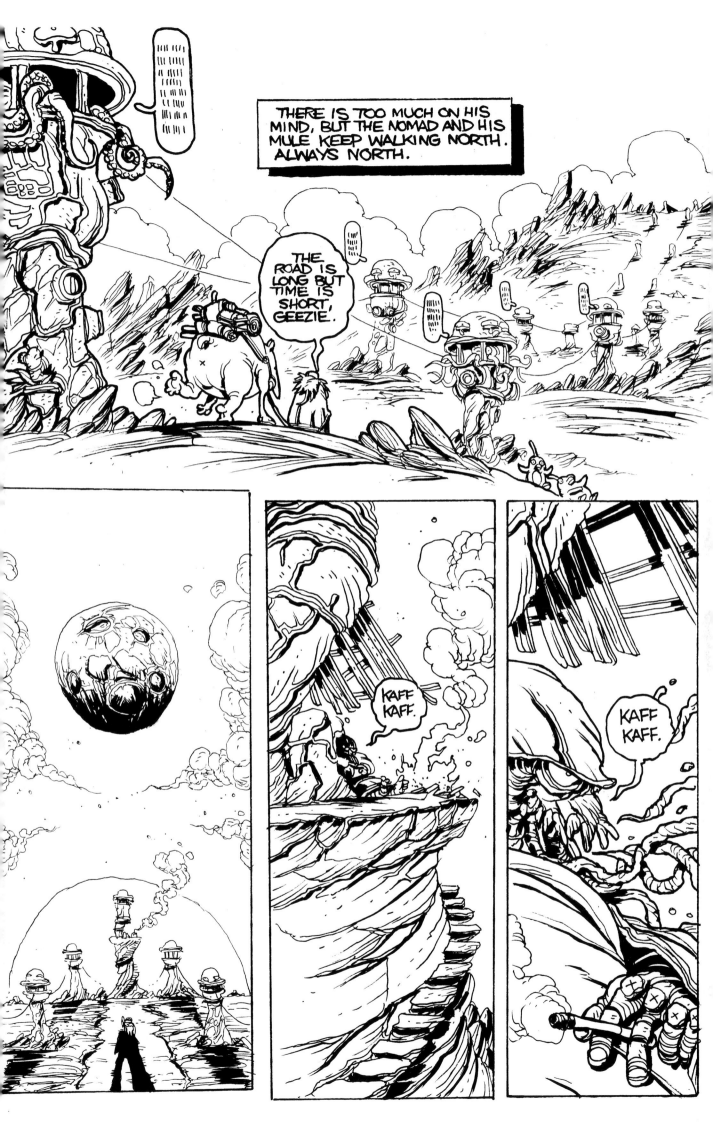

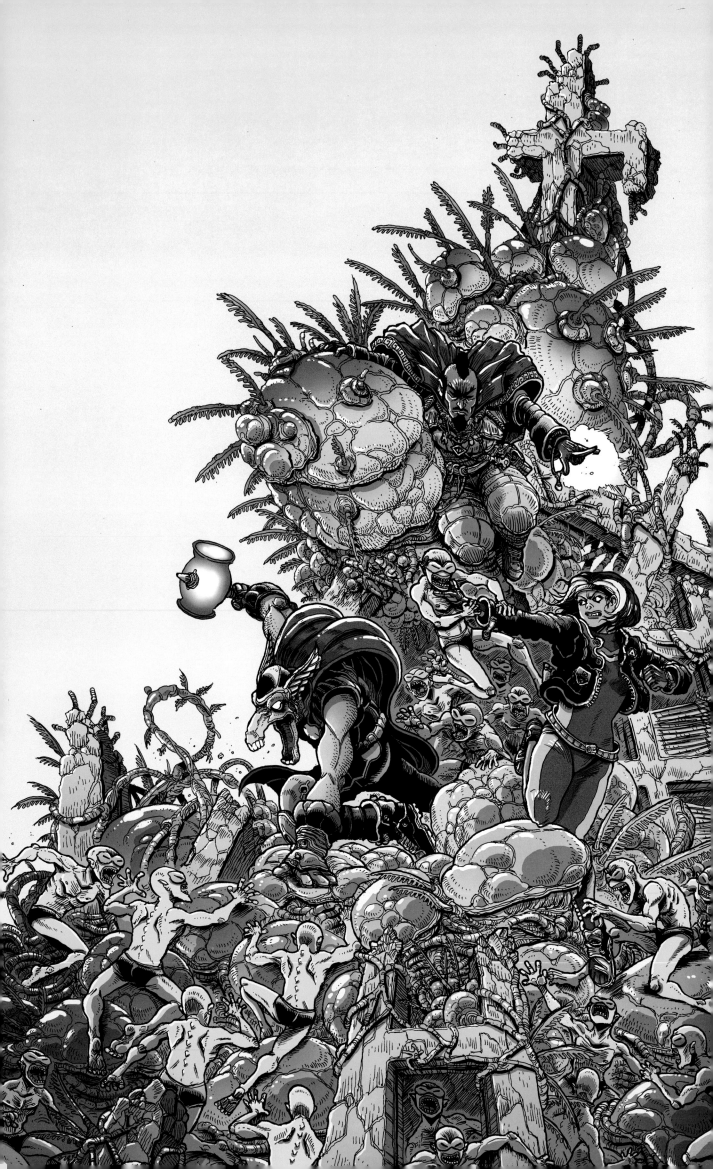

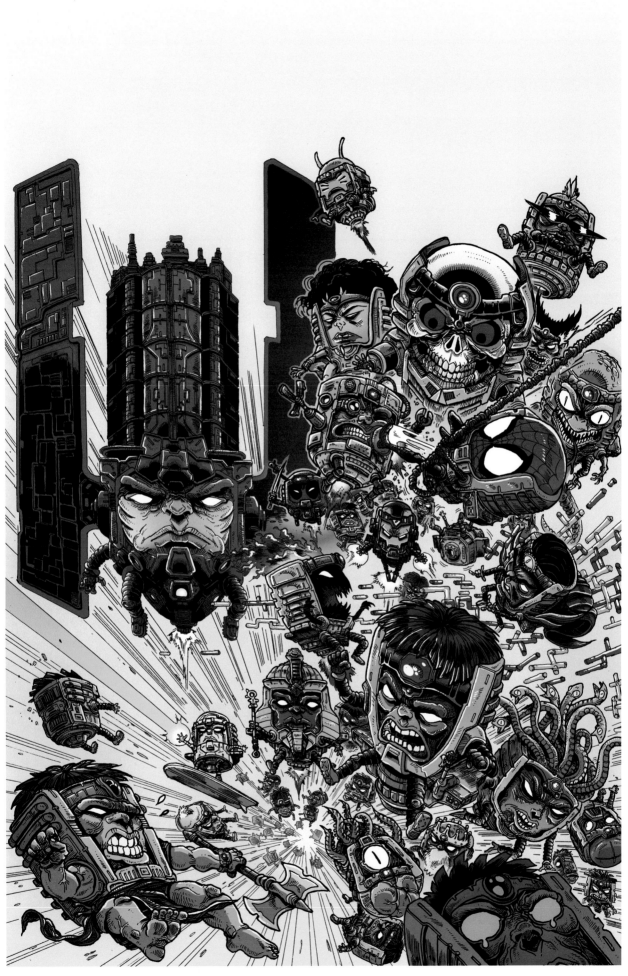

The following pages feature James Stokoe's published Marvel art.

Cover art for *Secret Wars: Battleworld* #1, published by Marvel Comics.

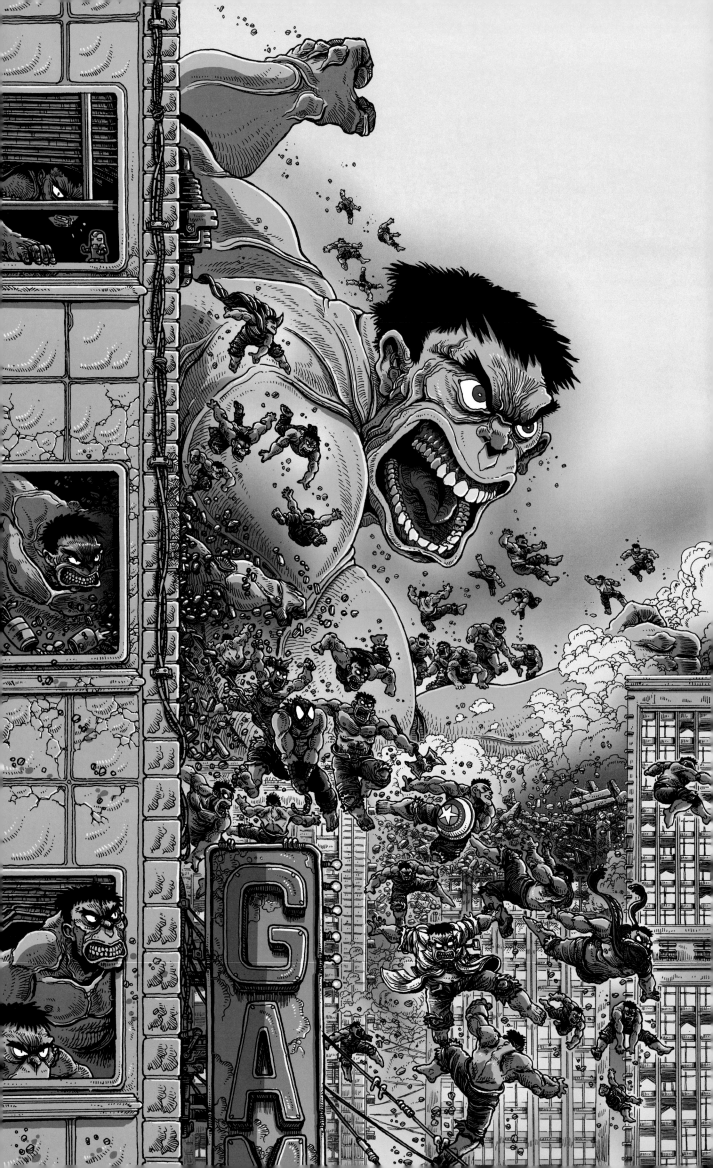

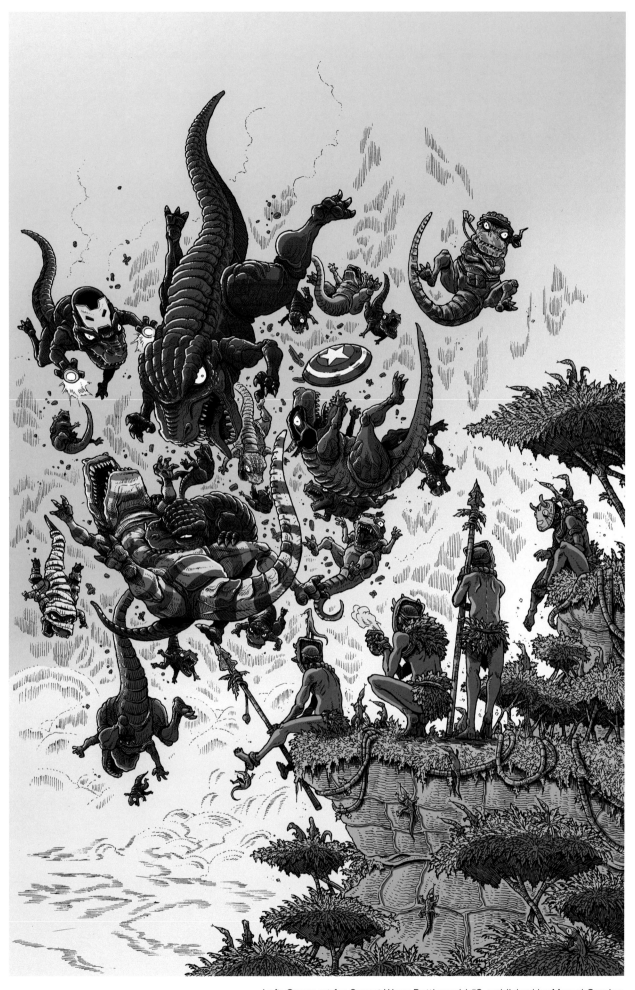

Left: Cover art for *Secret Wars: Battleworld* #2, published by Marvel Comics.
2019 © Marvel.

Above: Cover art for *Secret Wars: Battleworld* #3, published by Marvel Comics.
2019 © Marvel.

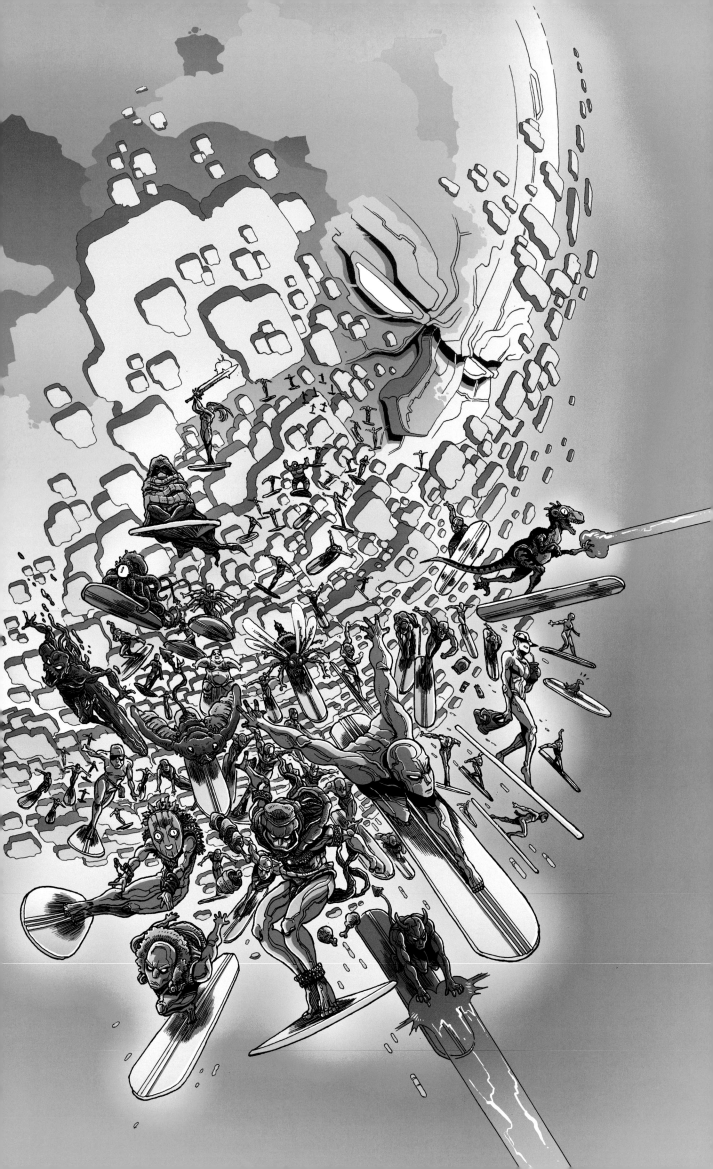

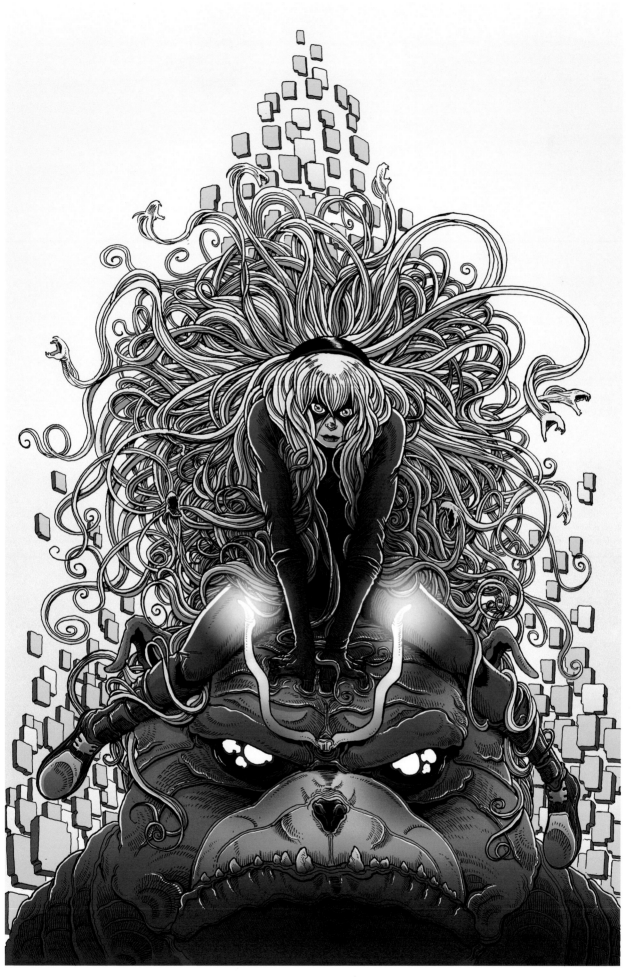

Left: Cover art for *Secret Wars: Battleworld* #4, published by Marvel Comics.
2019 © Marvel.

Above: Cover art for *Inhumans: Attilan Rising* #2, published by Marvel Comics.
2019 © Marvel.

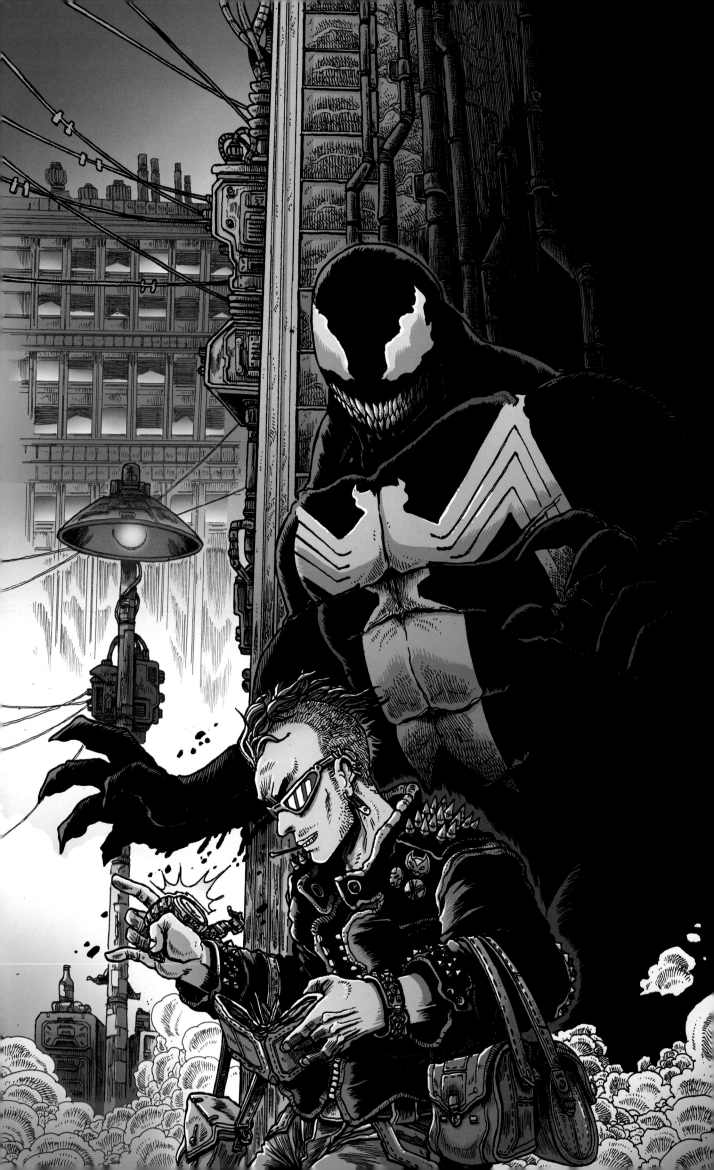

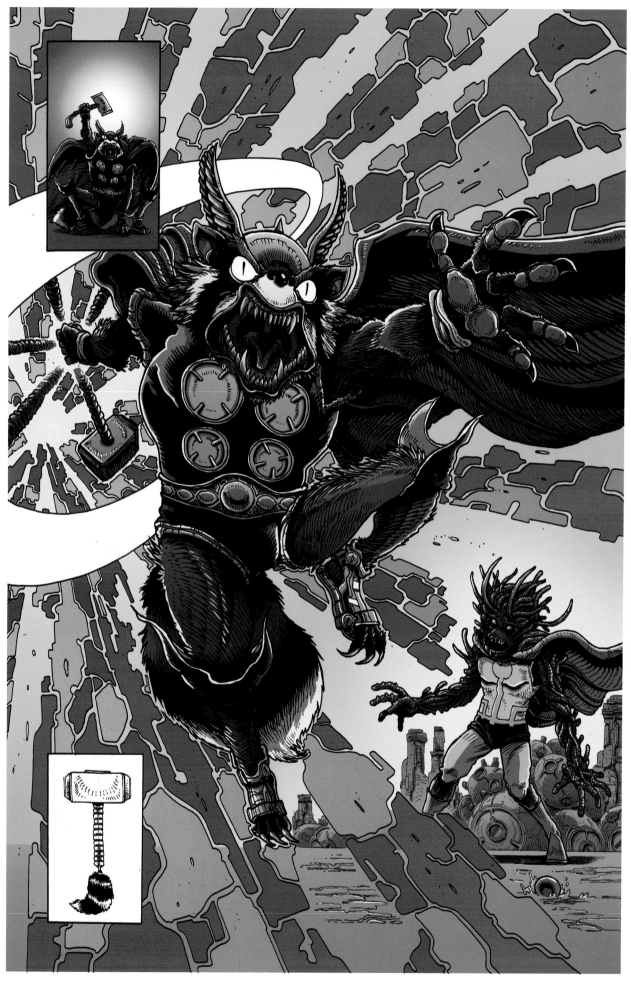

Left: Cover art for *Venom* #150, published by Marvel Comics.
2019 © Marvel.

Above: Cover art for *Thor* #2, published by Marvel Comics.
2019 © Marvel.

Next Page: Cover art for *Battleworld: Siege* #1, published by Marvel Comics.
2019 © Marvel.

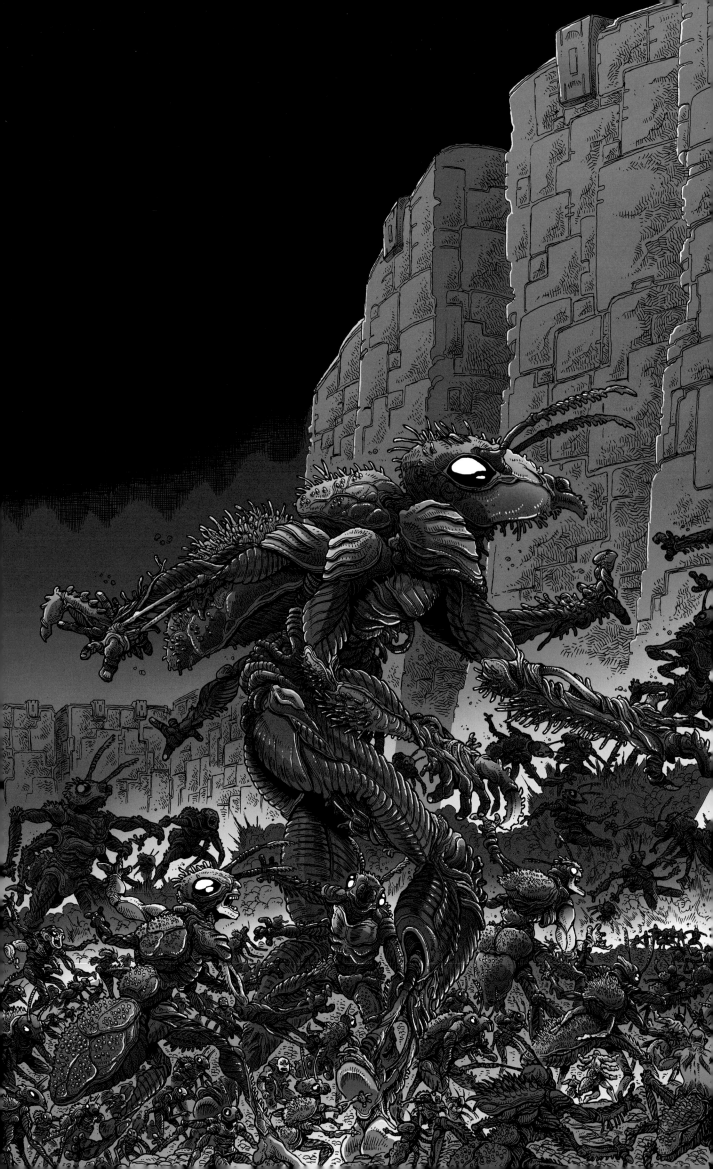

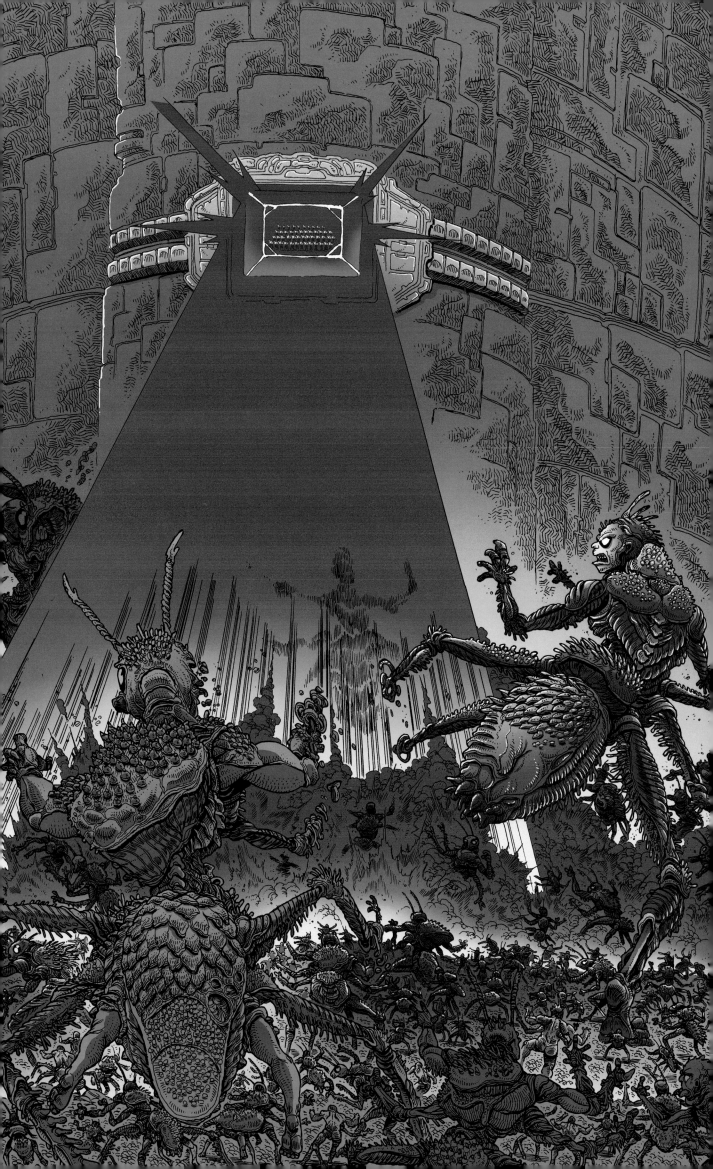

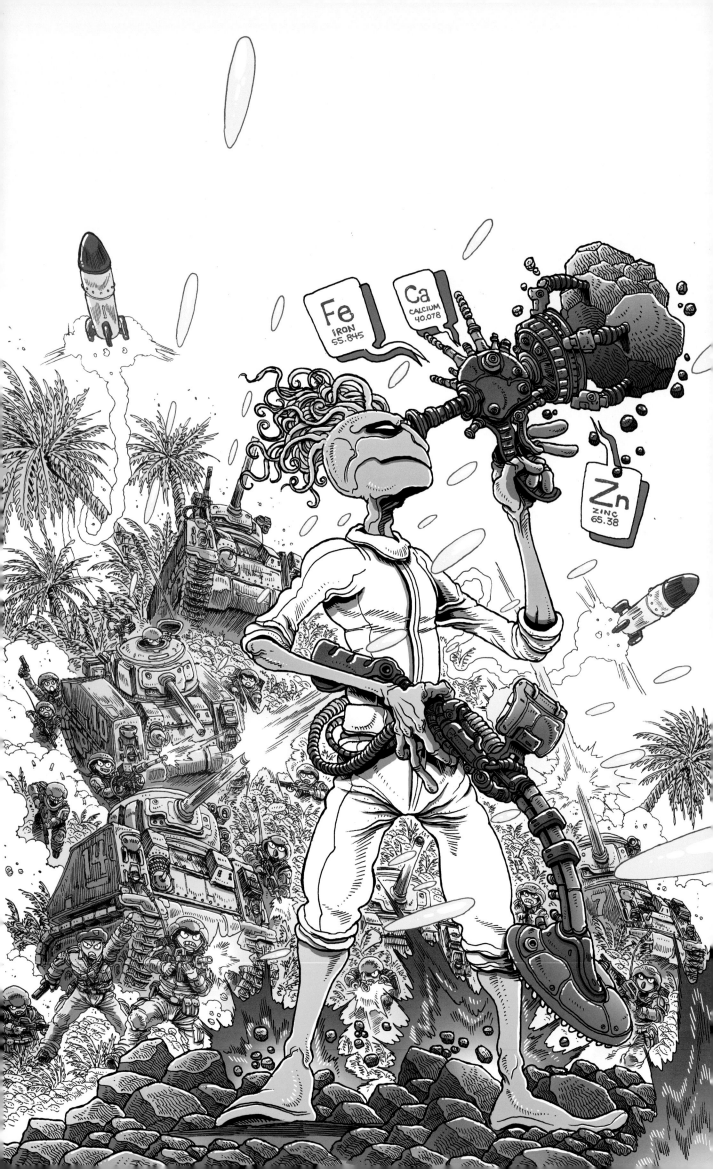

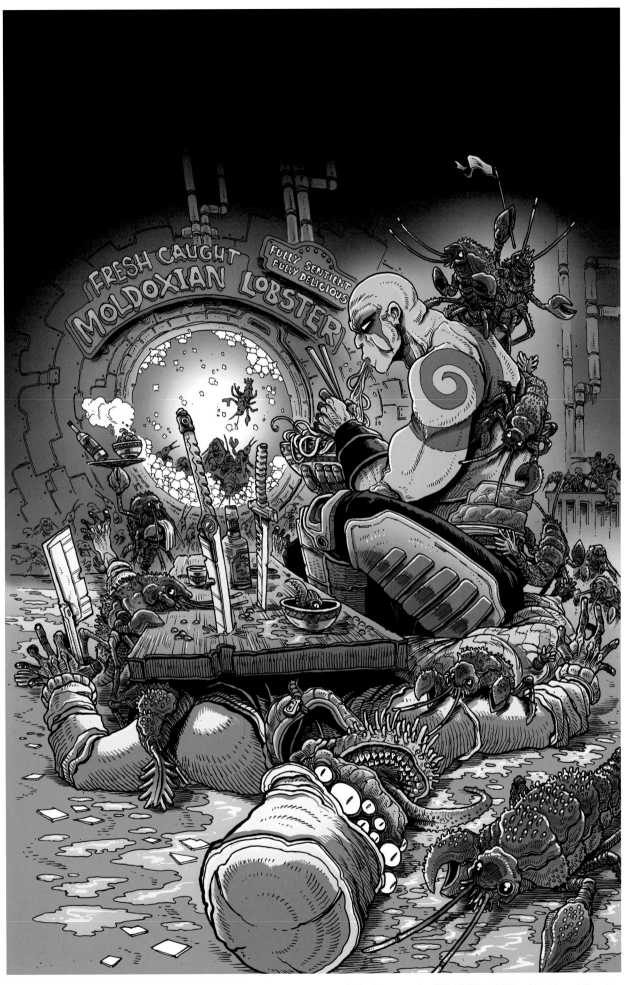

Left: Cover art for *Shield* #11, published by Marvel Comics.
2019 © Marvel.

Above: Cover art for *Drax* #2, published by Marvel Comics.
2019 © Marvel.

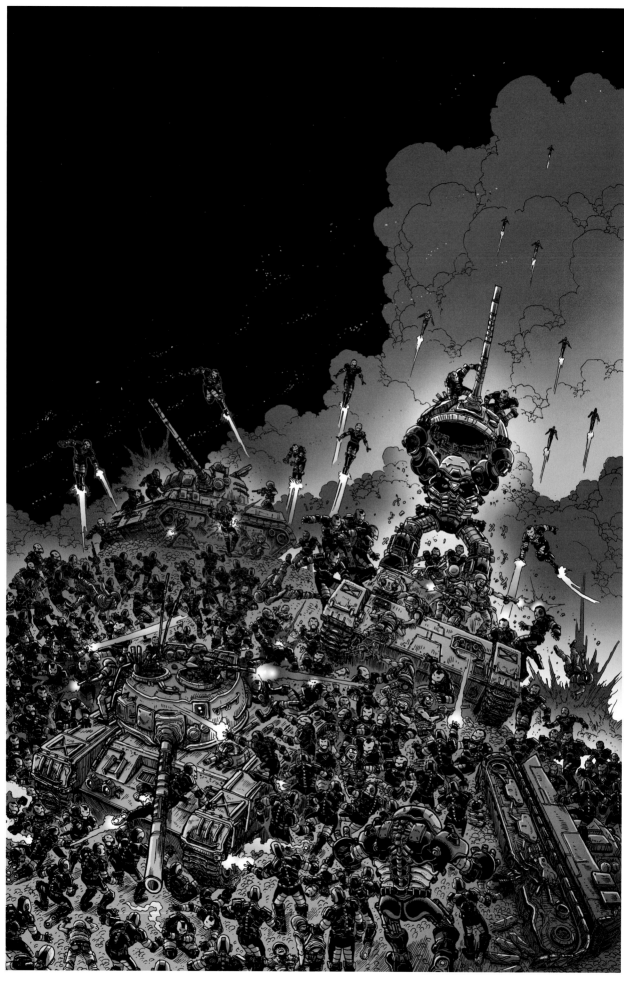

Cover art for *What If: Age of Ultron* #2, published by Marvel Comics.
2019 © Marvel.

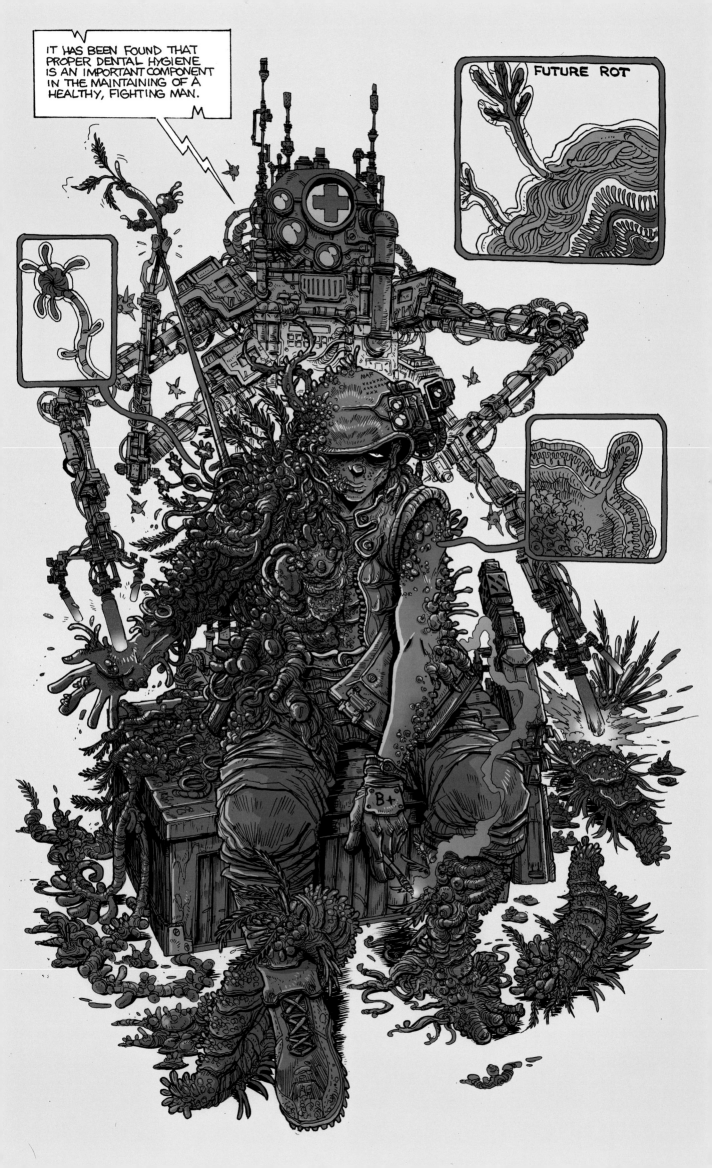

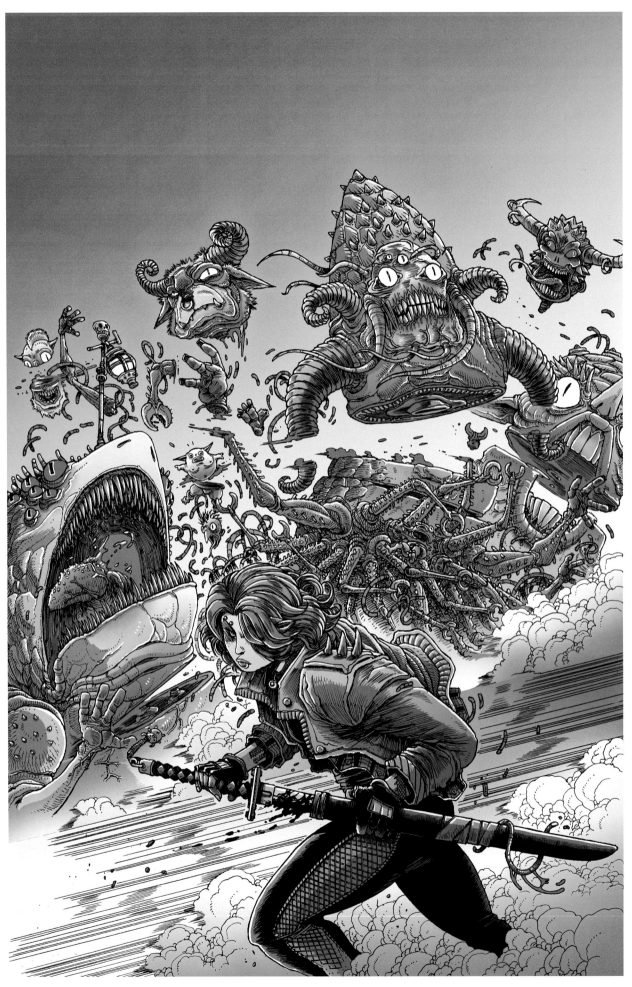

Calamity Kate © TM Magdalene Visaggio and Corin Howell .

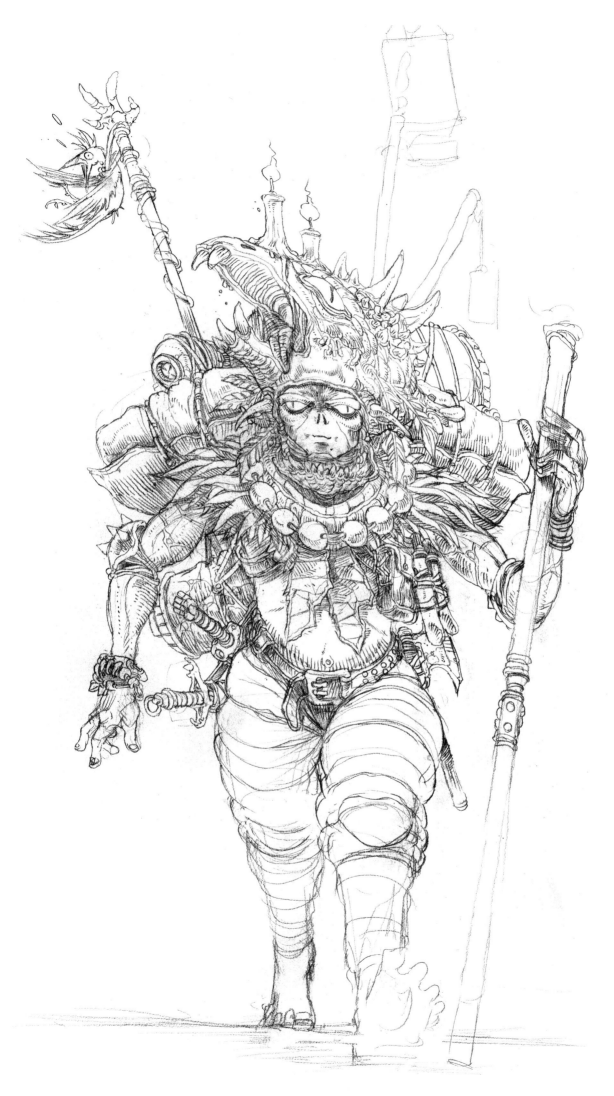

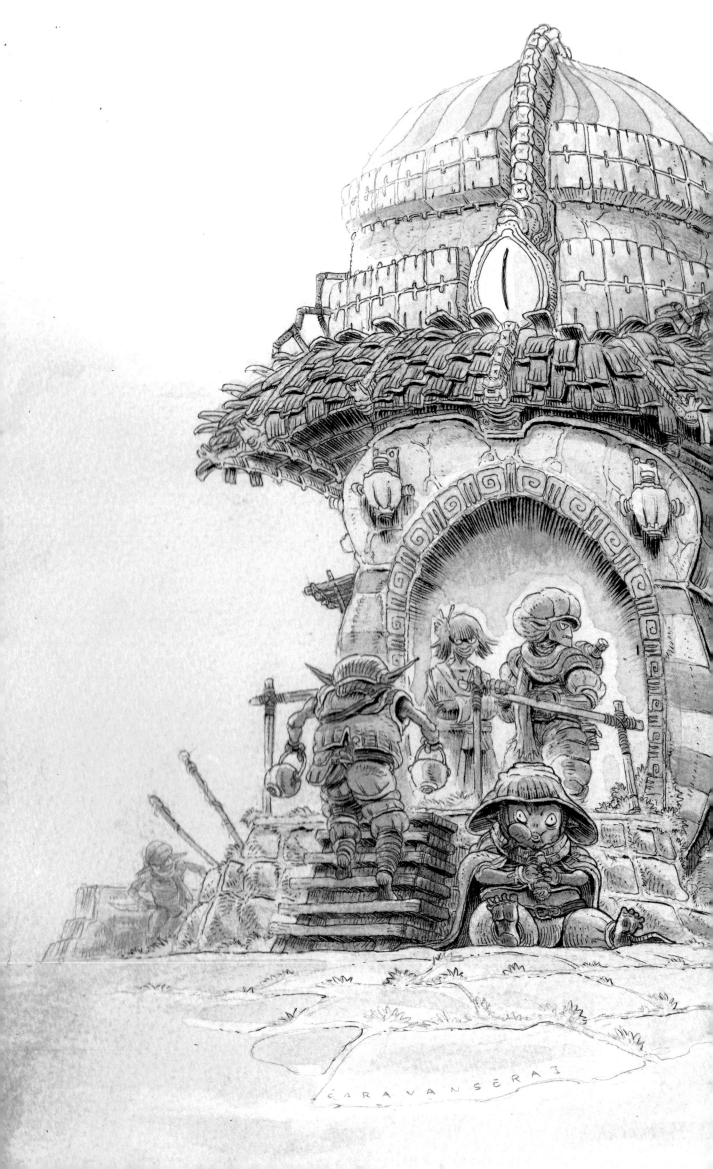

CARAVANSERAI

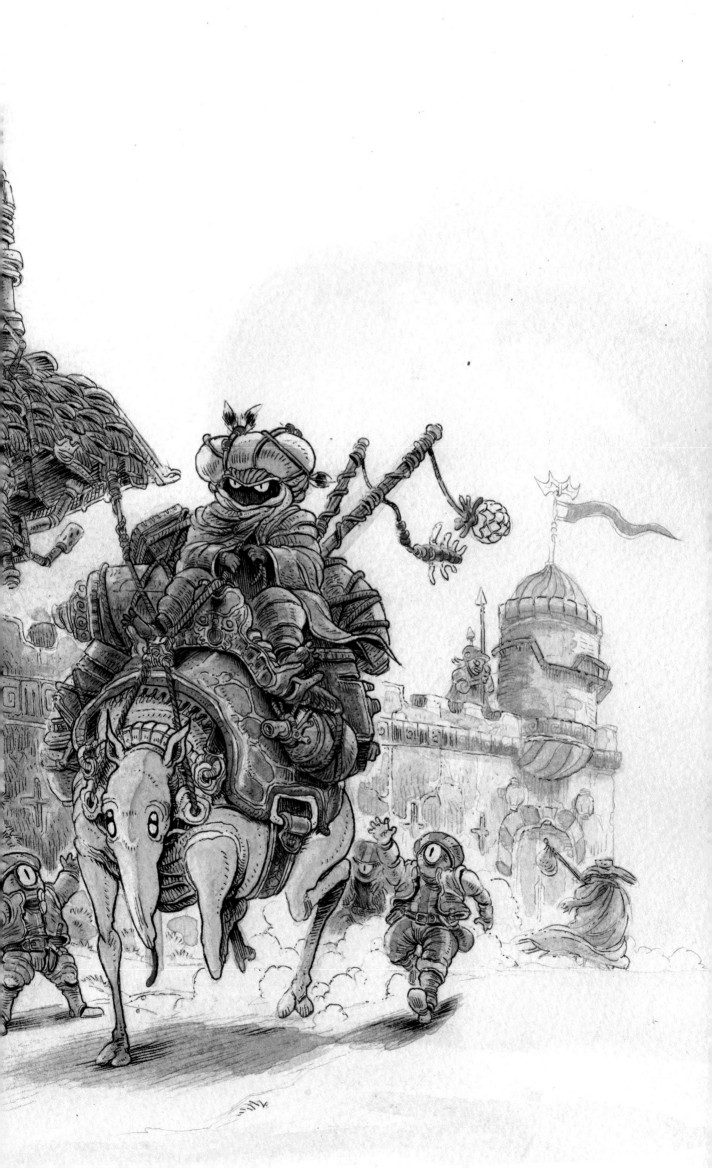

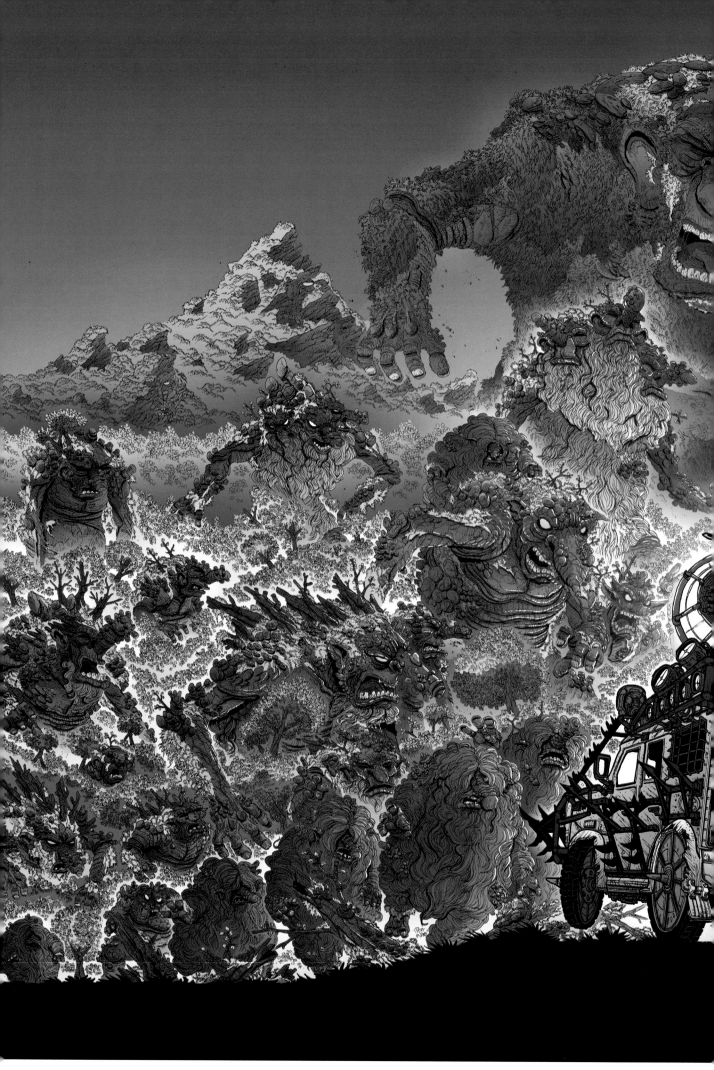

Promotional poster artwork for *Troll Hunter*.

© Filmkameratene AS.

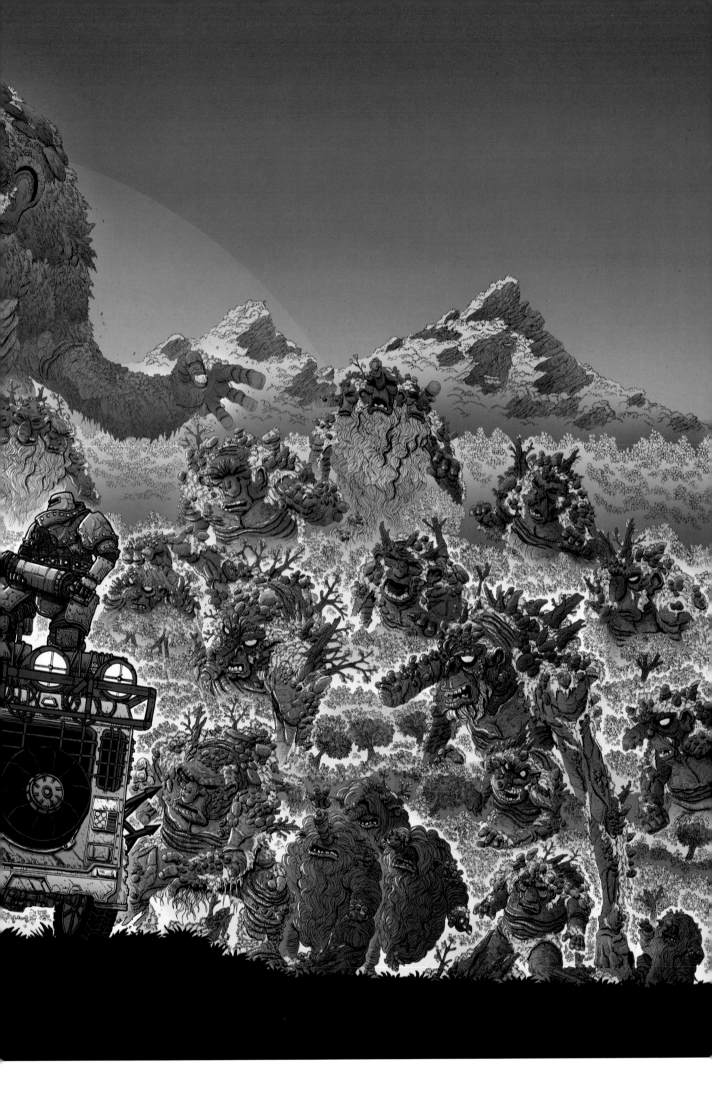

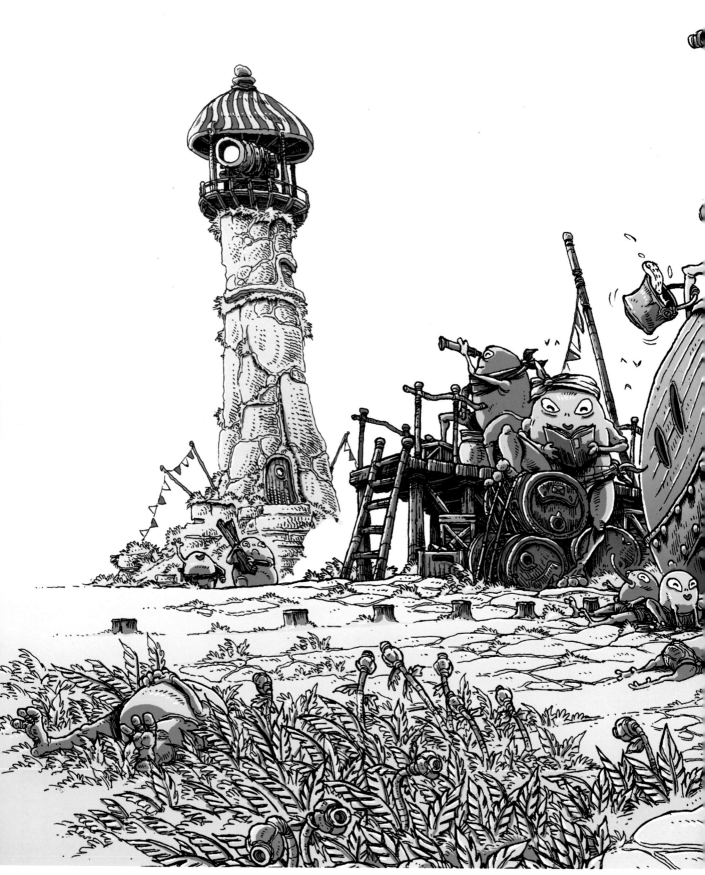

Comics 'n' Cola print.

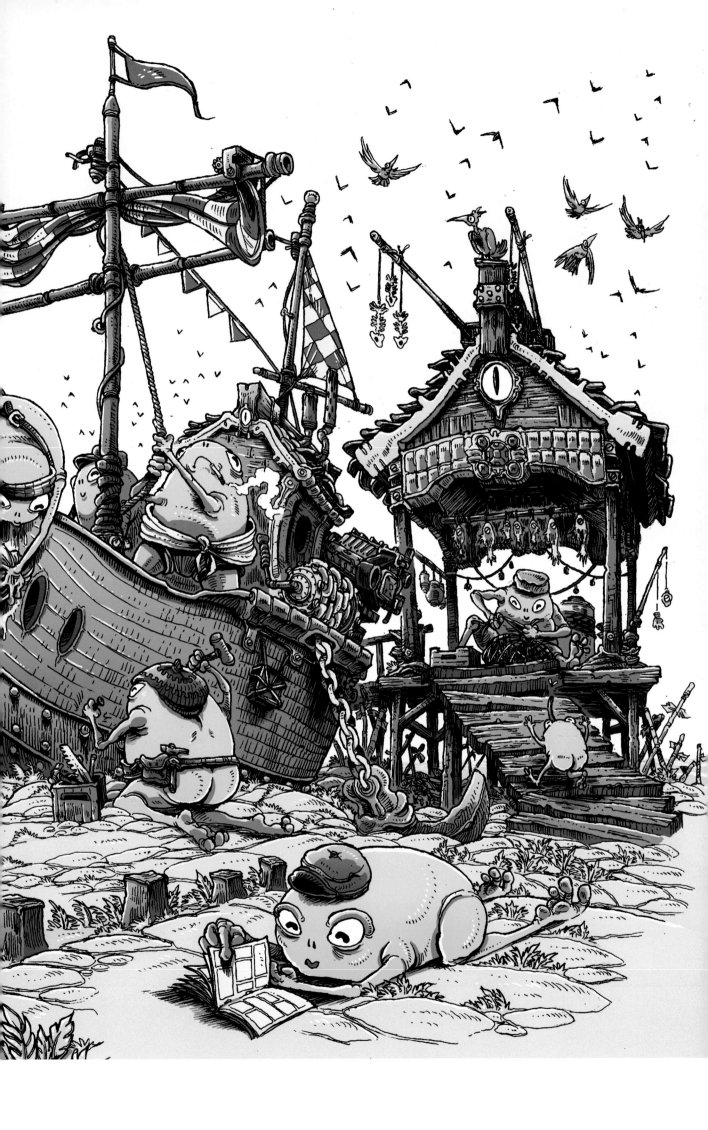

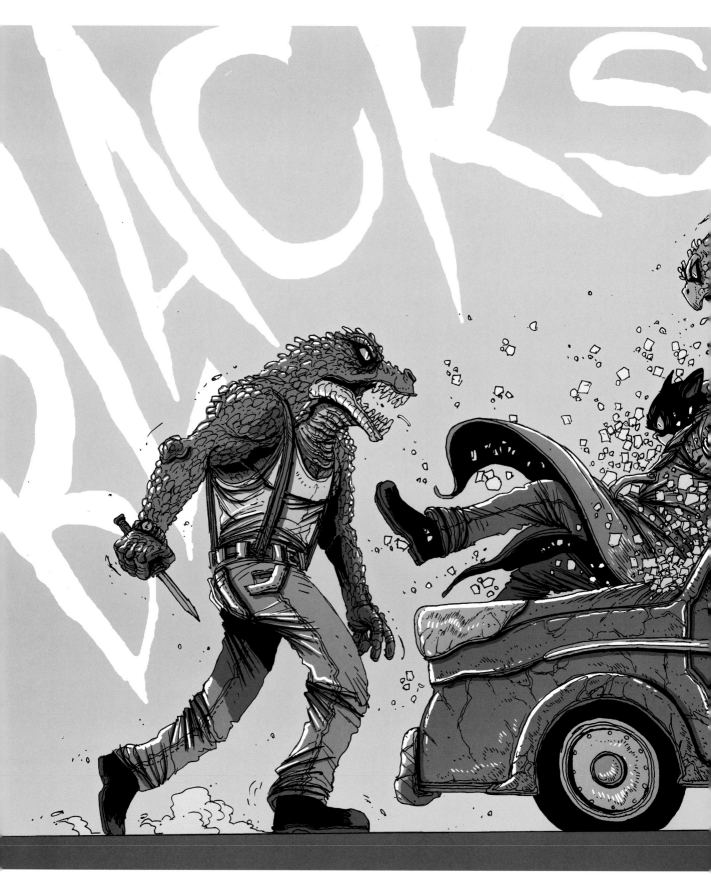

Blacksad fan art.
Blacksad © DARGAUD 2013, by Juan Diaz Canales and Juanjo Guarnido.

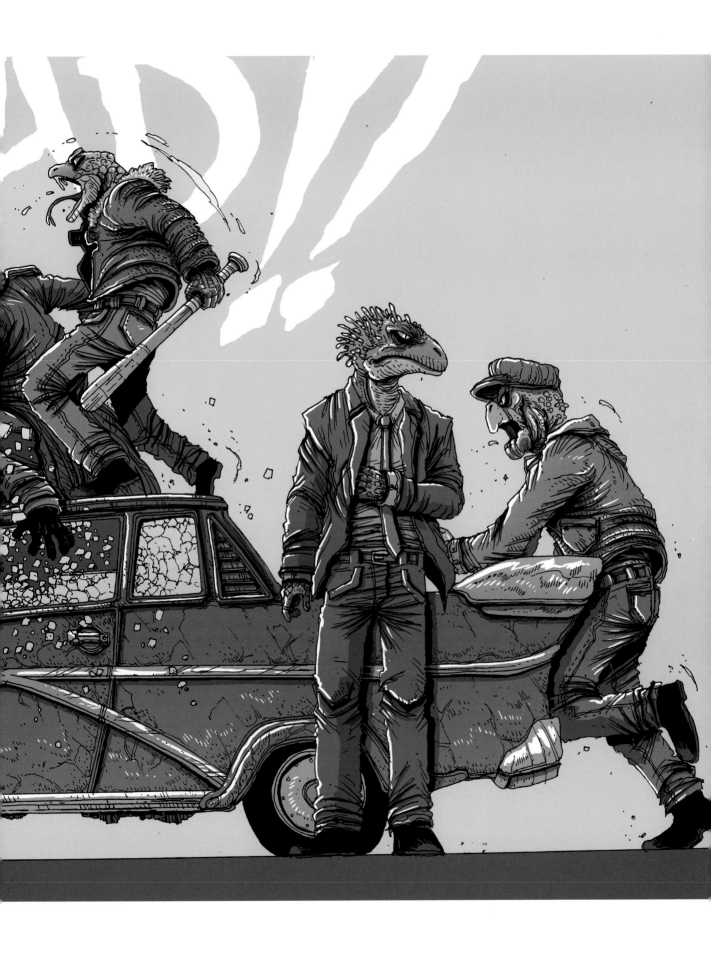

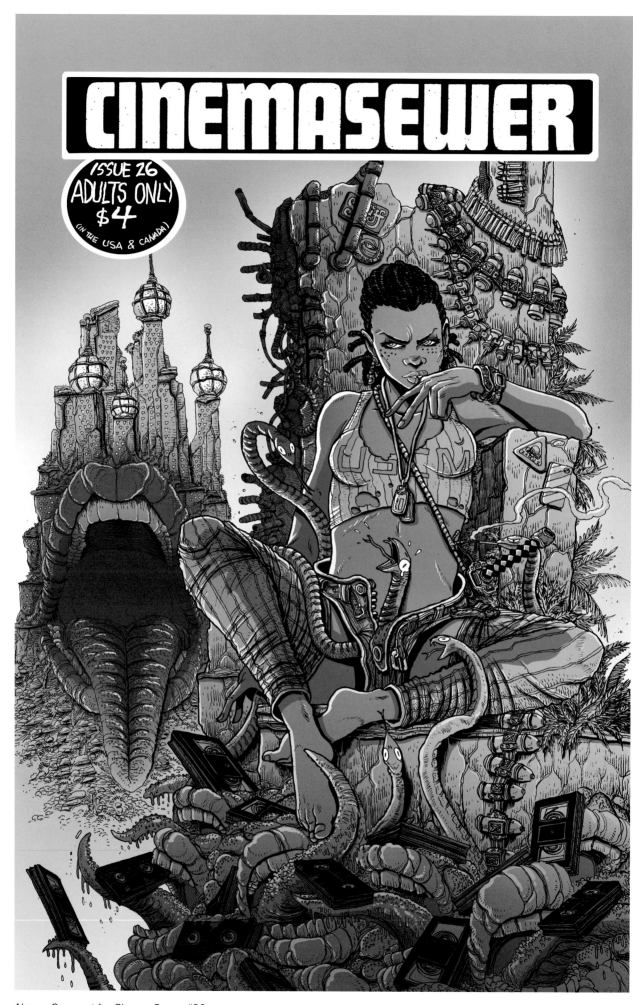

Above: Cover art for *Cinema Sewer* #26.
© Cinema Sewer 2018

Right: Poster art for Thought Bubble Comic Art Festival.

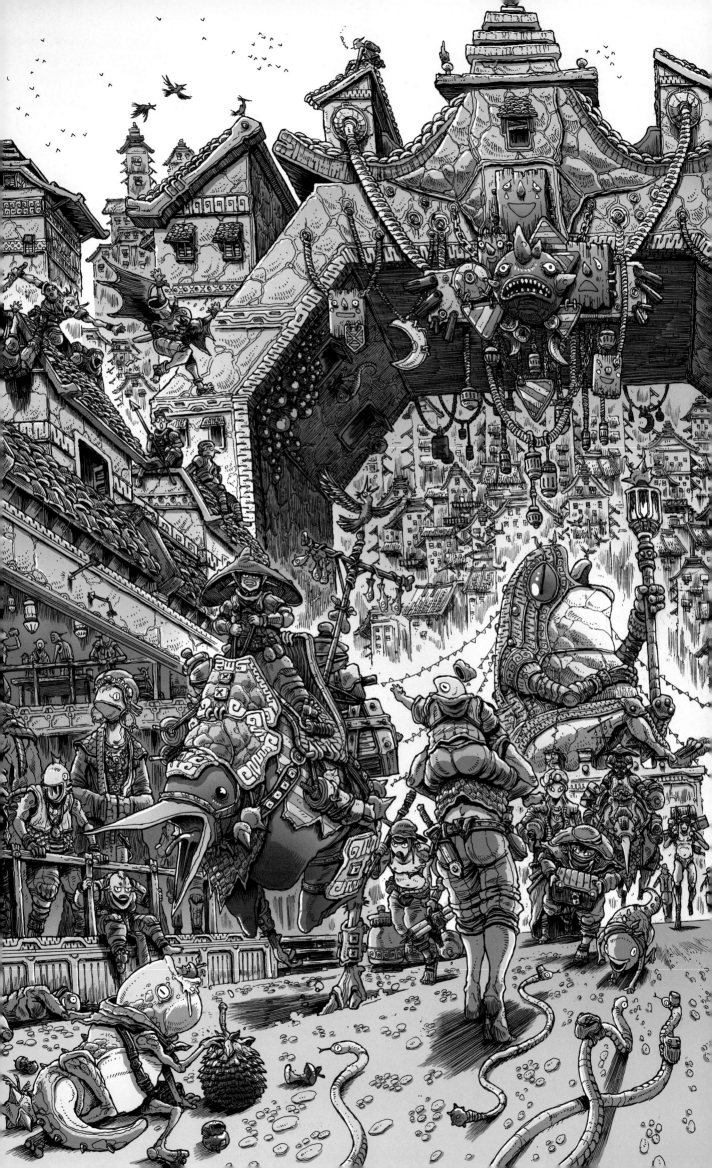

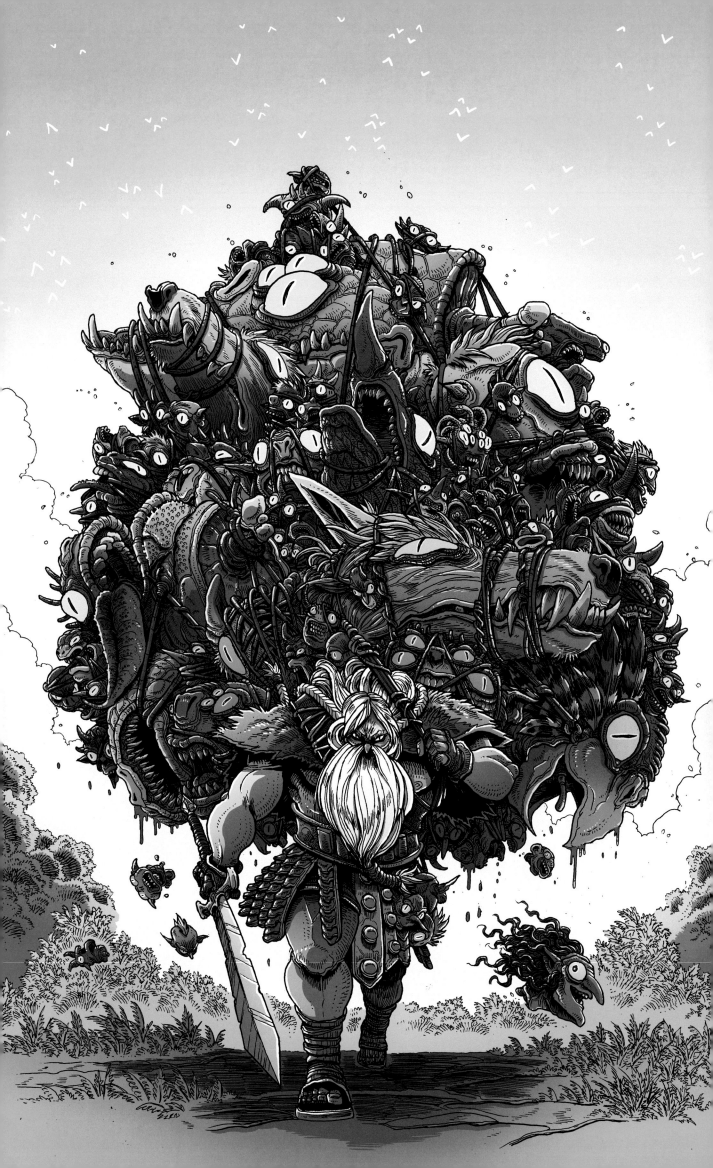

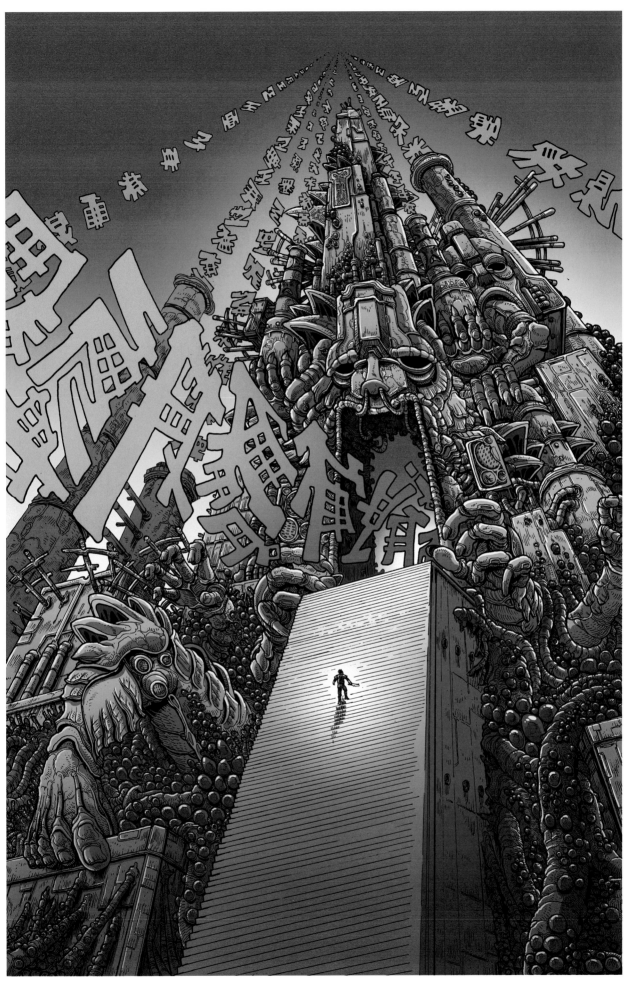

Left: Cover art for *Head Lopper* #3 by Andrew MacLean, published by Image Comics.

Above: Cover art for *Prophet* volume 4 by Brandon Graham, Simon Roy, and Giannis Milonogiannis, published by Image Comics.

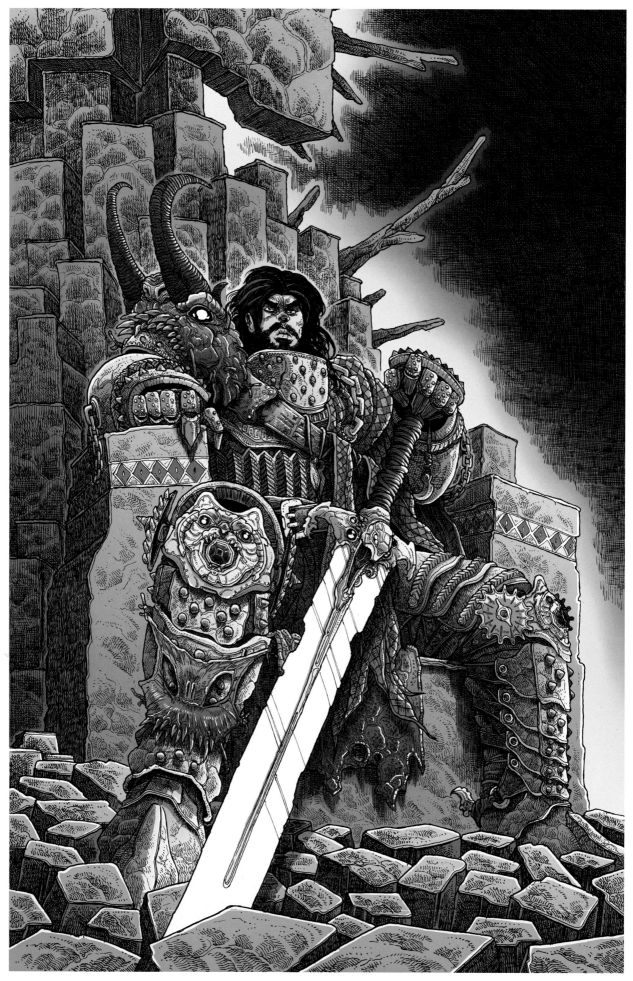

Above: Cover art for *Birthright* #15 by Joshua Williamson and Andrei Bressan, published by Skybound.
Birthright © 2019 Skybound, LLC

Right: Variant cover art for *Black Hammer: Age of Doom* #1 by Jeff Lemire and Dean Ormston, published by Dark Horse Comics.
Text and illustrations of *Black Hammer*™ © 2019 171 Studios, Inc. and Dean Ormston.

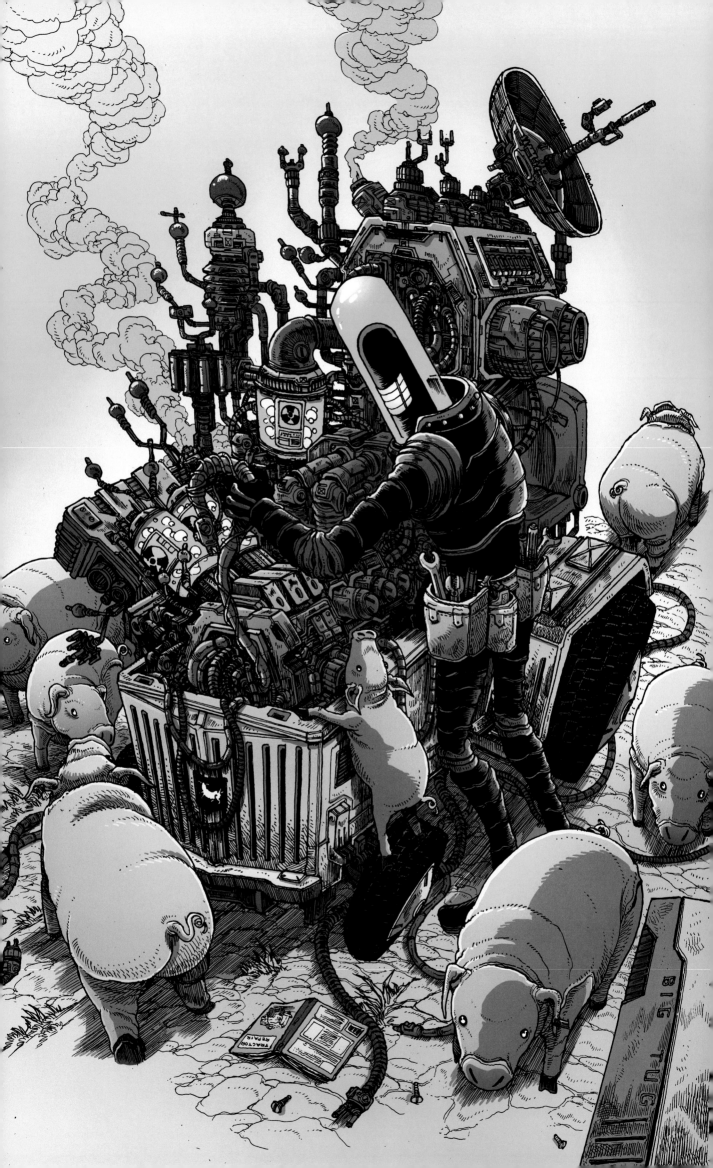

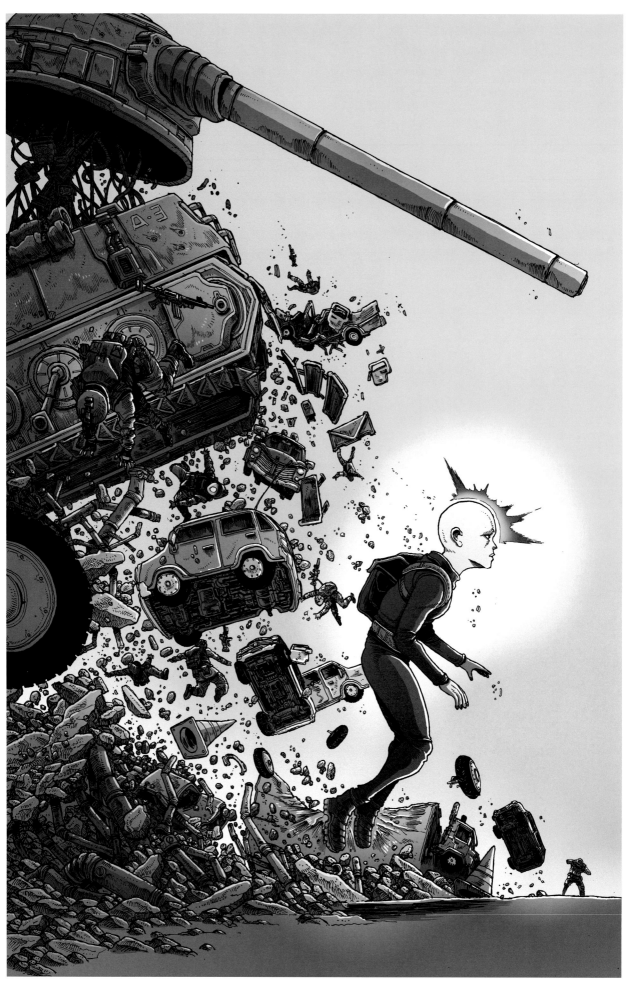

Above: Cover art for *2021* by Stephane Betbeder and Stephane Bervas, published by Titan Comics.
2021 © EDITIONS SOLEIL / BETBEDER / BERVAS

Right: Cover art for *Monstrosity II* by Phil McClorey.
© Phil McClorey

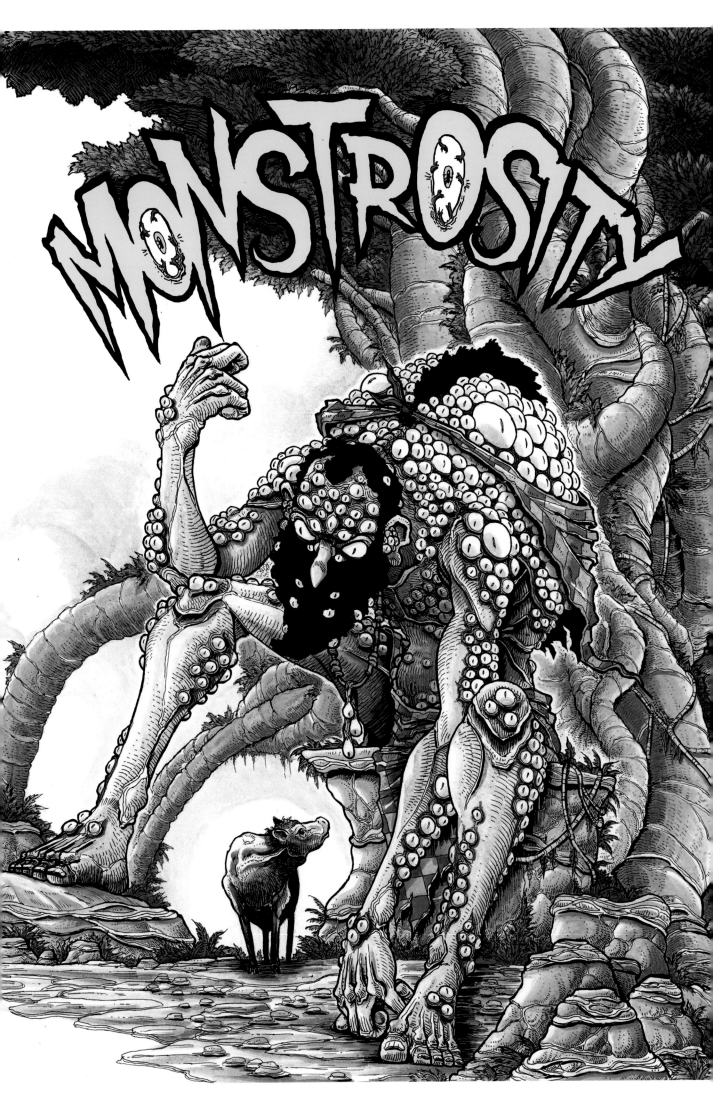

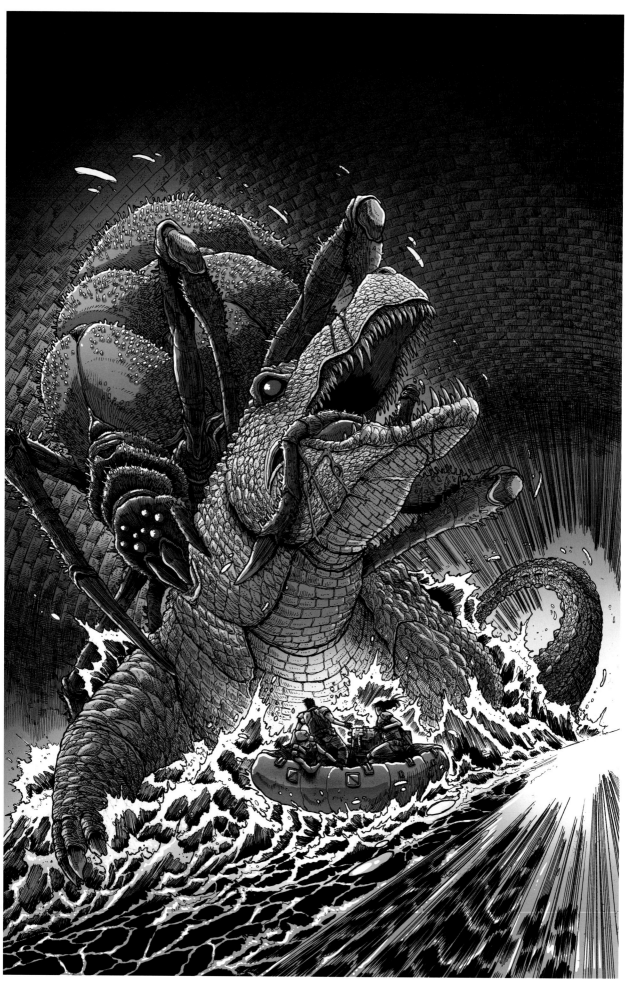

Cover art for *Under: Scourge of the Sewer* #1 and #2 by
Stefano Raffaele and Christophe Bec, published by Titan Comics.

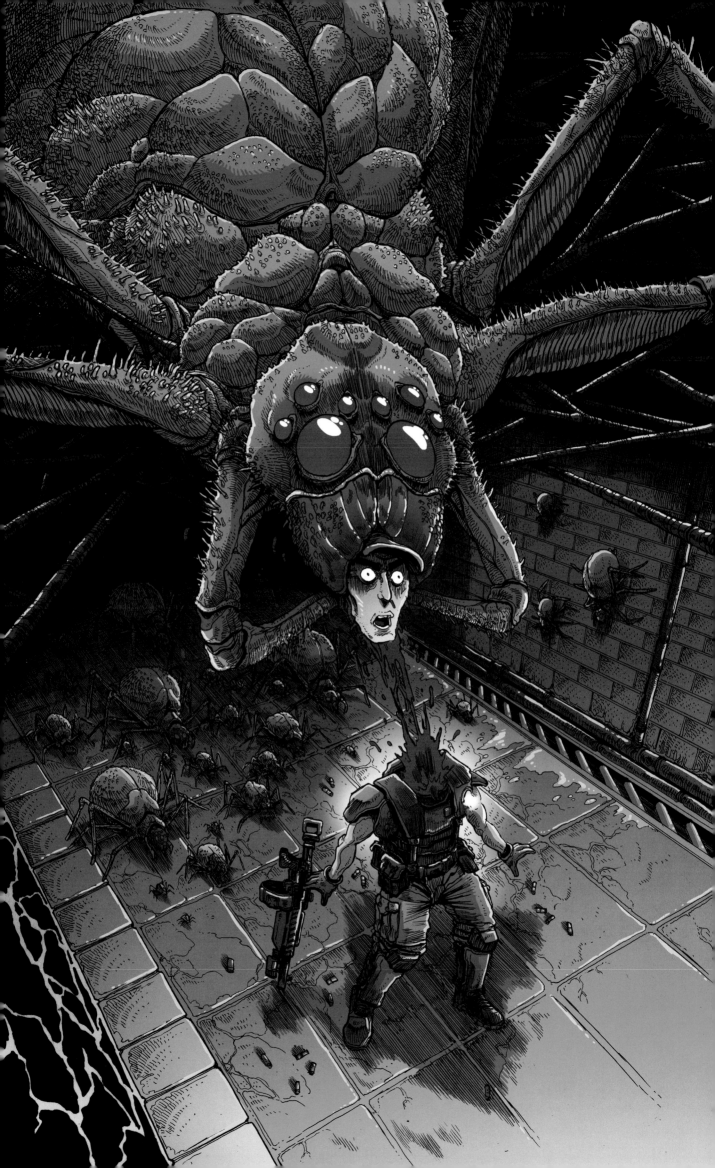

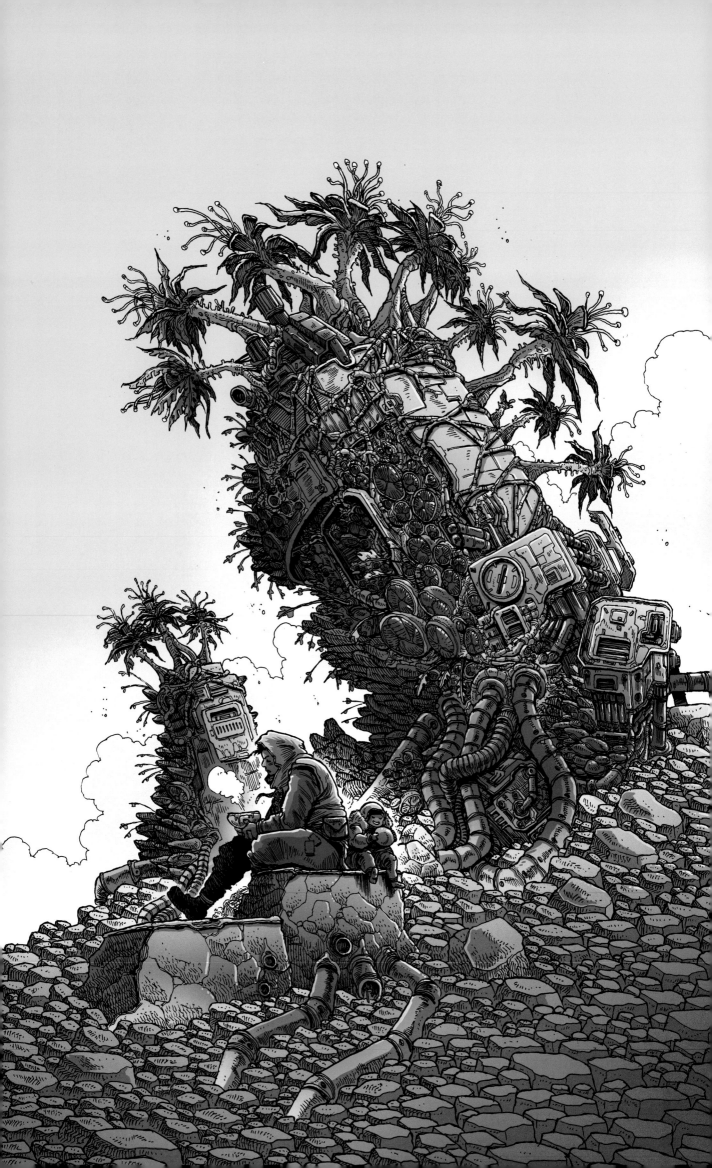

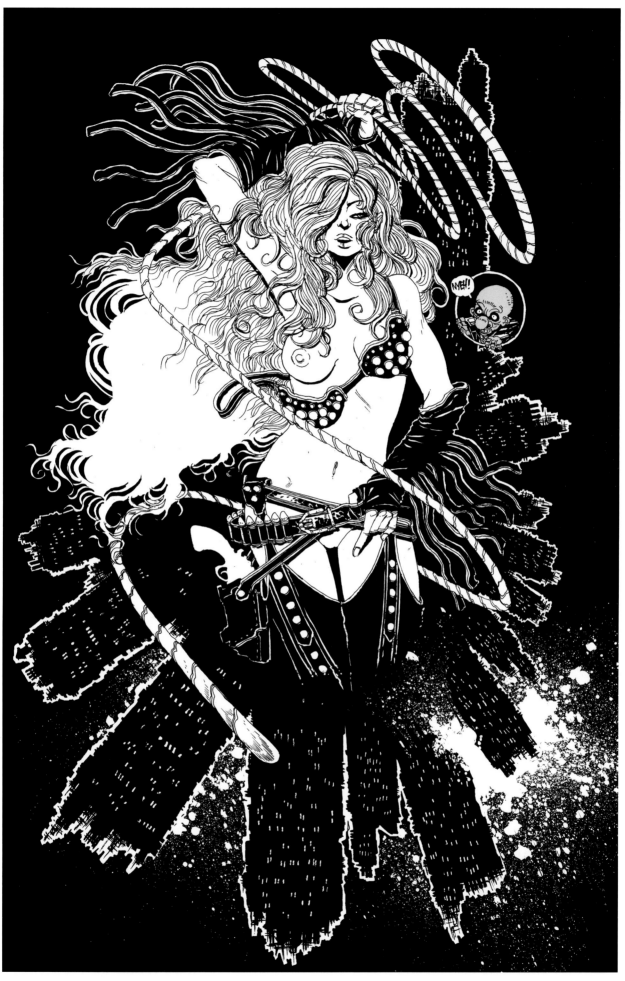

Left: Front cover art for *Cayrell's Ring* by Shannon Lentz.
Cayrell's Ring © 2019 Shannon Lentz

Above: Pinup fan art for Frank Miller's *Sin City*.
Sin City © 2019 Frank Miller, Inc.

Next page: The following pages feature unpublished comics by James Stokoe. The first six pages are from a story called *The Calling*.

THE CA

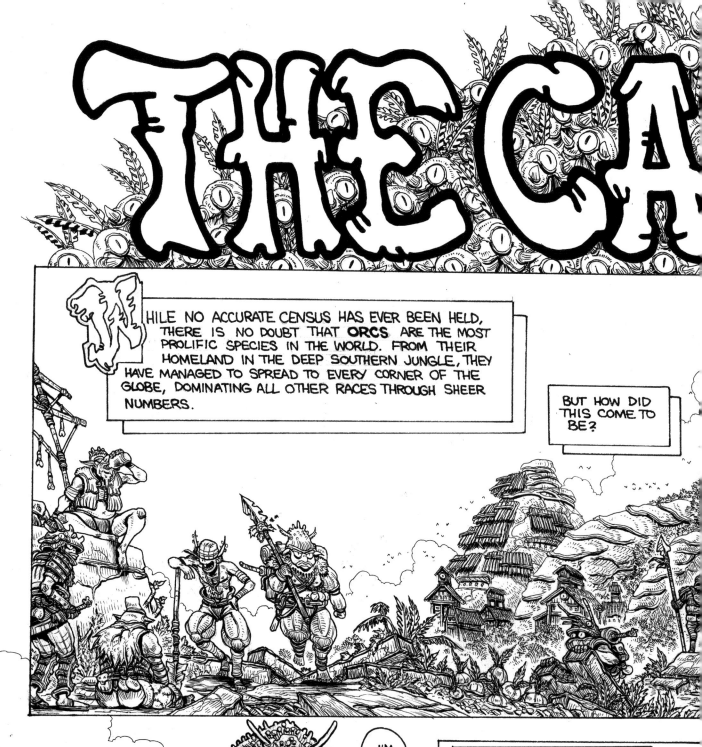

W HILE NO ACCURATE CENSUS HAS EVER BEEN HELD, THERE IS NO DOUBT THAT **ORCS** ARE THE MOST PROLIFIC SPECIES IN THE WORLD. FROM THEIR HOMELAND IN THE DEEP SOUTHERN JUNGLE, THEY HAVE MANAGED TO SPREAD TO EVERY CORNER OF THE GLOBE, DOMINATING ALL OTHER RACES THROUGH SHEER NUMBERS.

BUT HOW DID THIS COME TO BE?

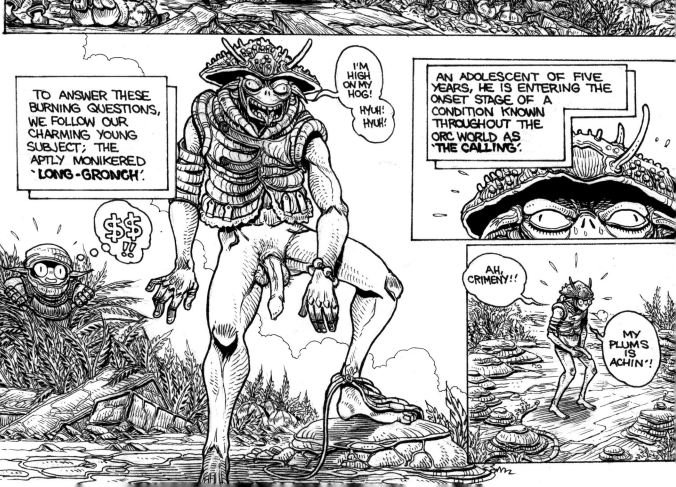

TO ANSWER THESE BURNING QUESTIONS, WE FOLLOW OUR CHARMING YOUNG SUBJECT; THE APTLY MONIKERED `LONG-GRONCH`.

$$!!

I'M HIGH ON MY HOG!

HYUH! HYUH!

AN ADOLESCENT OF FIVE YEARS, HE IS ENTERING THE ONSET STAGE OF A CONDITION KNOWN THROUGHOUT THE ORC WORLD AS `THE CALLING`.

AH, CRIMENY!!

MY PLUMS IS ACHIN`!

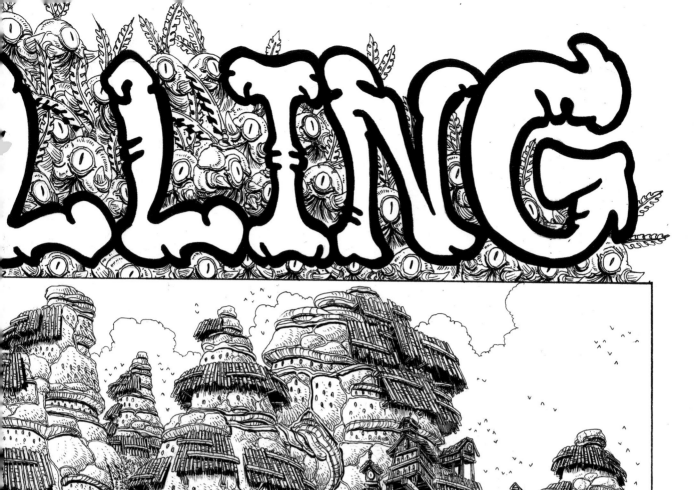

ORCS SHARE A REMARKABLY VIOLENT AND WARLIKE CULTURE, CERTAINLY THIS WOULD KEEP THEIR POPULATION LOW? WHERE ARE ALL THE FEMALE ORCS? WHY HAVEN'T WE EVER SEEN ANY ORCISH BABIES?

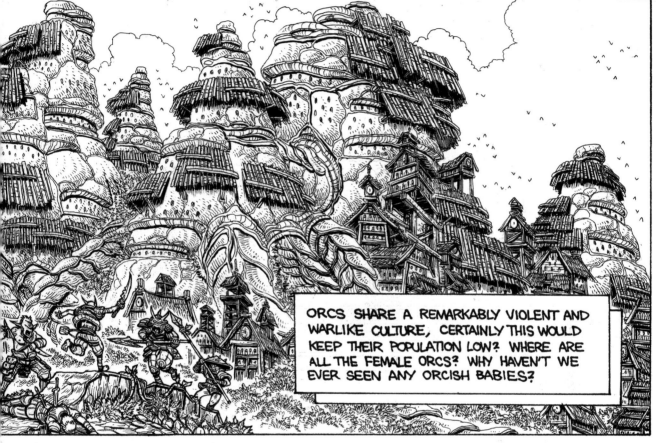

LONG-GRONCH HAS RECENTLY FELT AN UNCONTROLLABLE URGE TO BREAK AWAY FROM THE MOB AND VENTURE OUT IN SEARCH OF A BIT OF SOLITUDE...

OI? WHERE ARE YOU OFF TO, FLOOR-SCRAPER?

I'M TAKIN' IT FOR A WALK!

HYUH! HYUH!

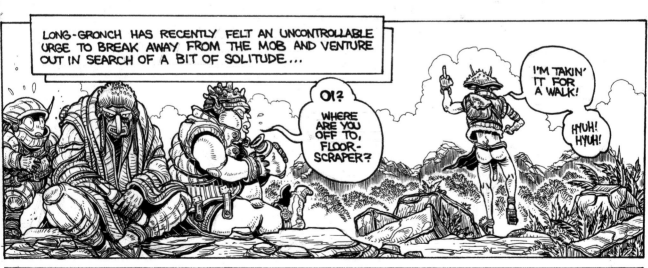

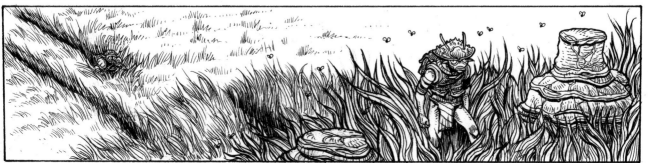

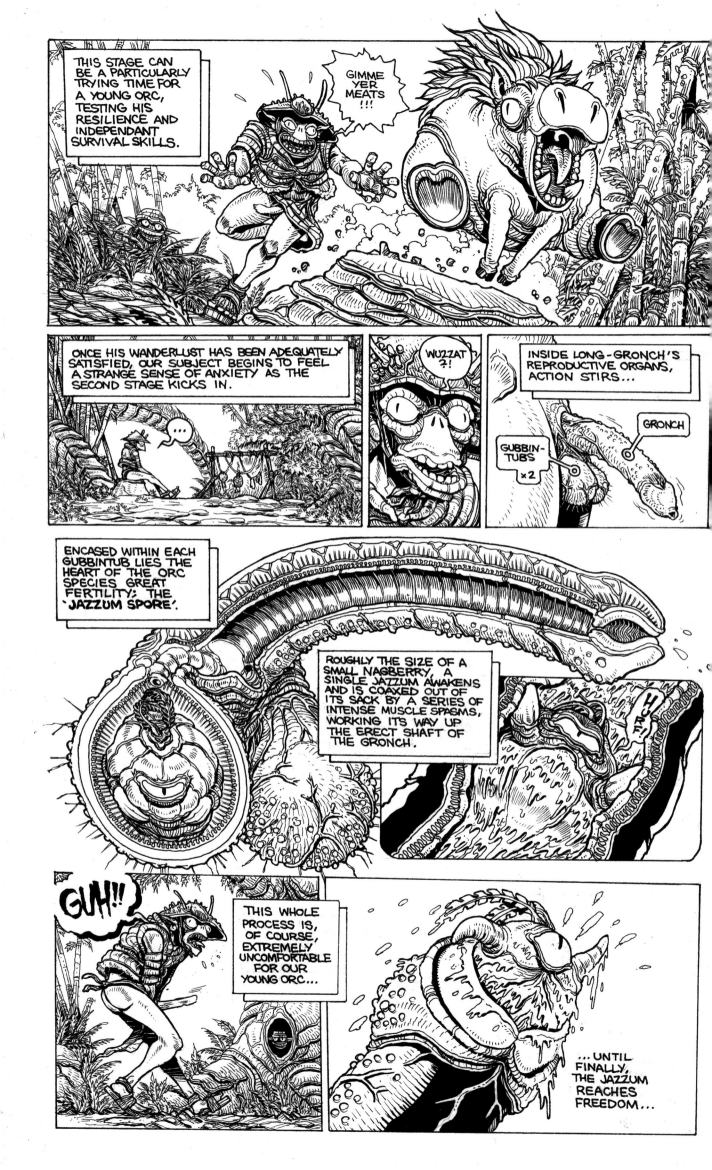

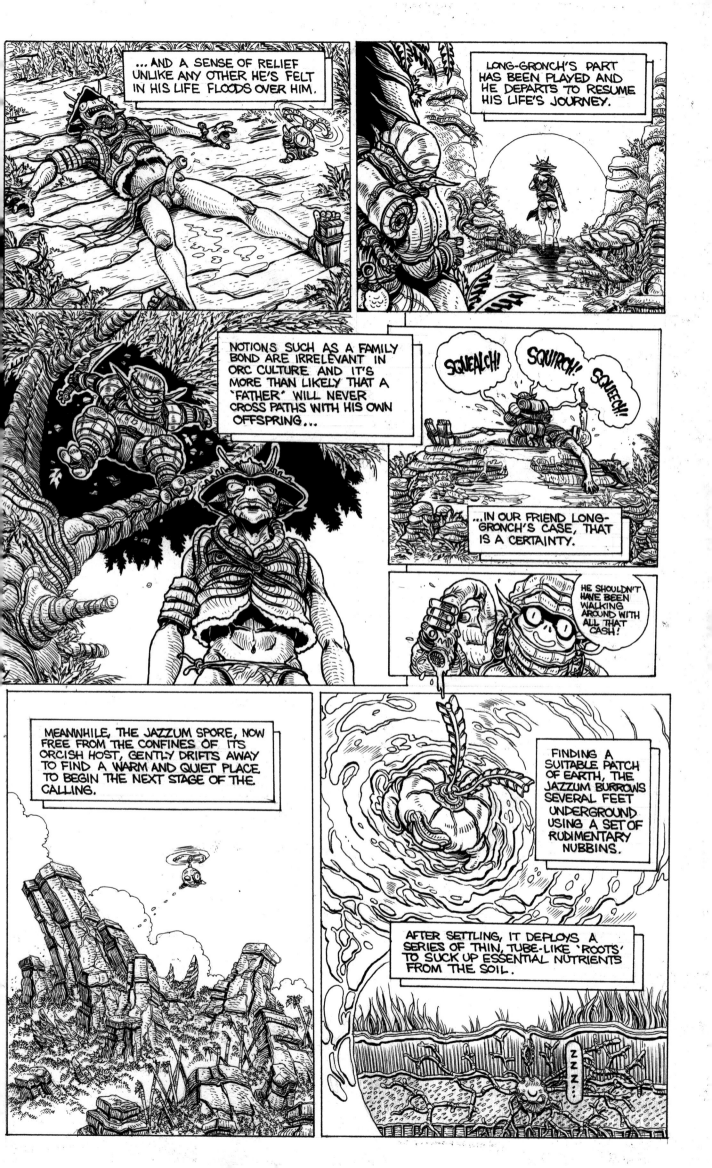

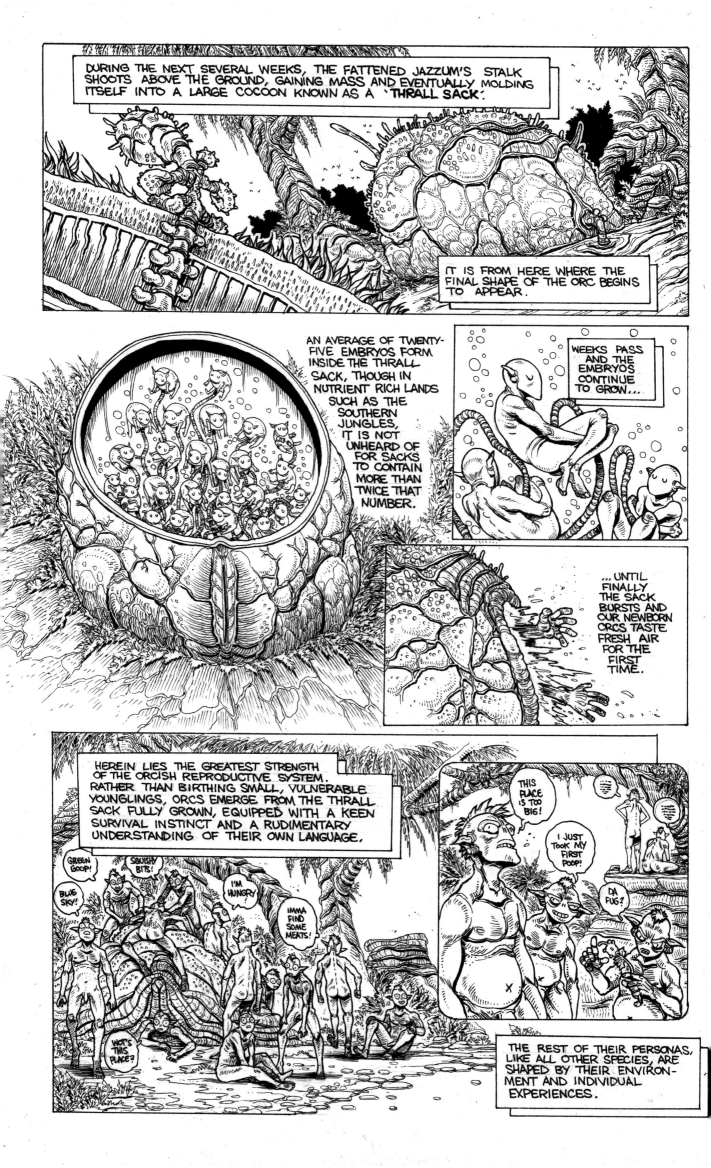

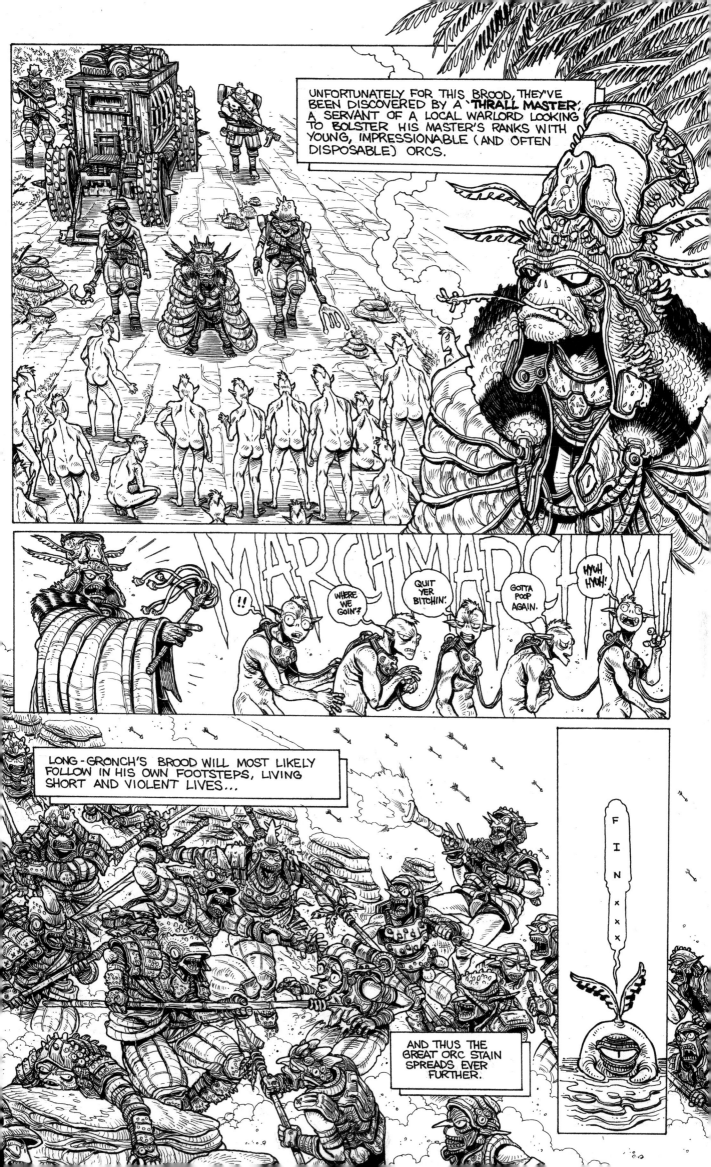

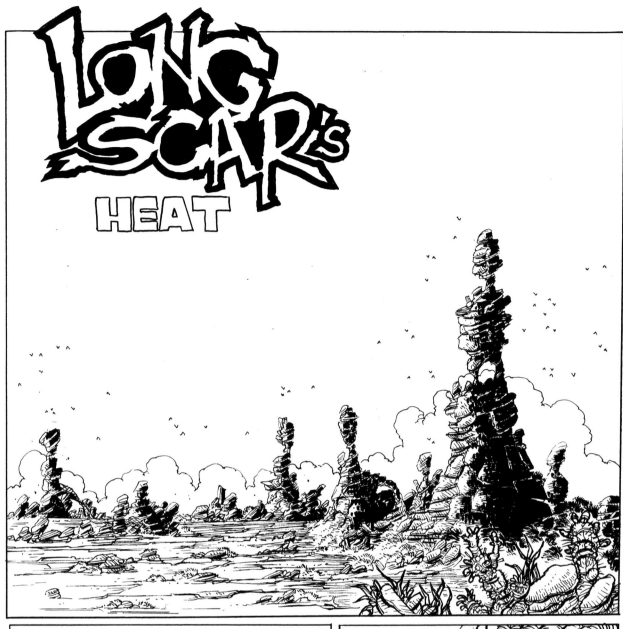

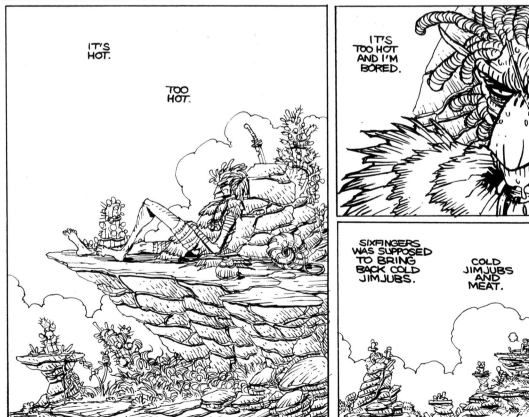

These two pages are from a story called *Long Scar's Heat*.

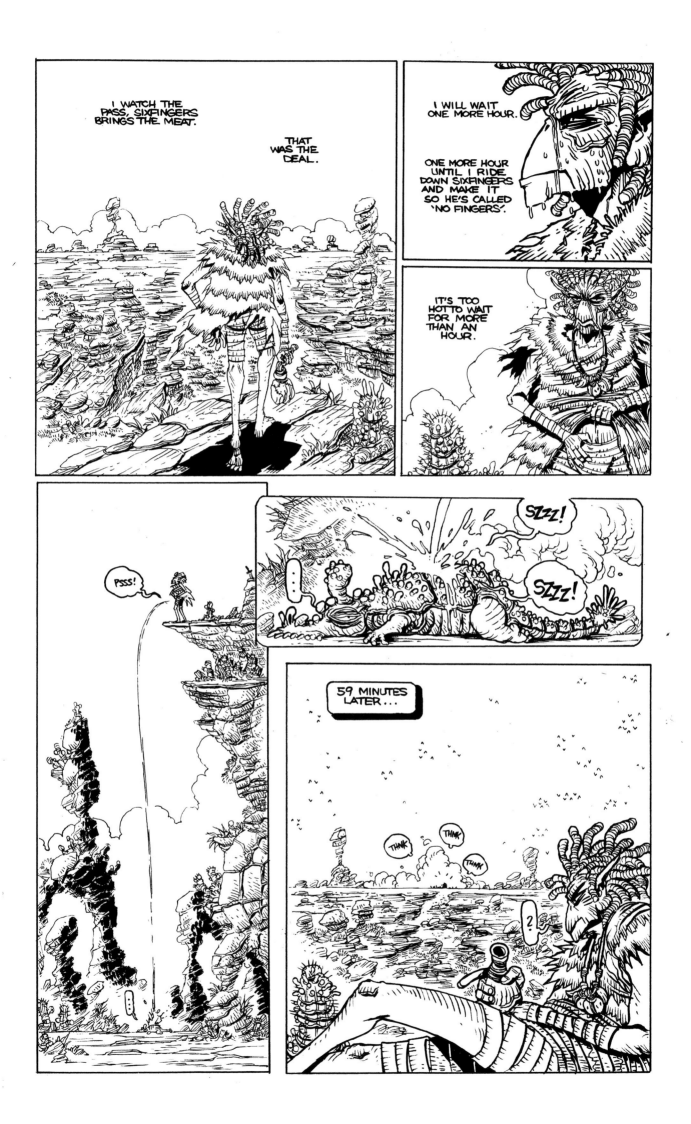

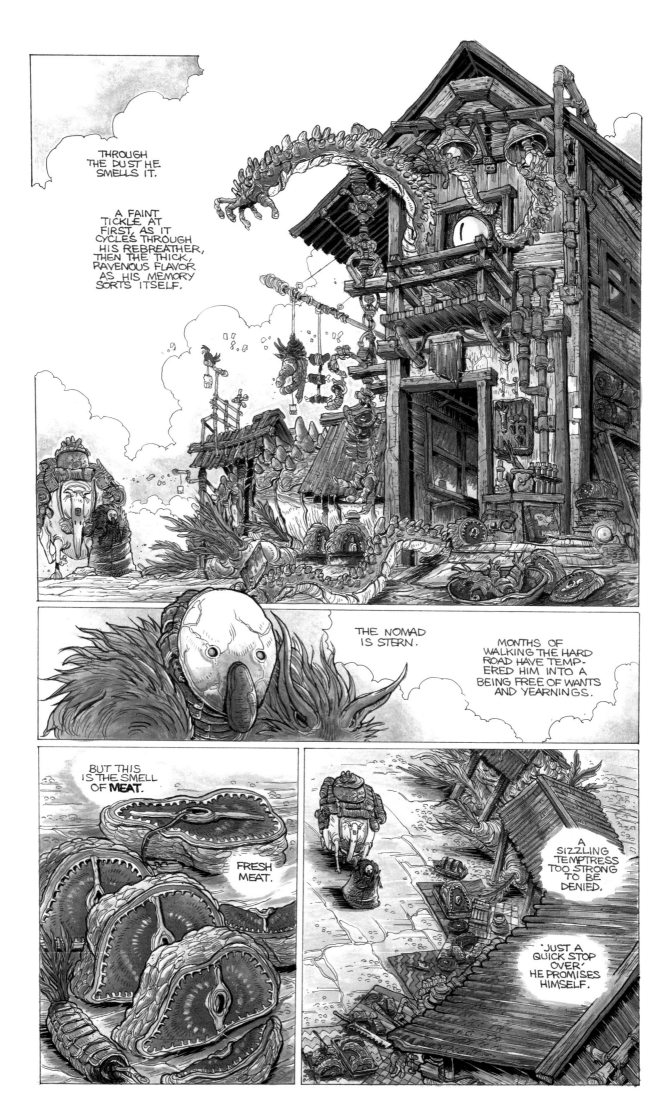

These four pages are from a story called *Nomad of the Domes*.

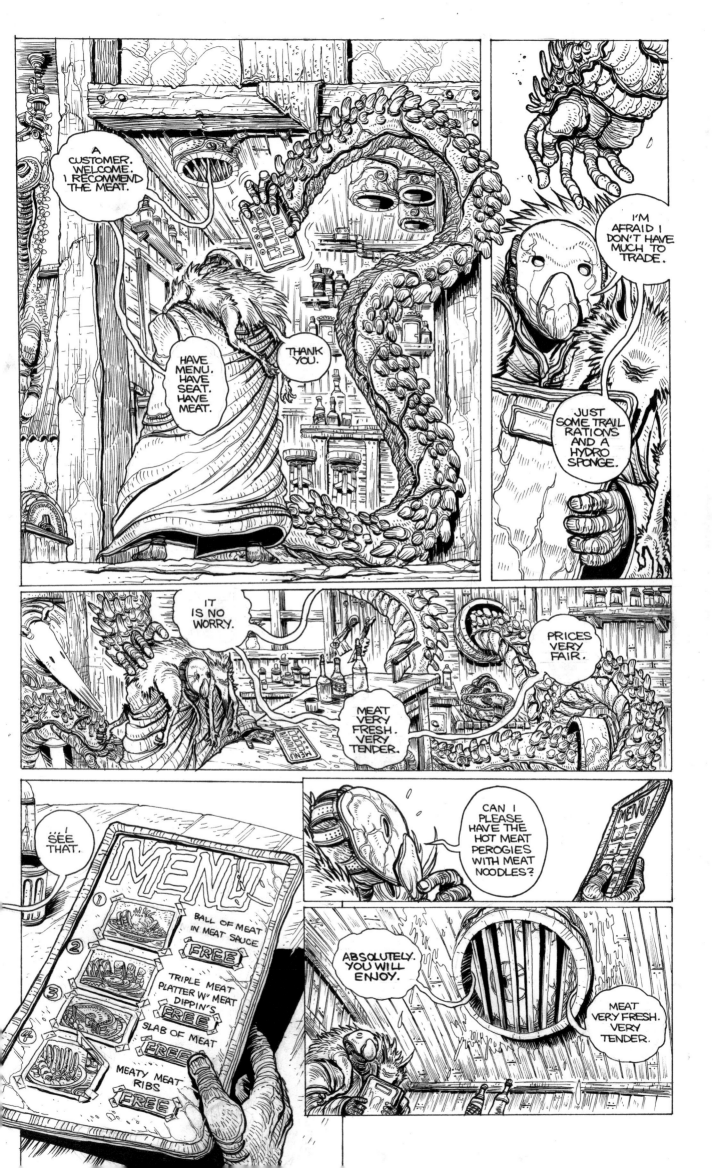

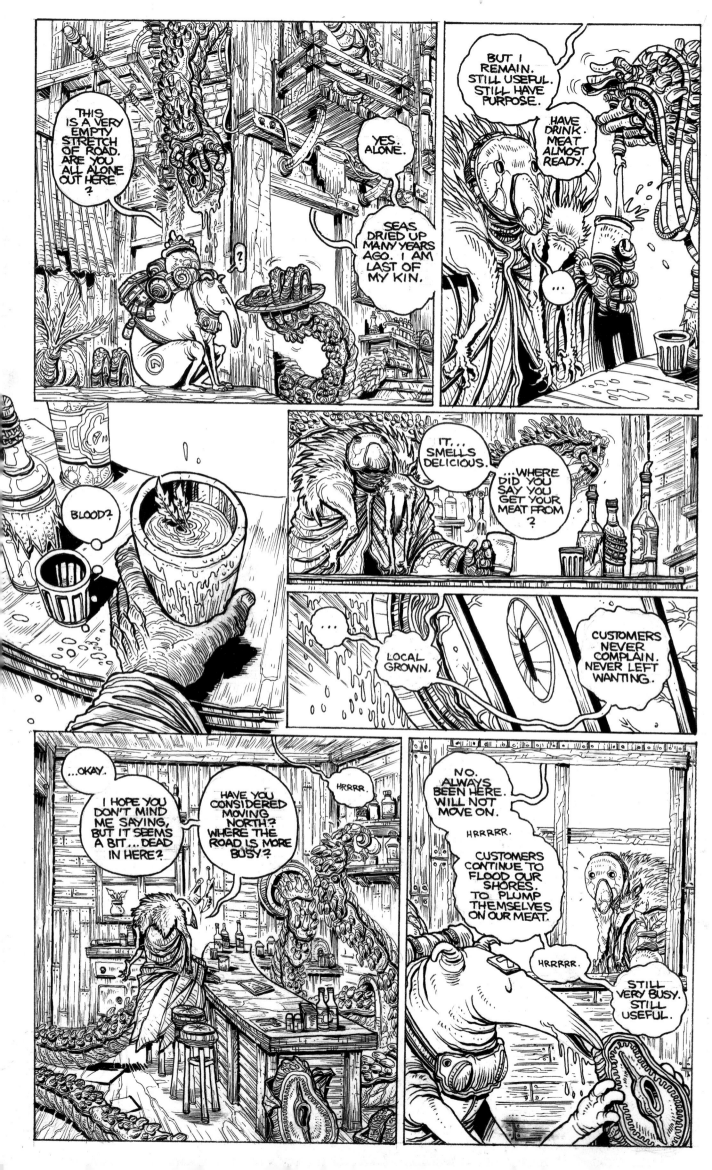

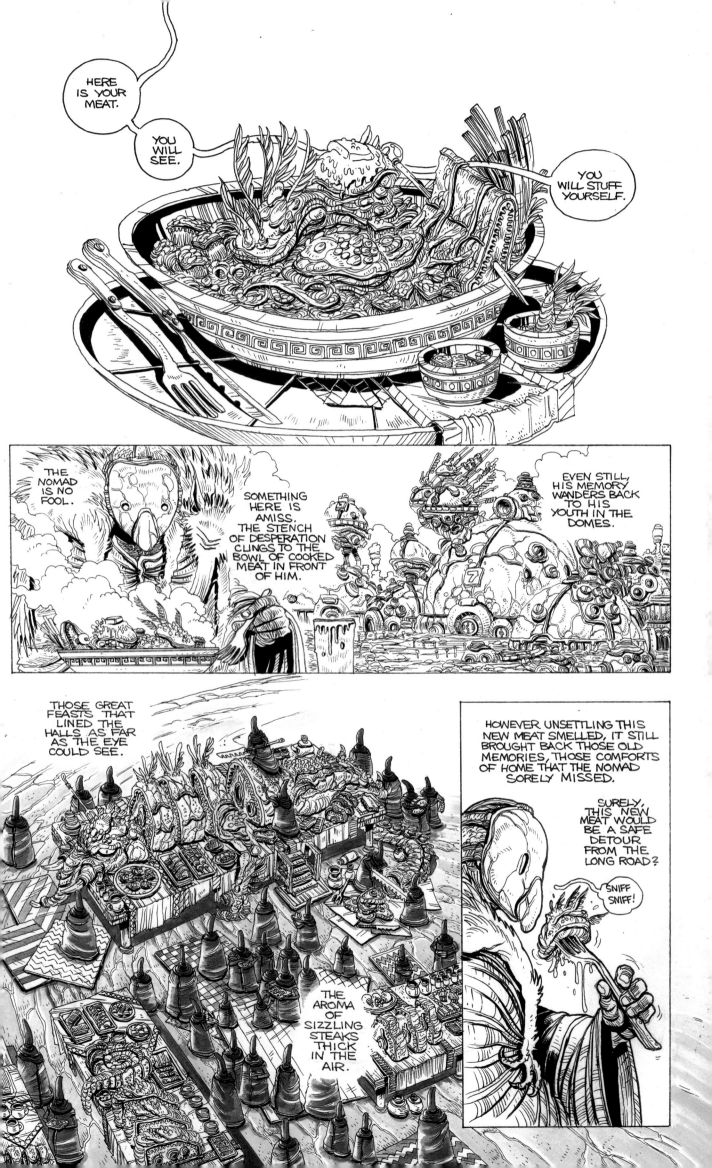

These pages are from the unpublished comic called *Fire for Effect*.

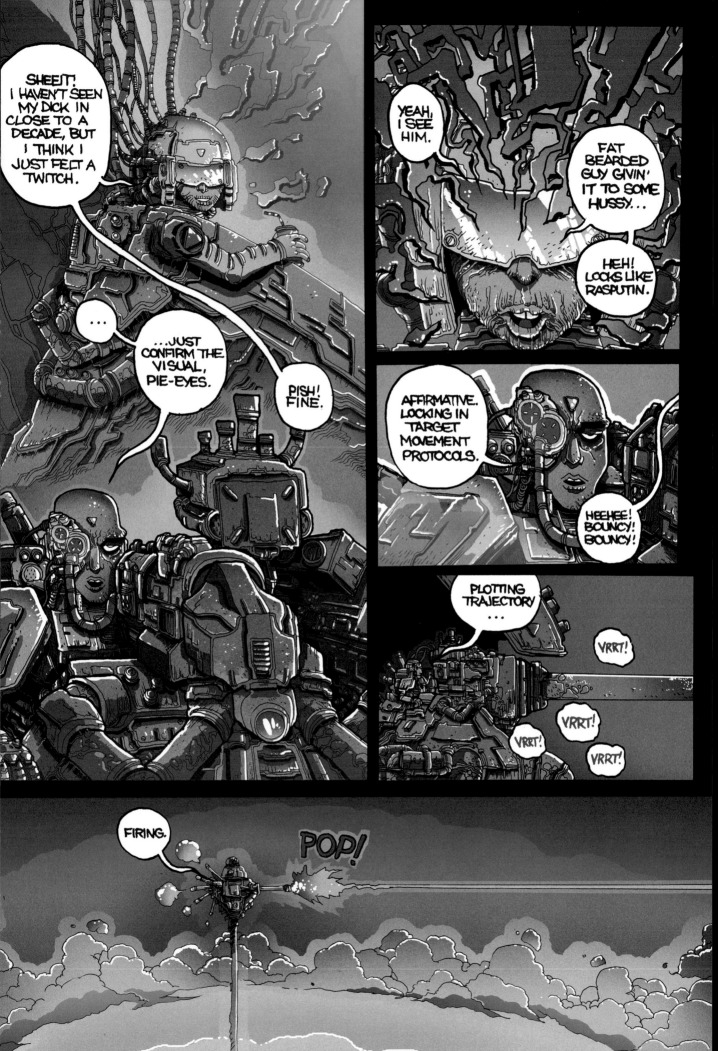

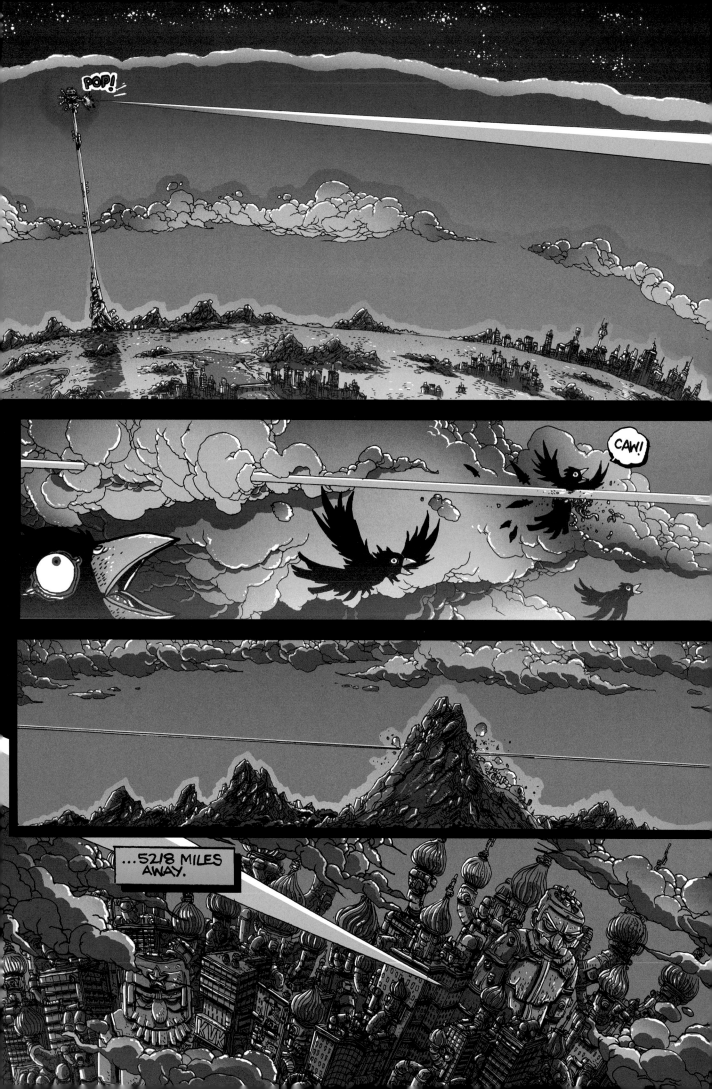

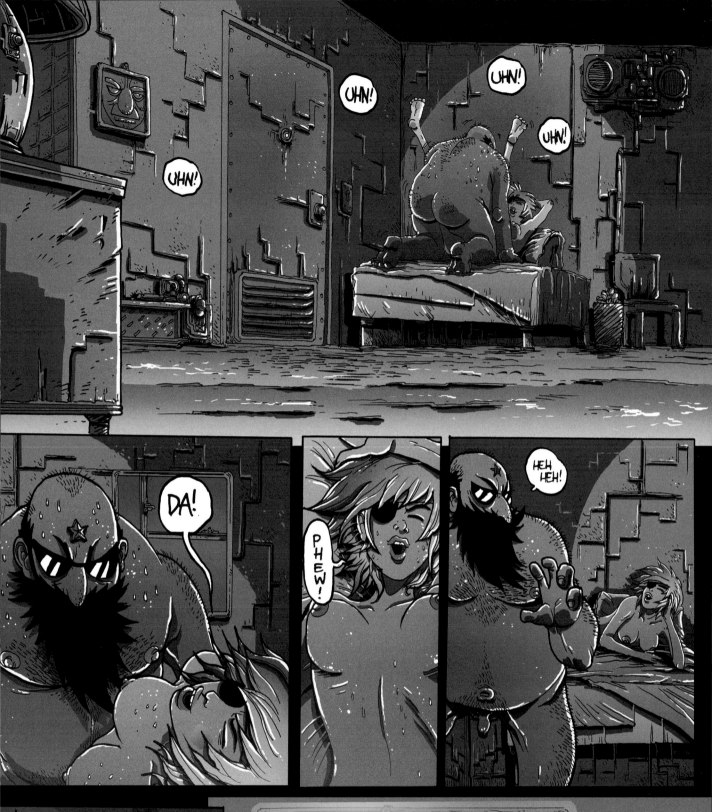

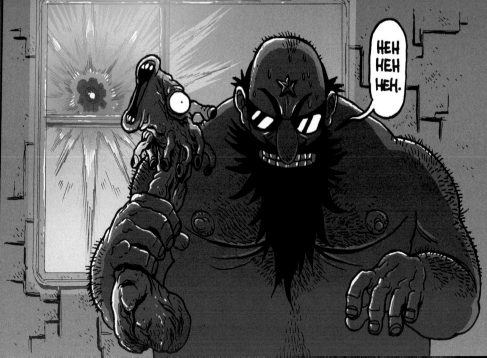

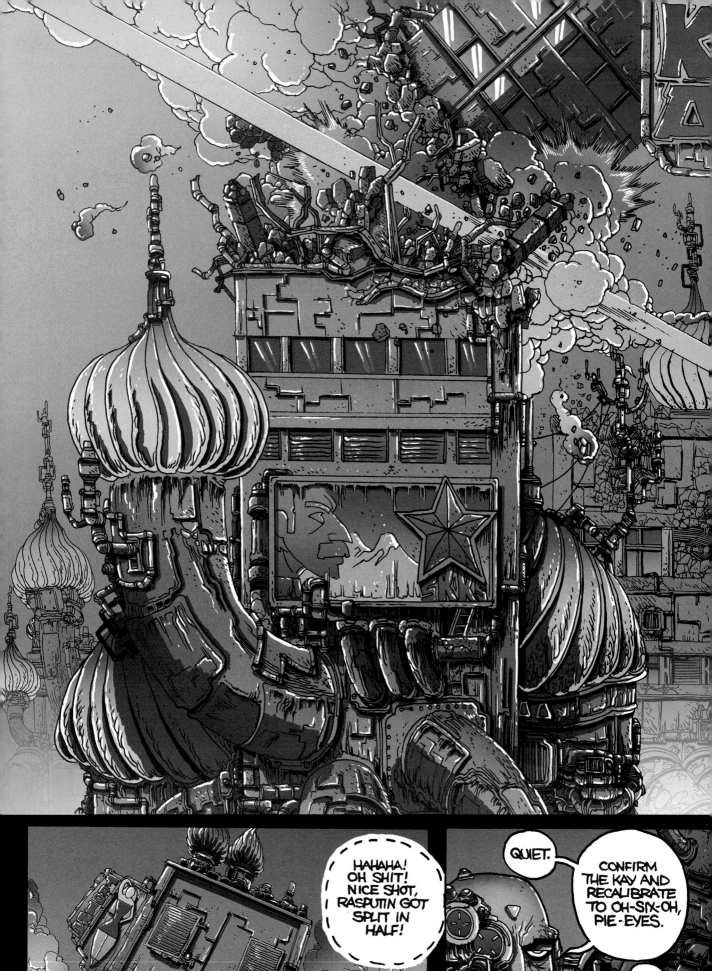
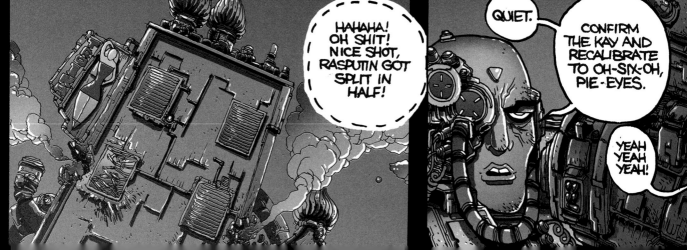

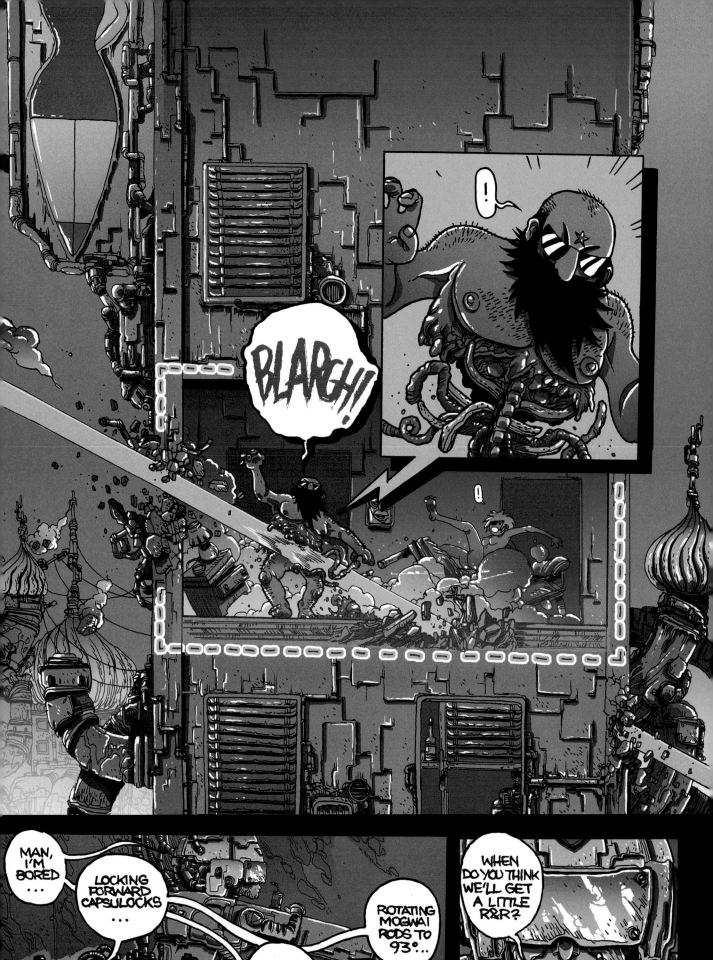
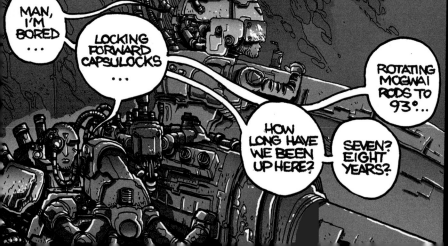
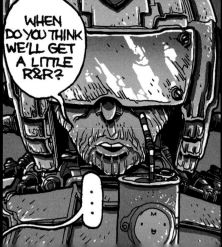

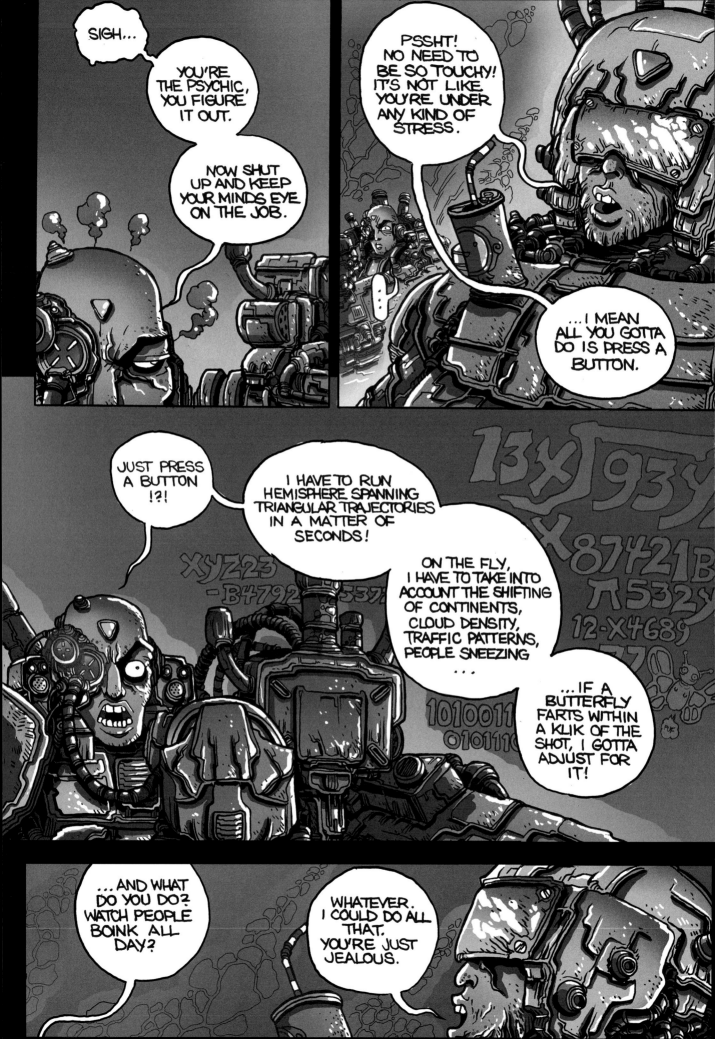

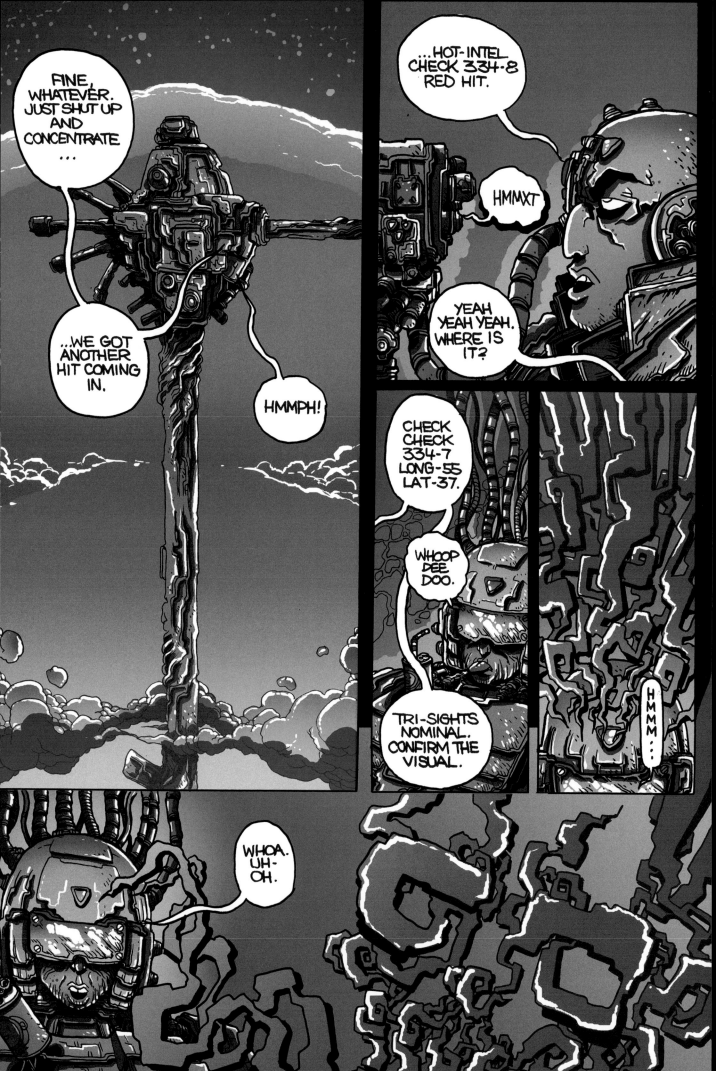

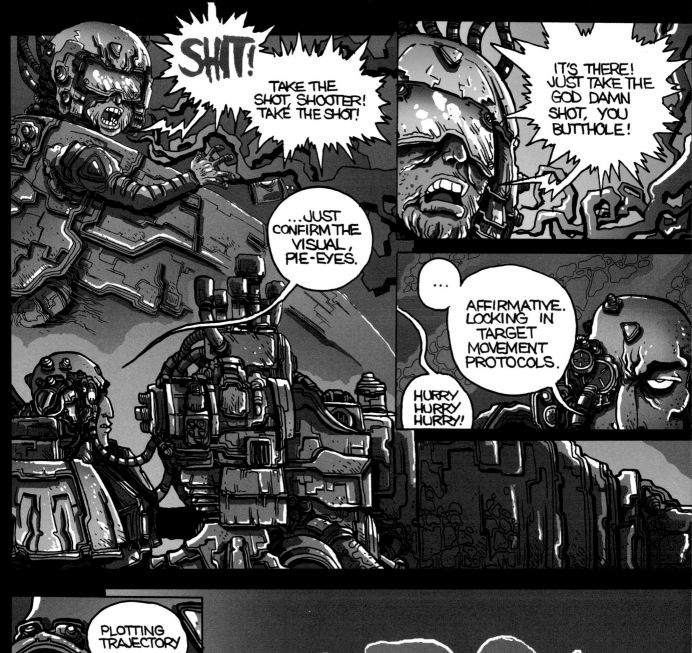

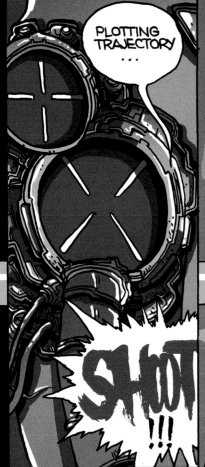

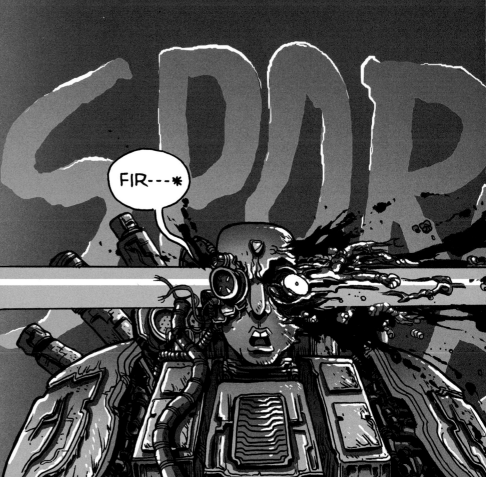

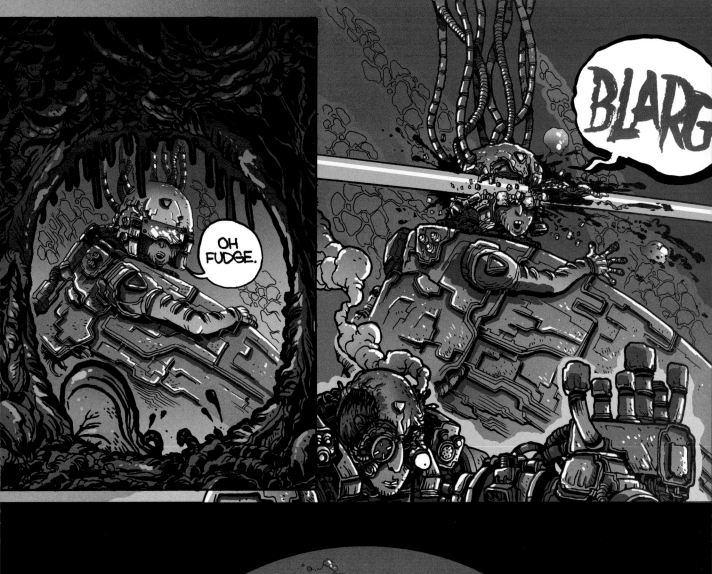

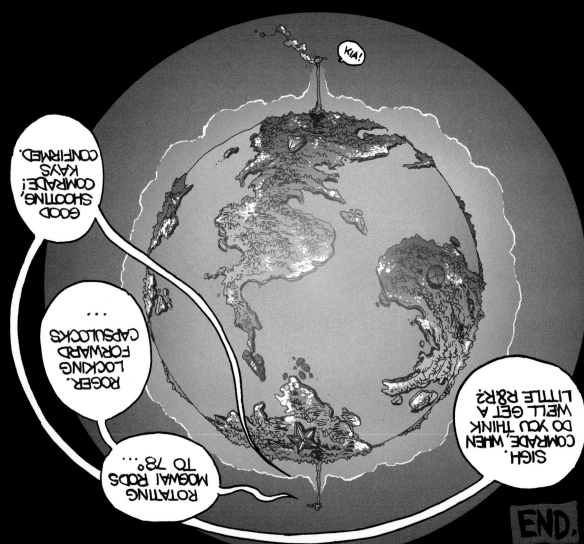

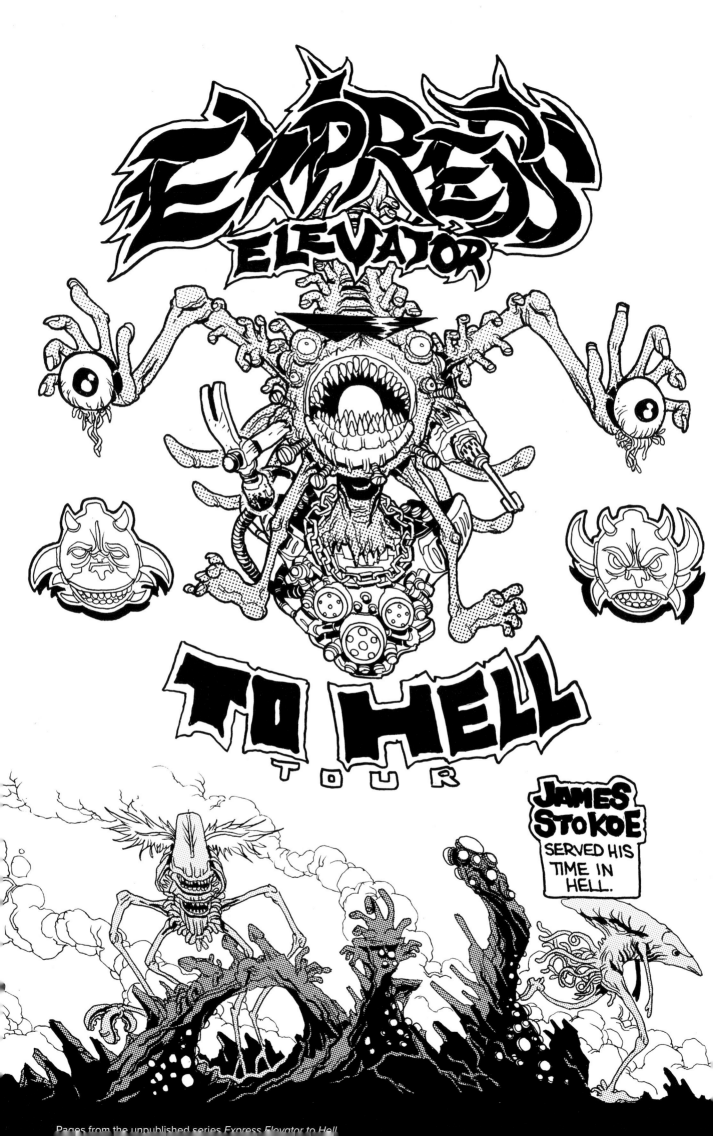

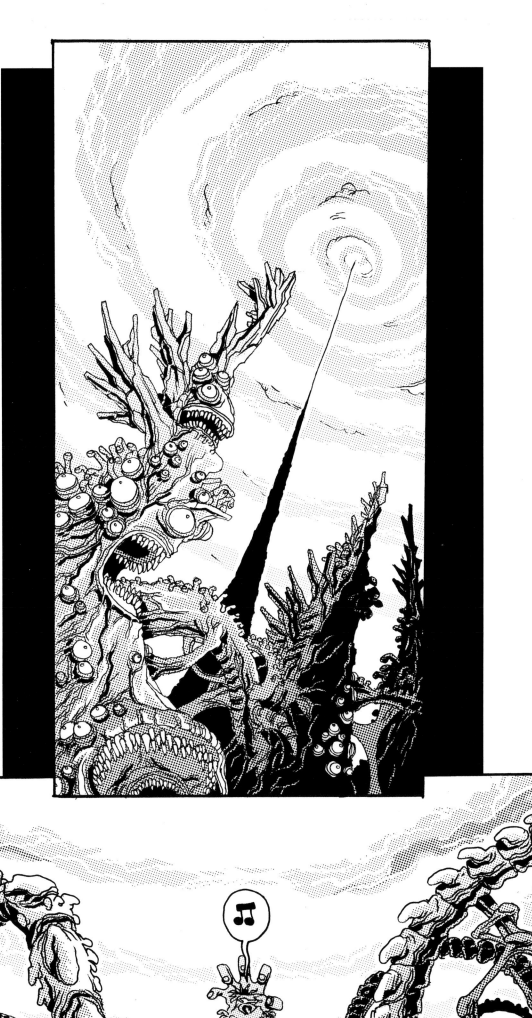

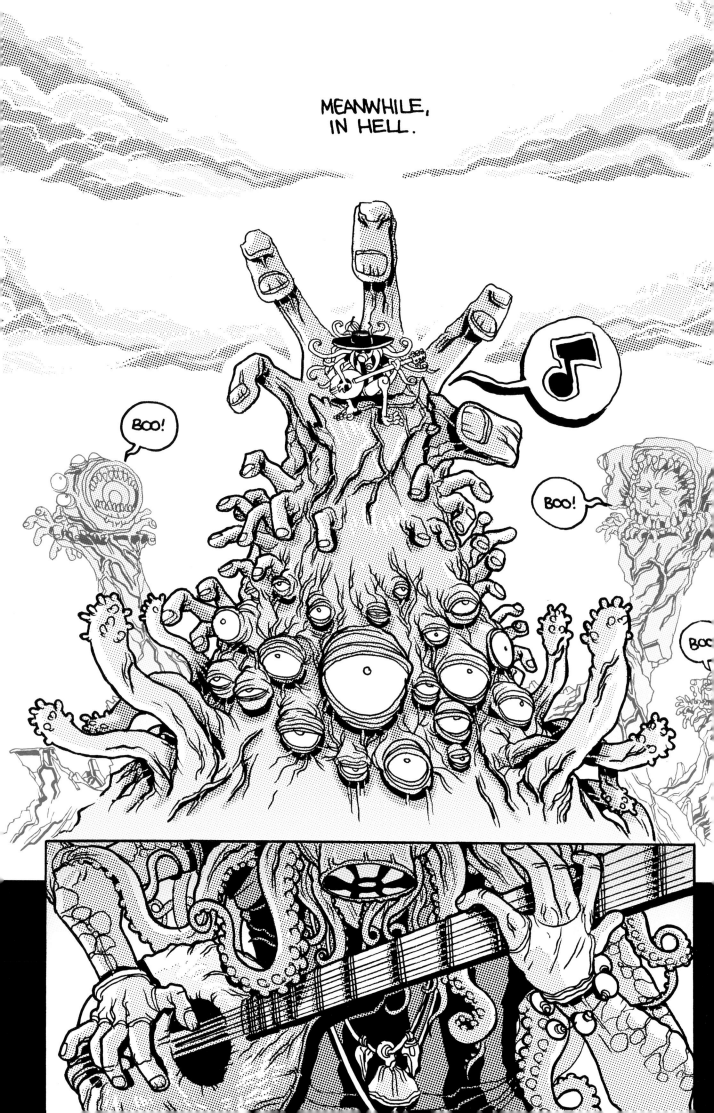

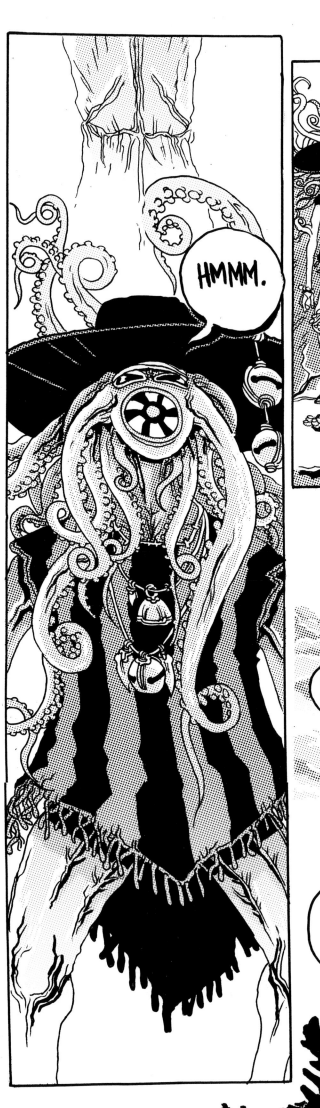

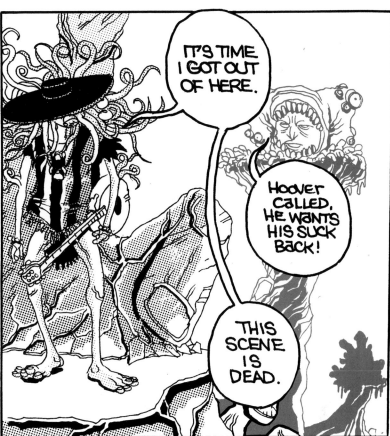

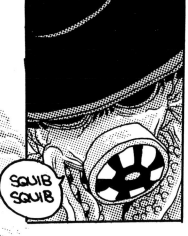

I NEVER THOUGHT THAT BEING IN HELL WOULD GET SO BORING.

YOU CAN ONLY SEE A TWELVE DICKED CELTIC CHURNABOG DEMON SO MANY TIMES BEFORE IT GETS OLD.

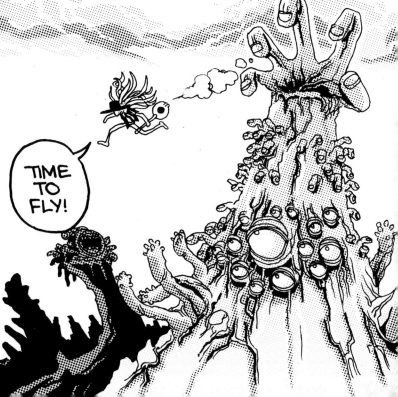

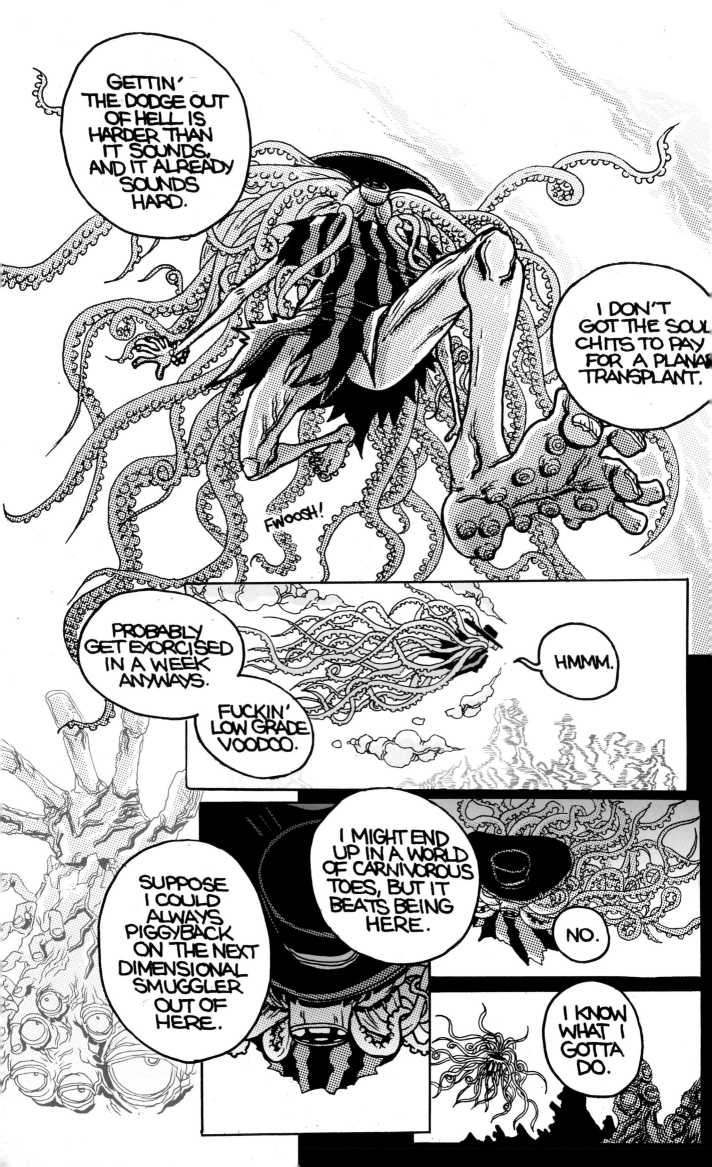

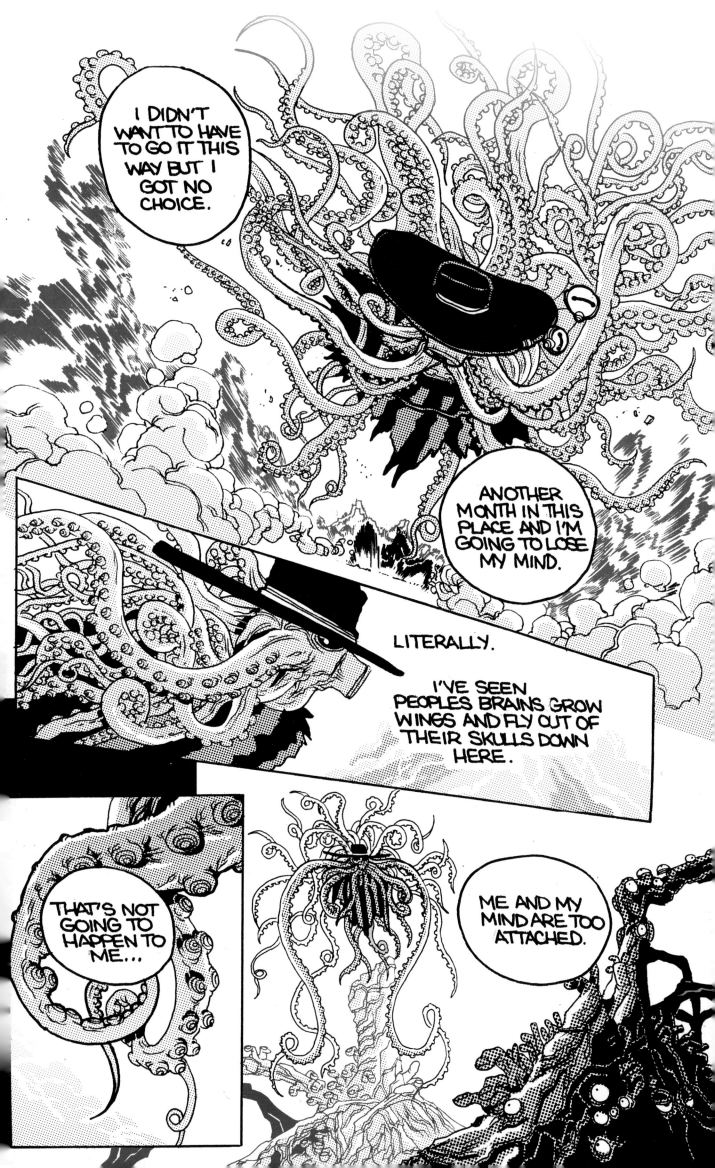

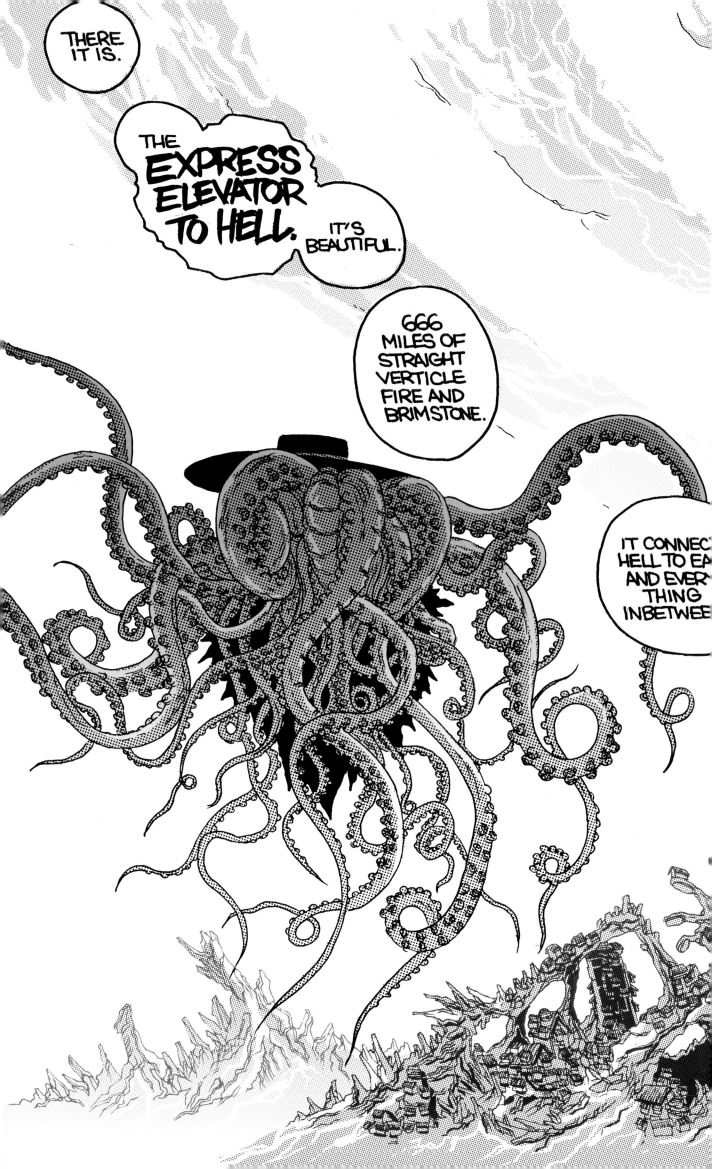

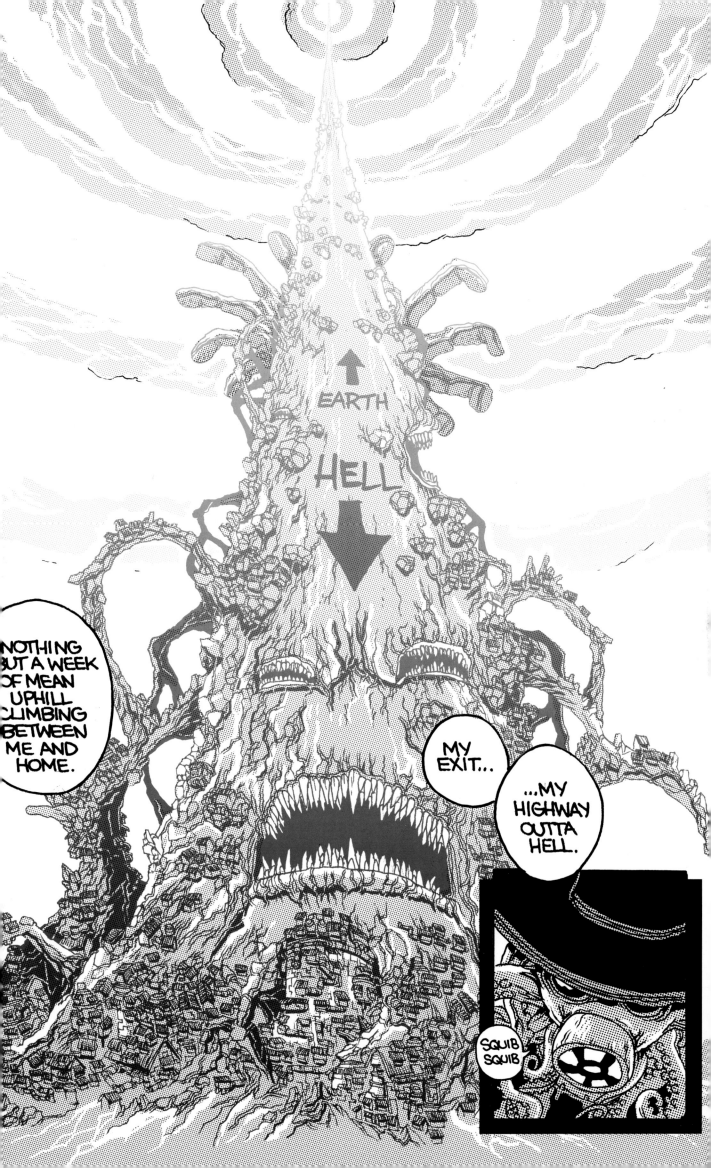

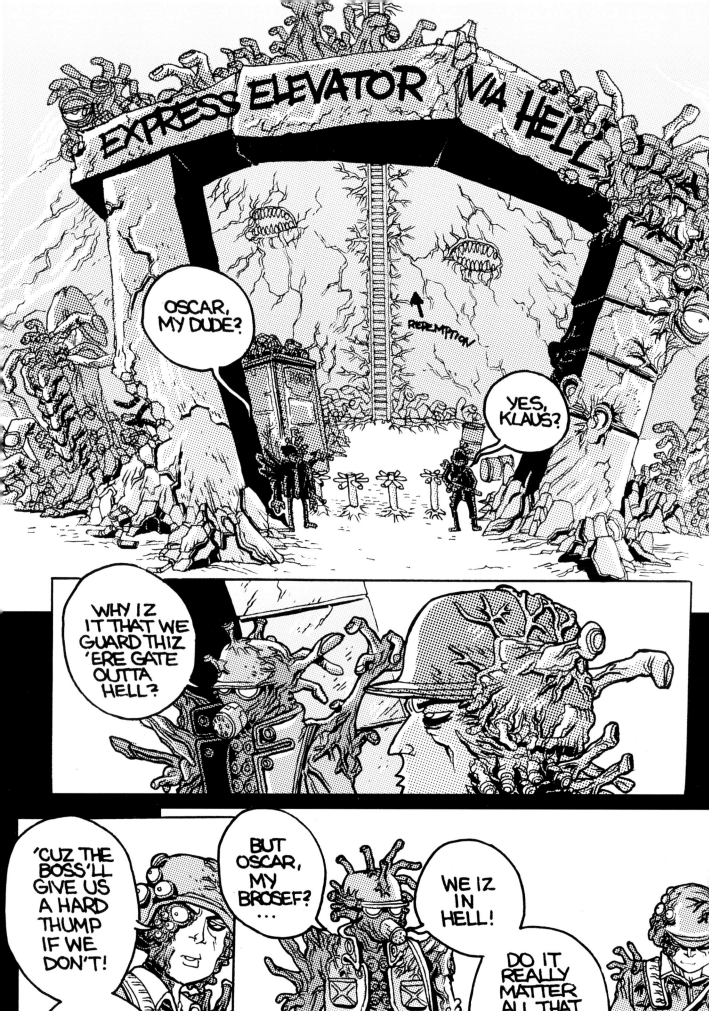

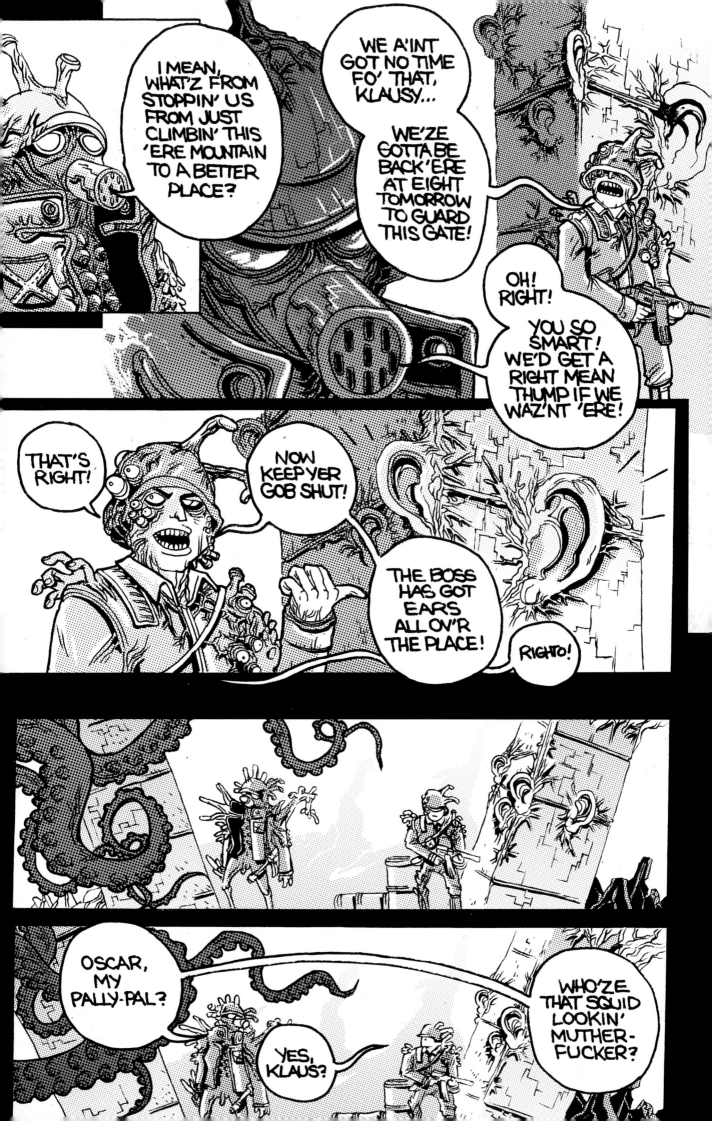

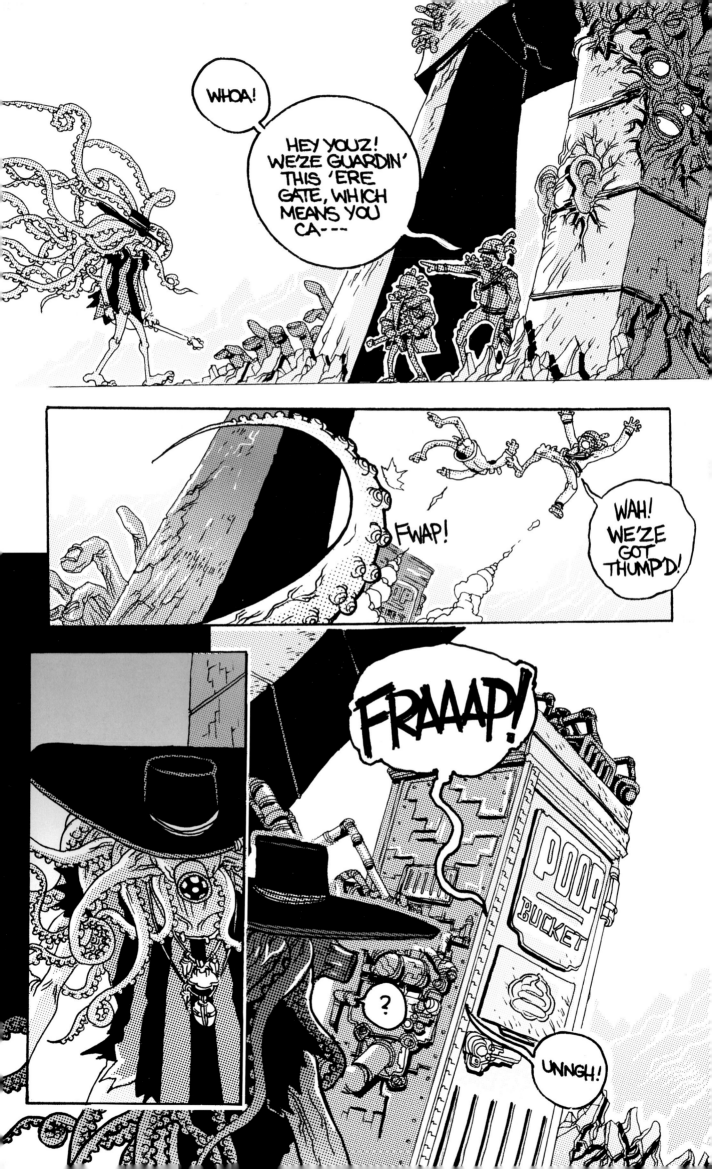

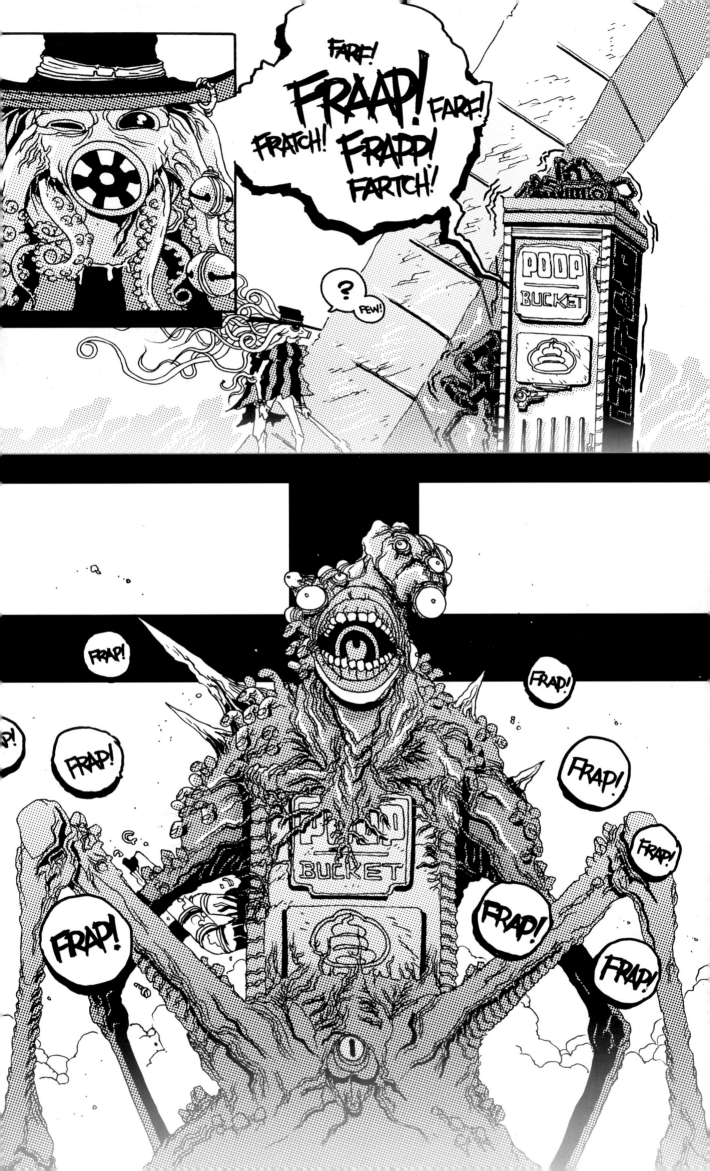

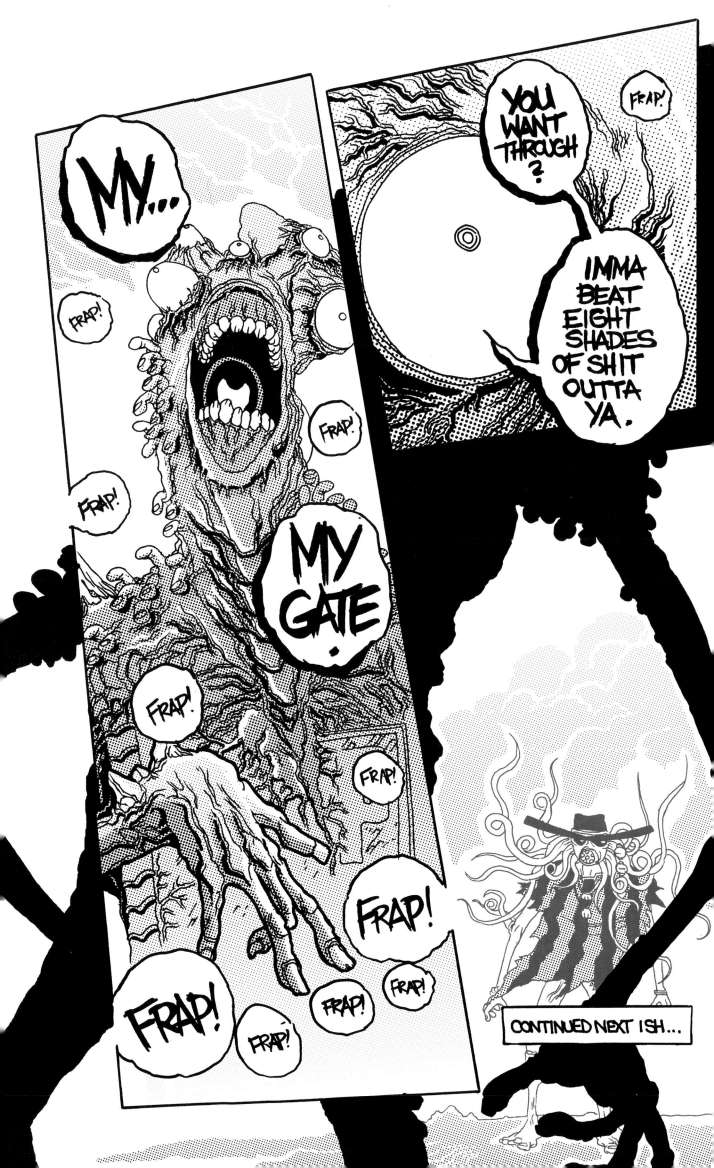

CONTINUED NEXT ISH...

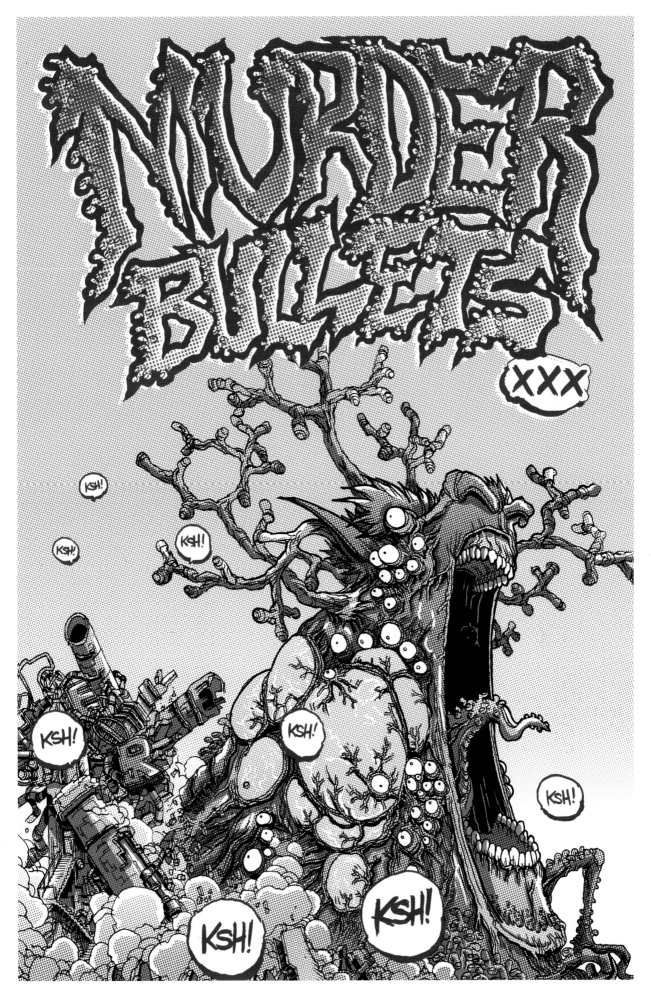

These following pages are from the unpublished comic *Murder Bullets*.

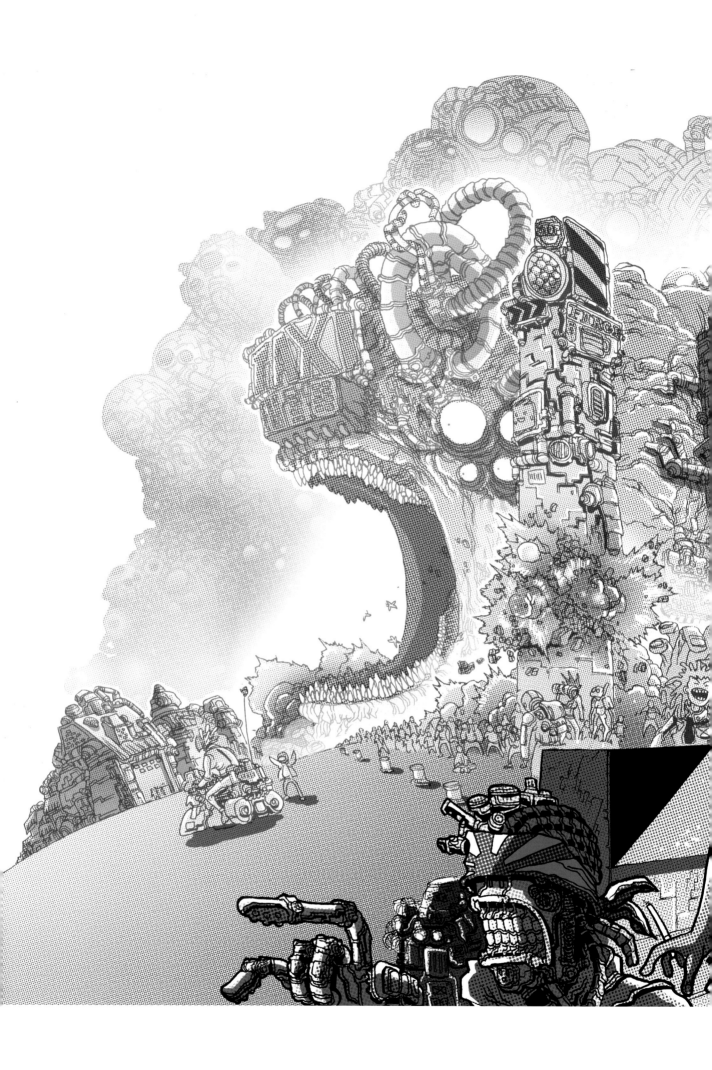

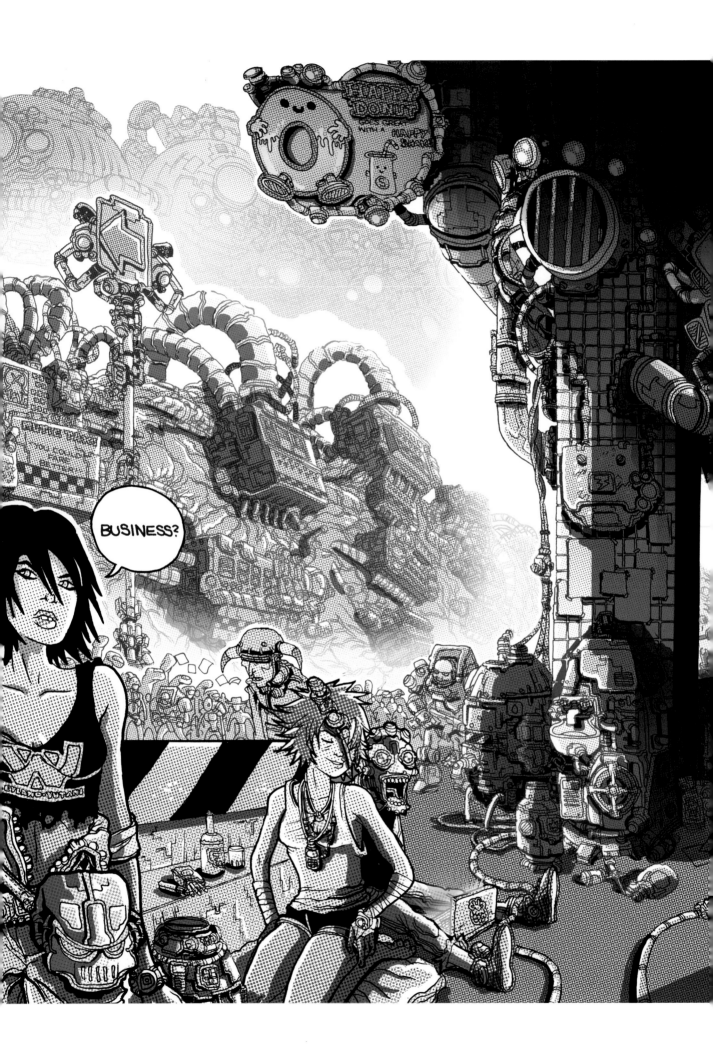

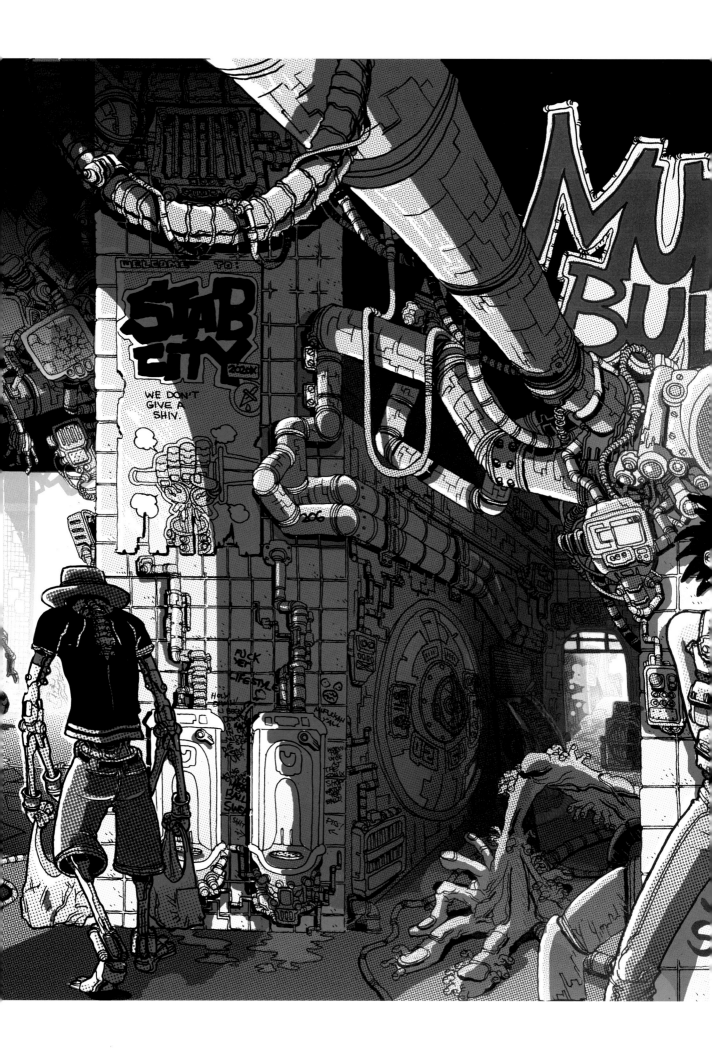

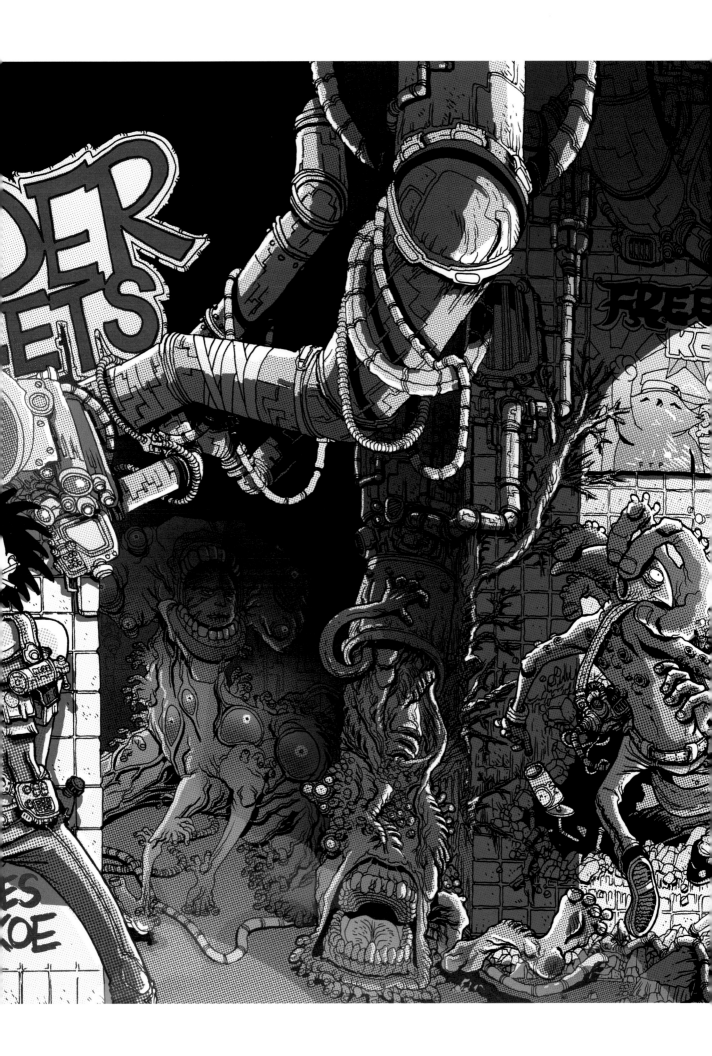

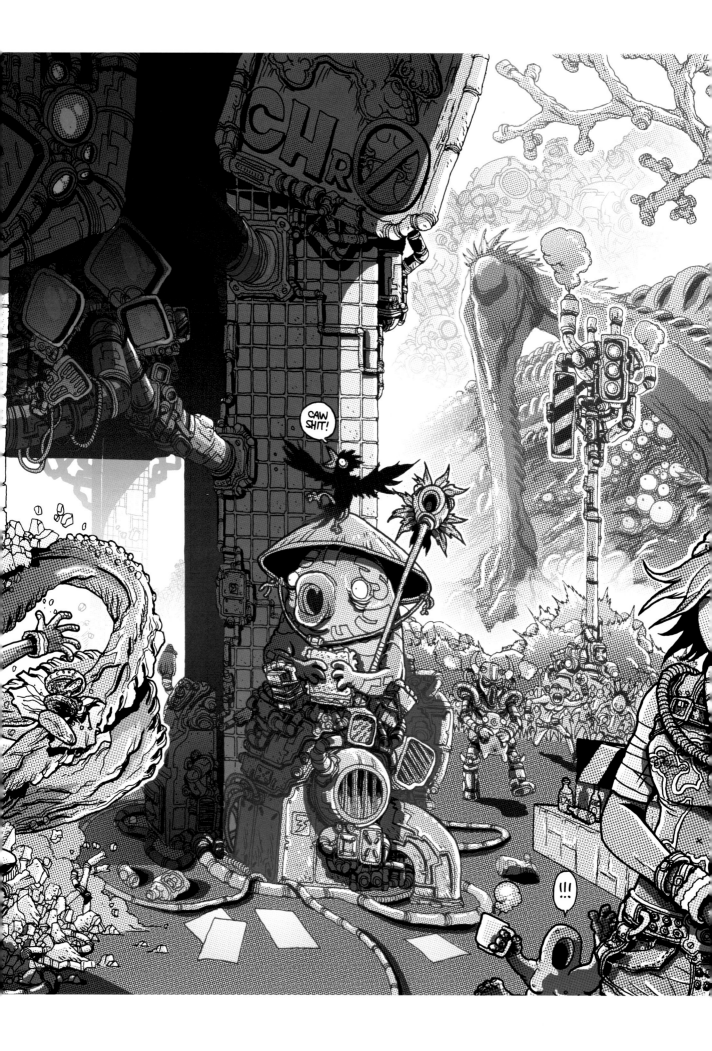

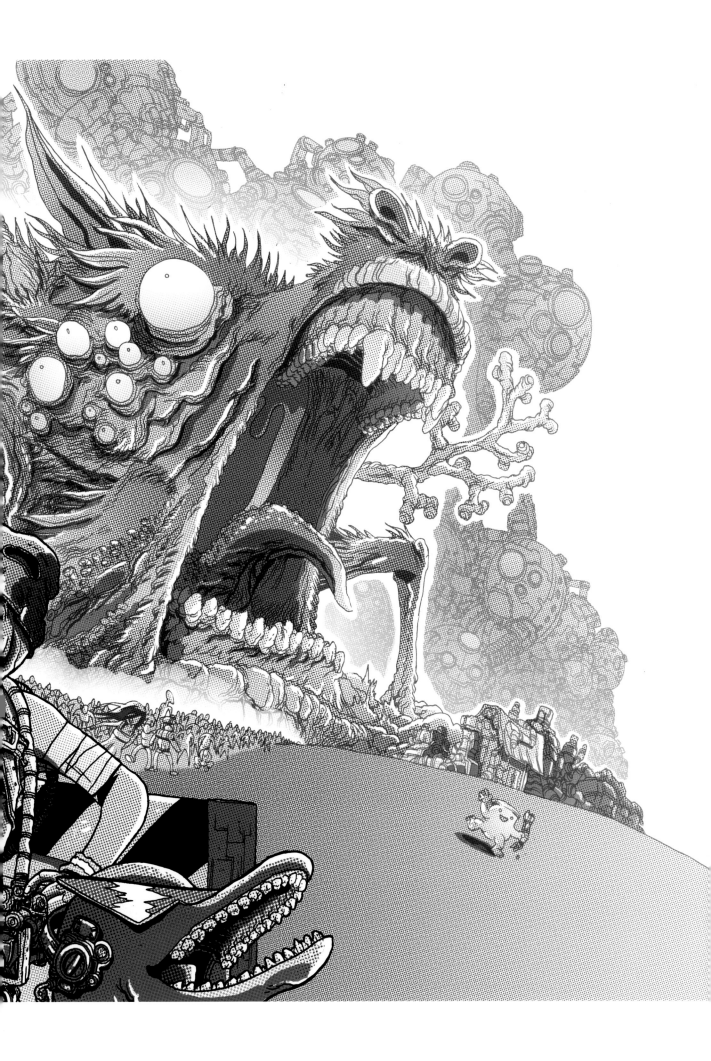

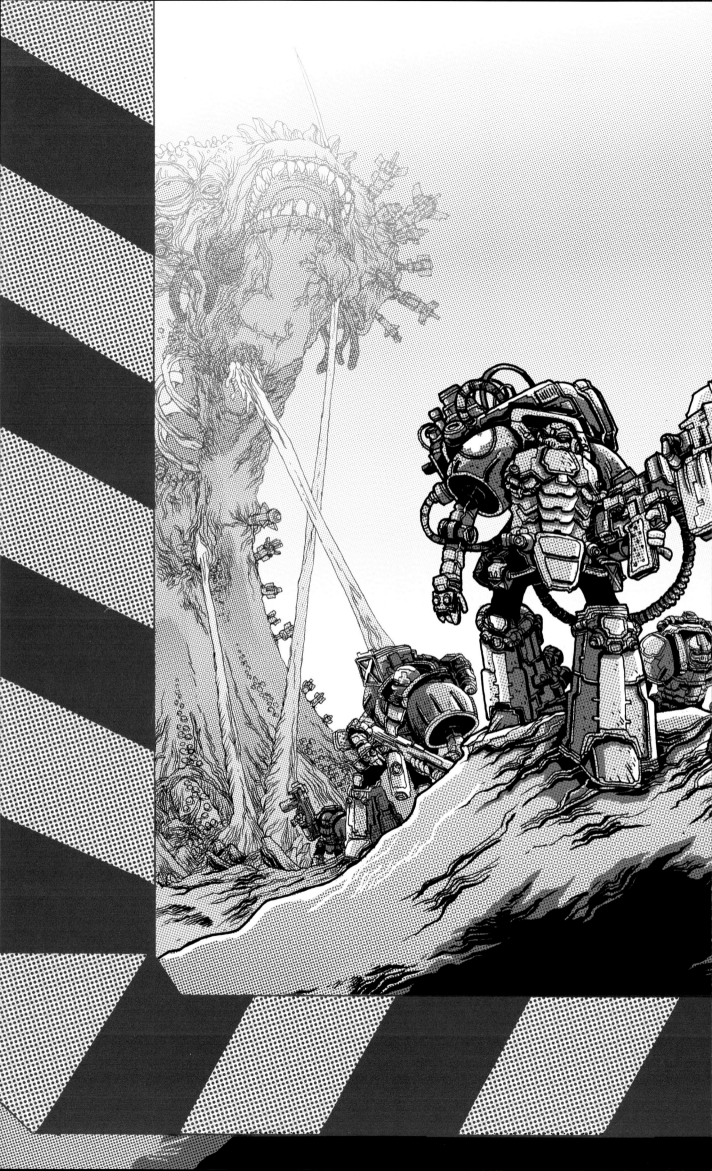

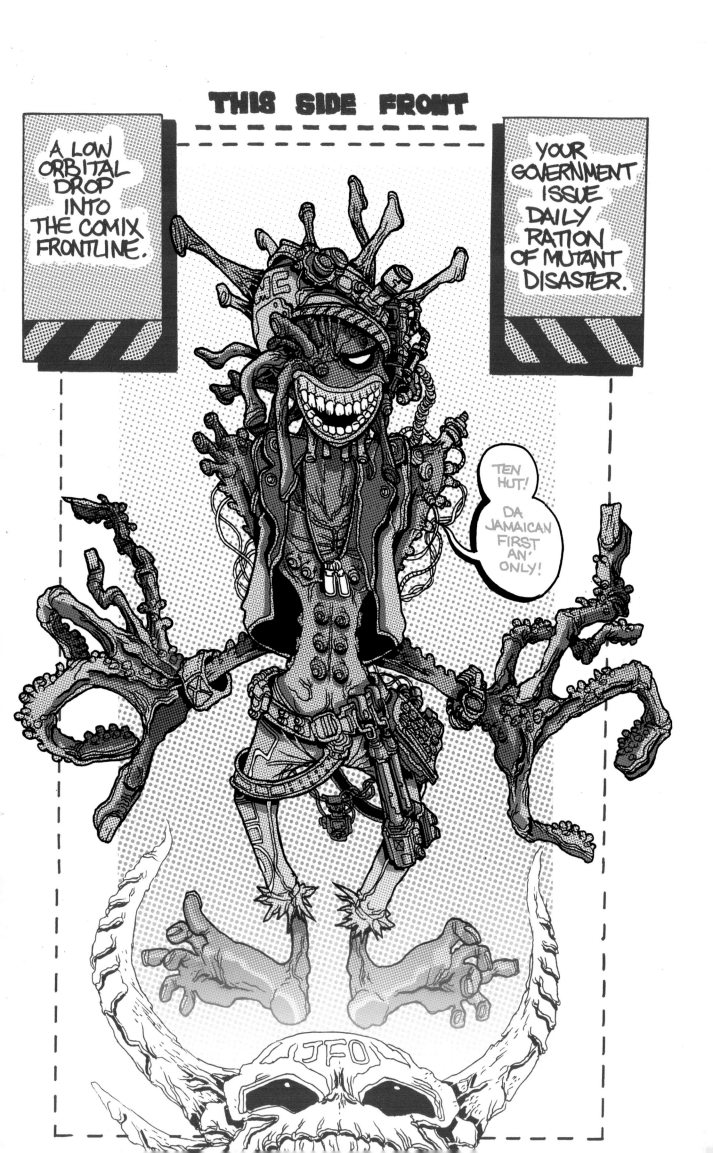

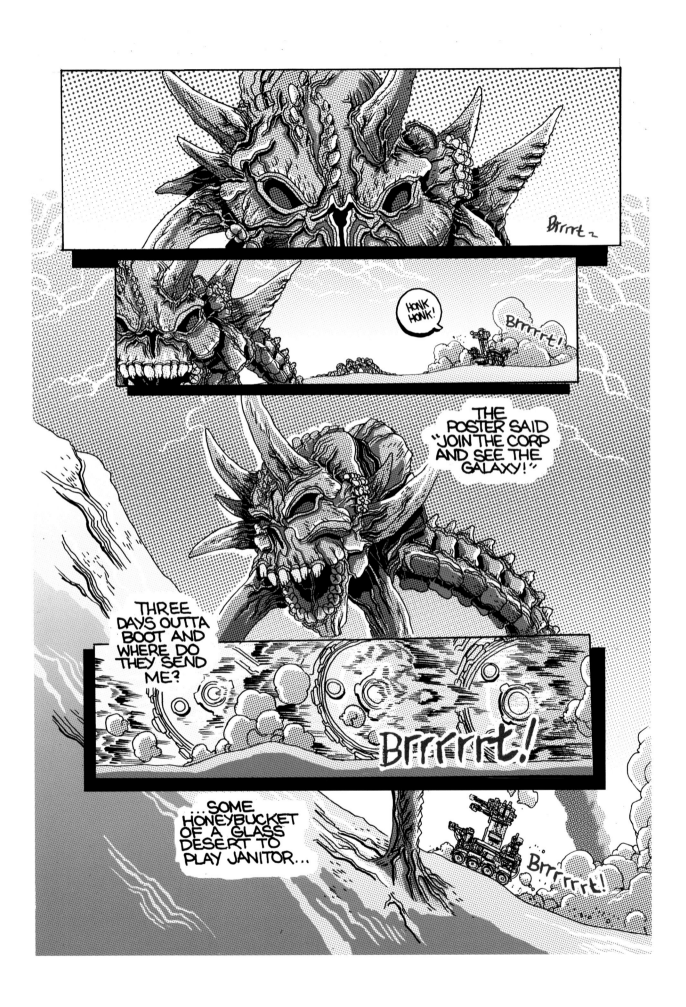

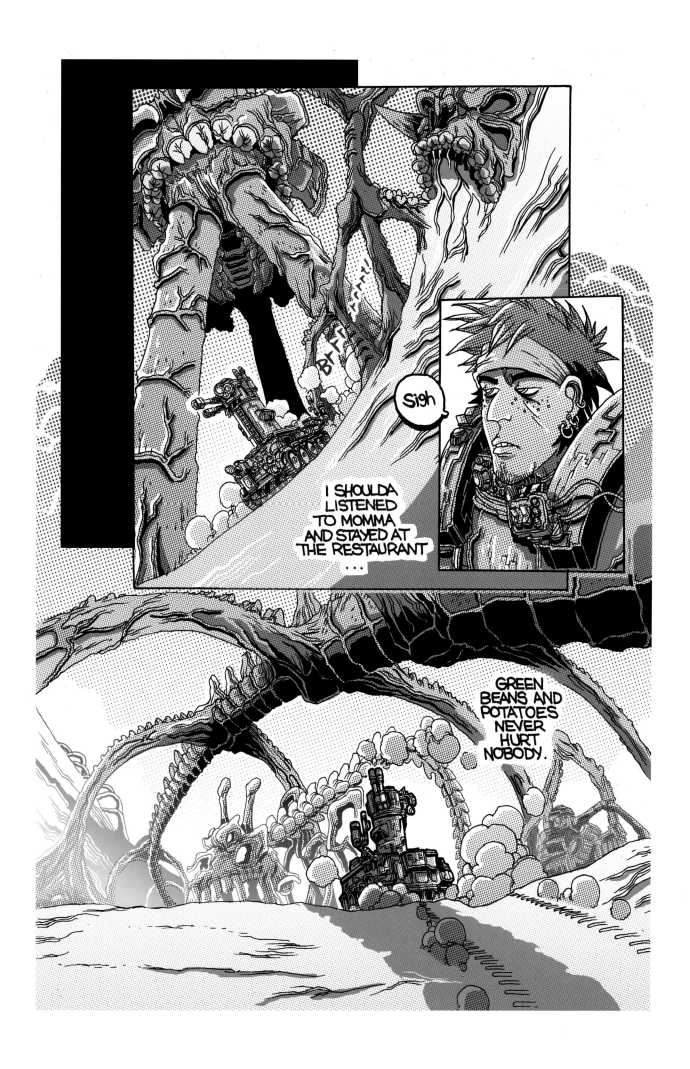

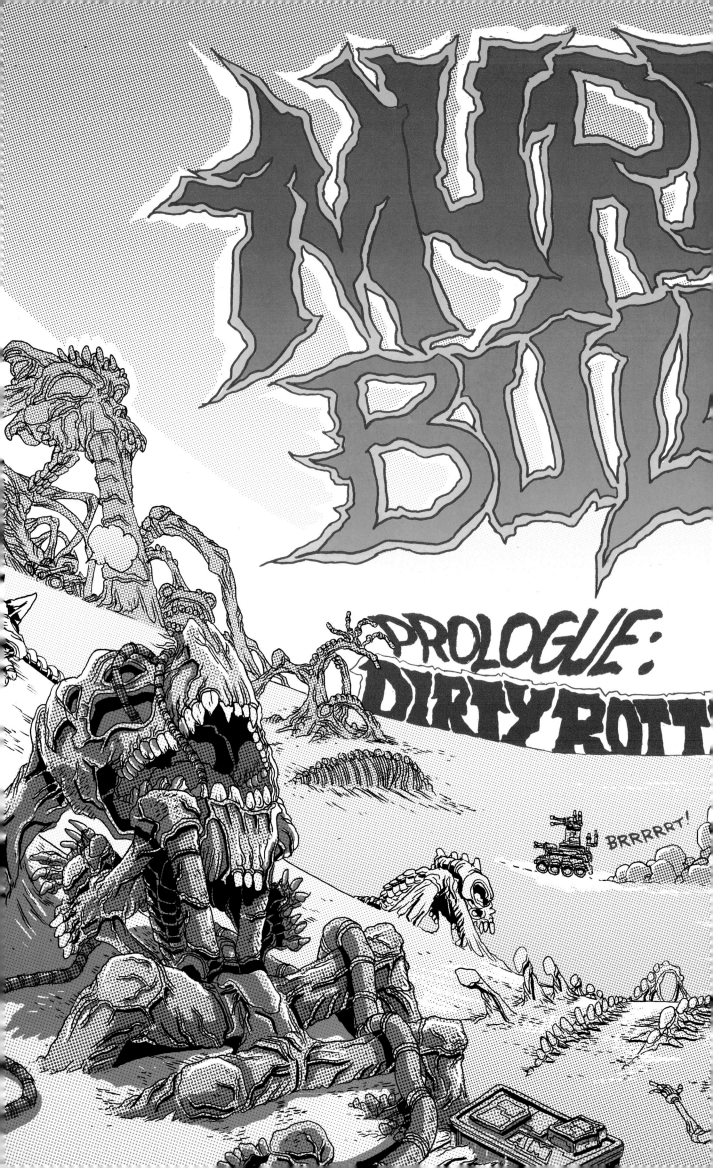

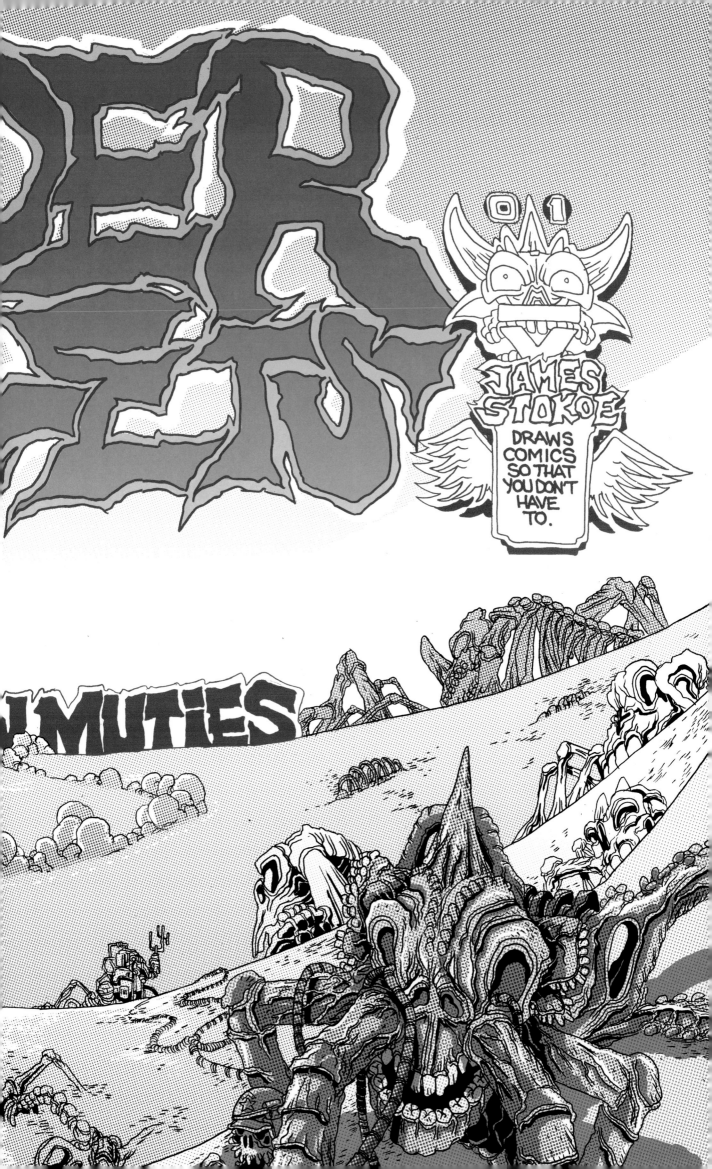

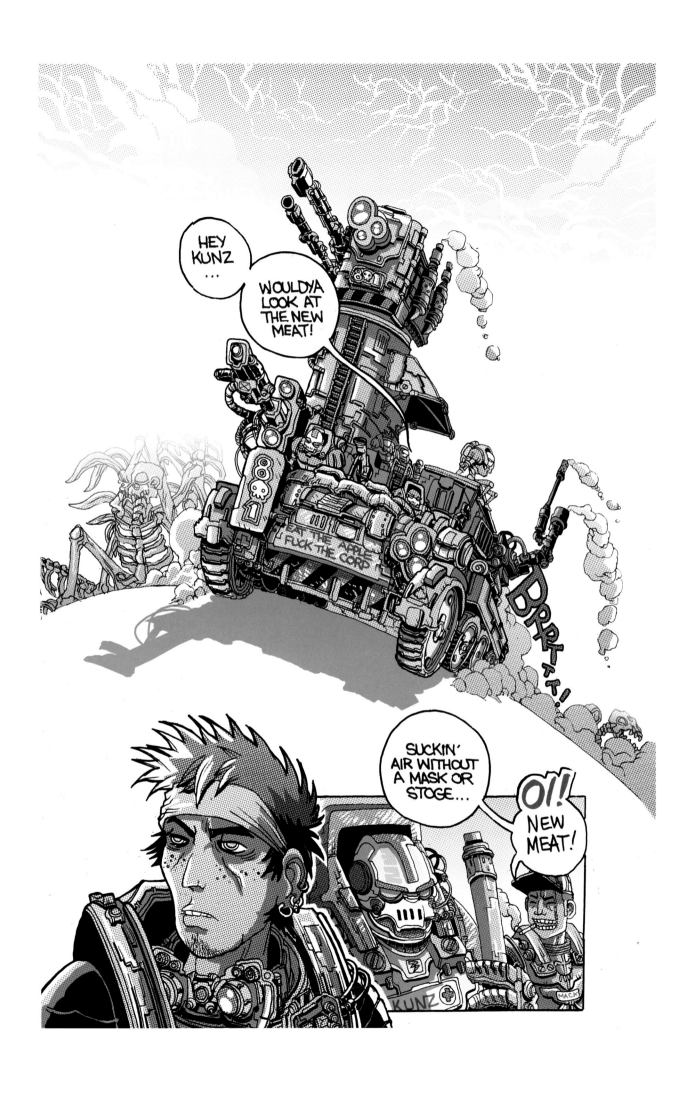

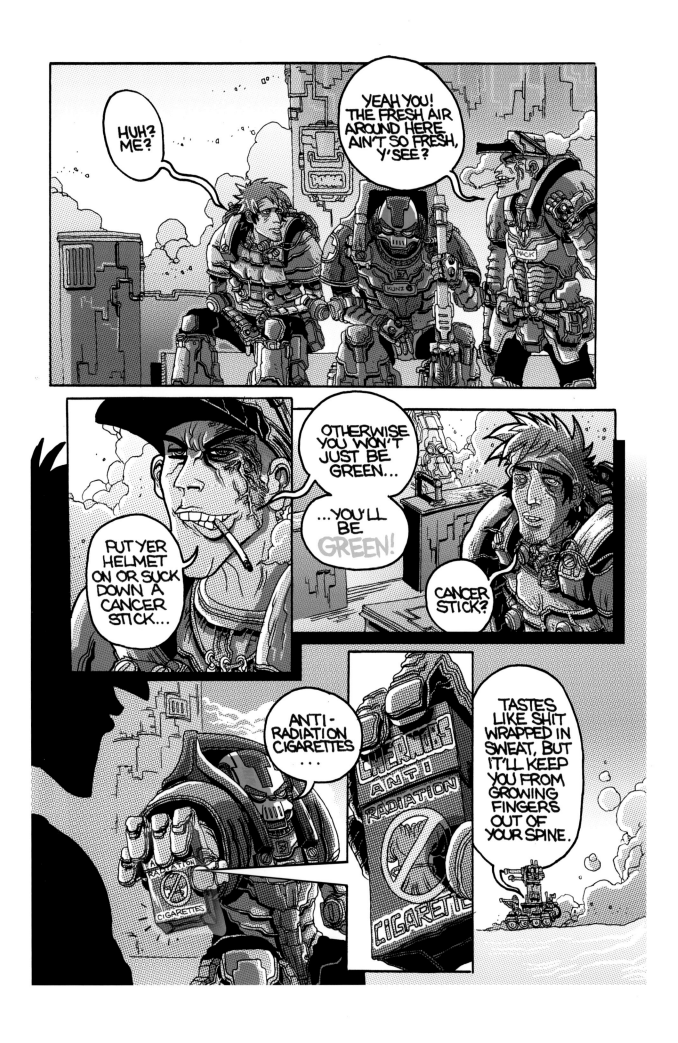

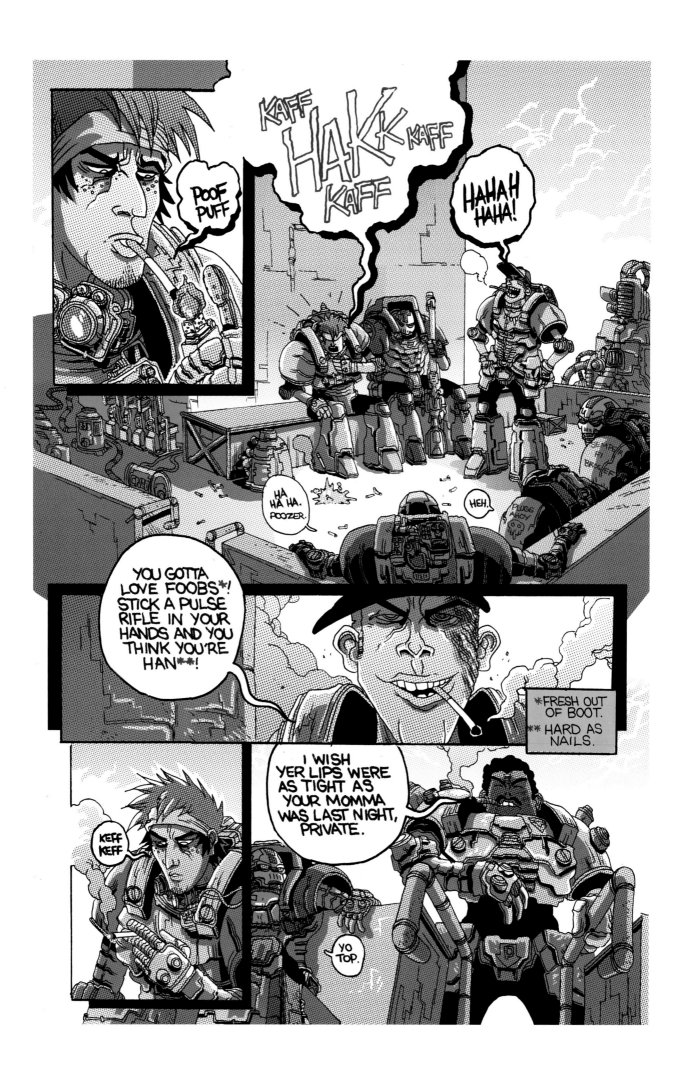

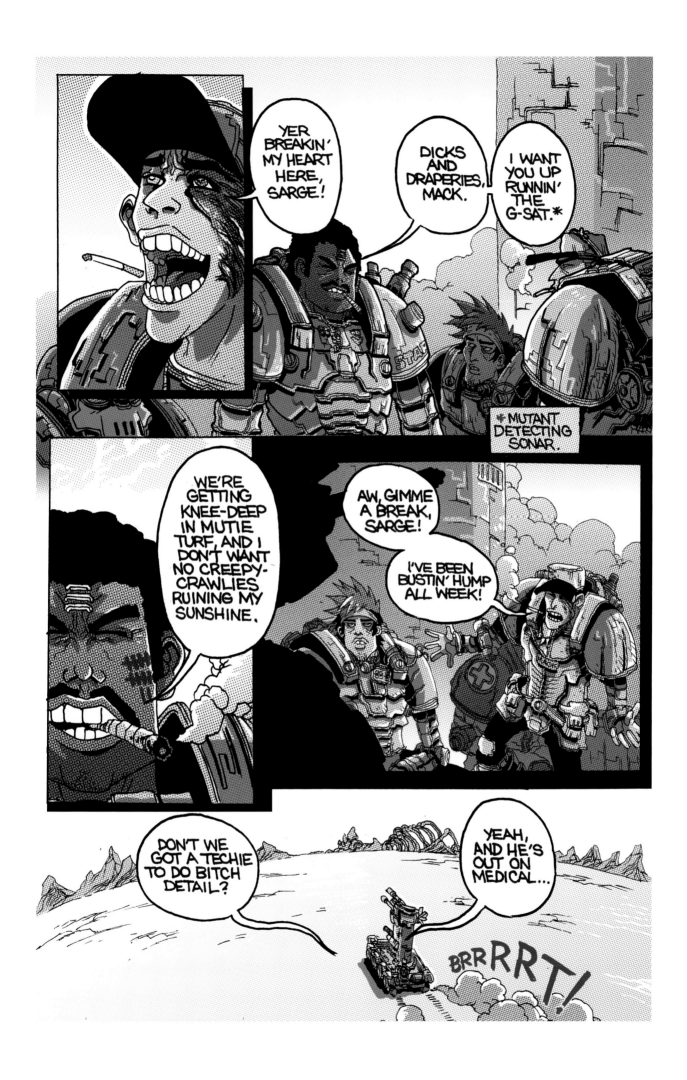

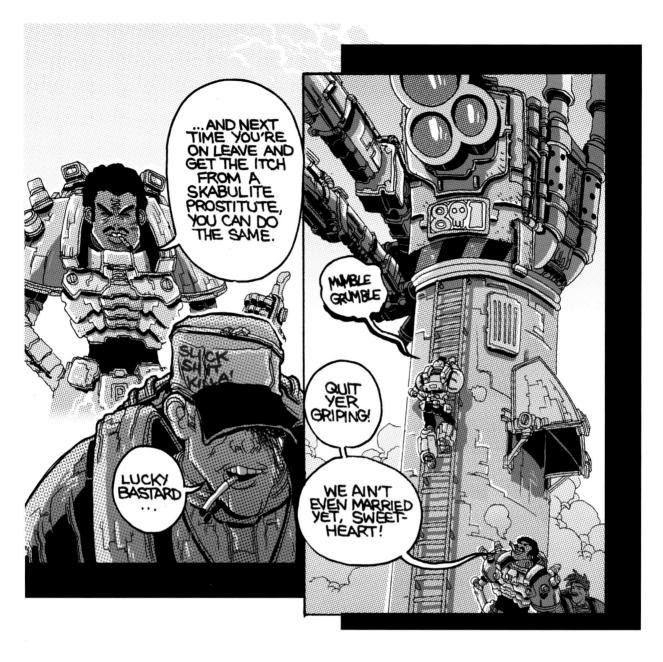

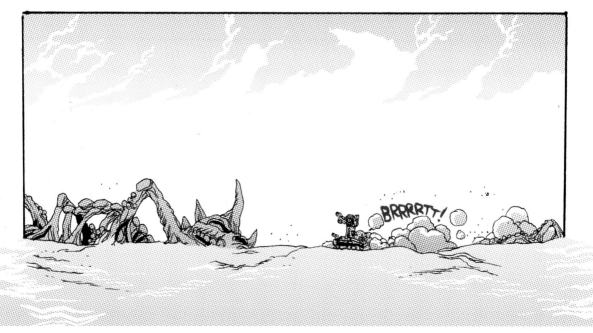

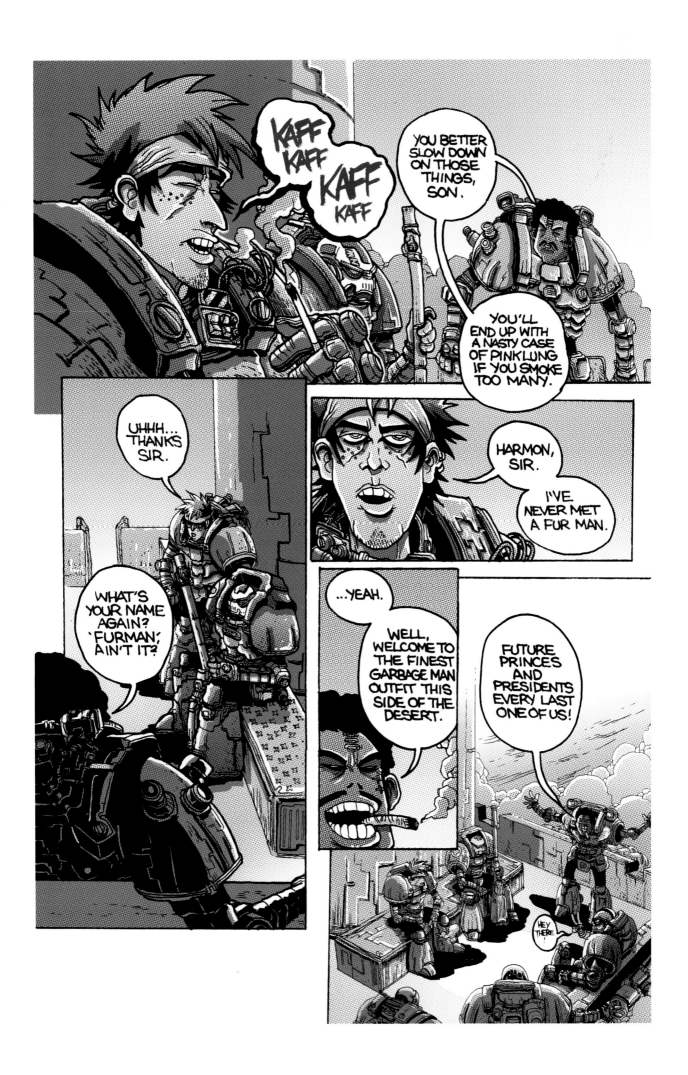

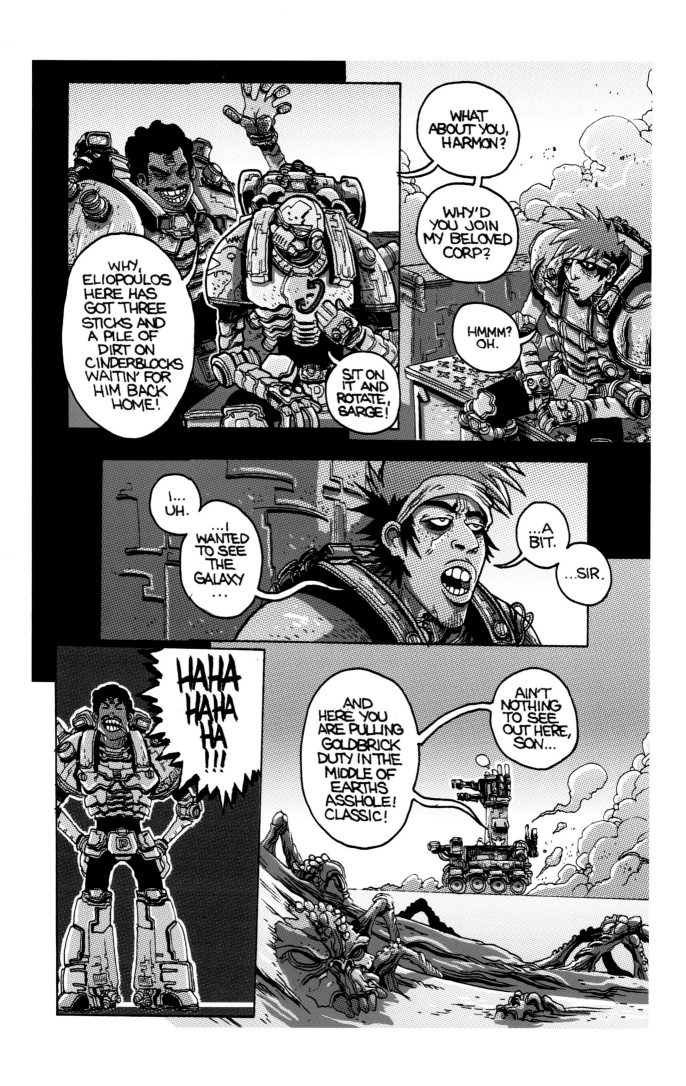

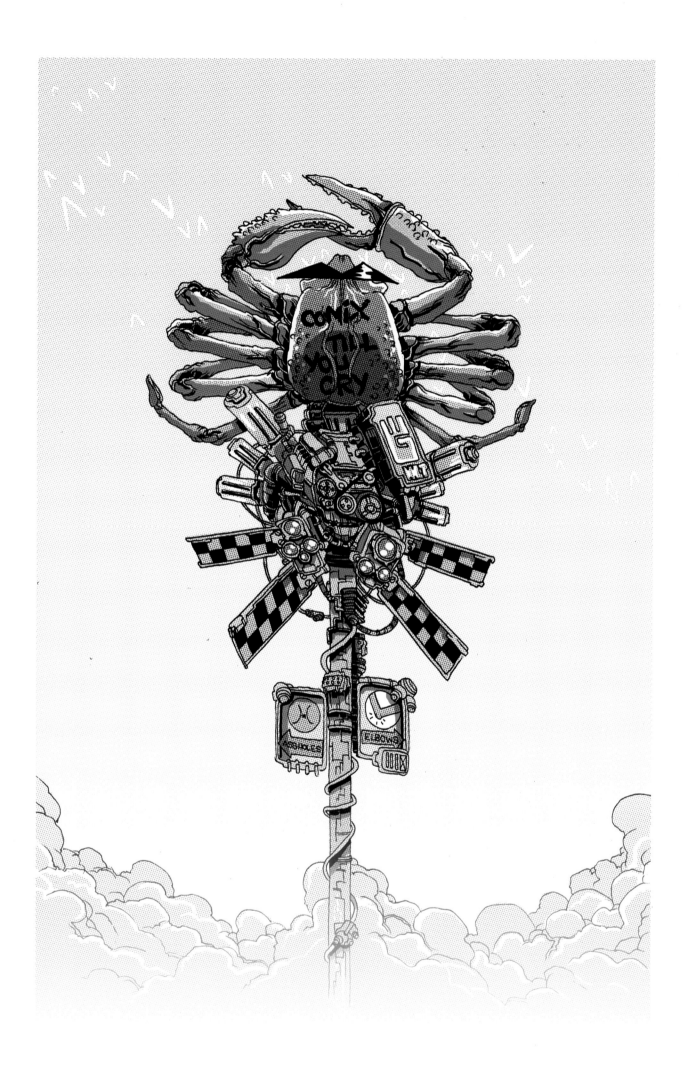

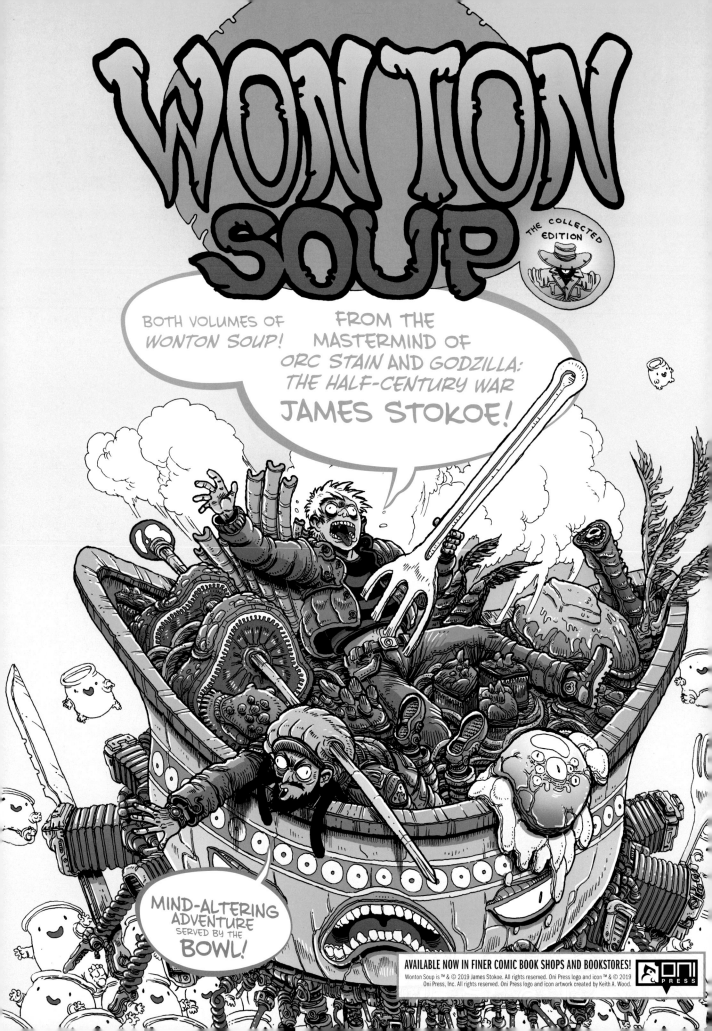